THE BEST OF WILDLIFE ART

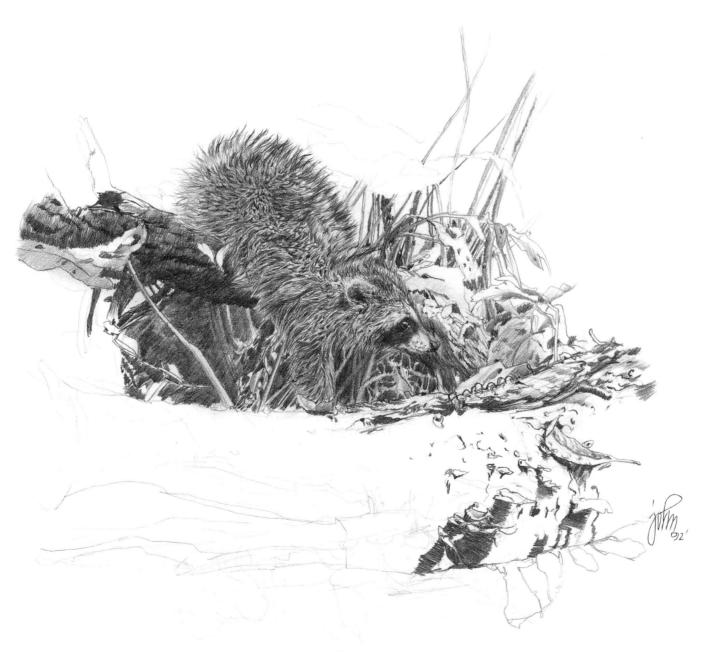

John P. Mullane

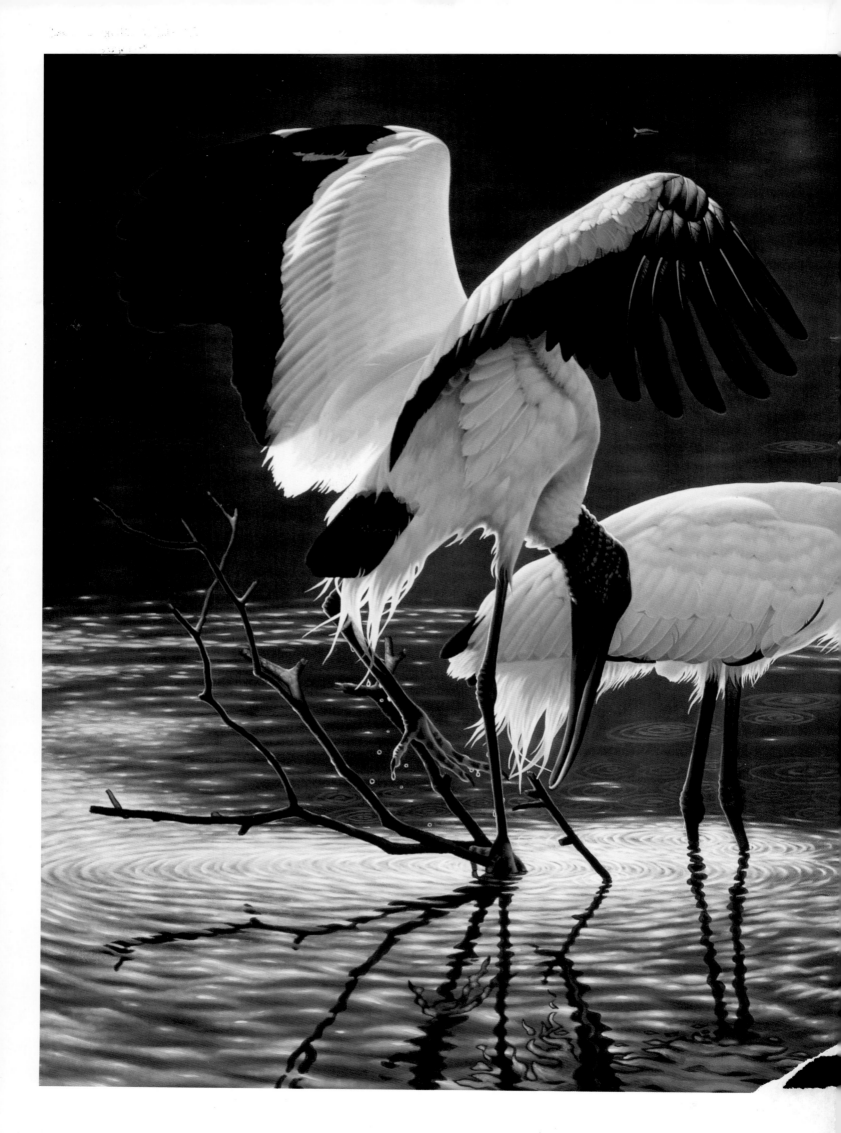

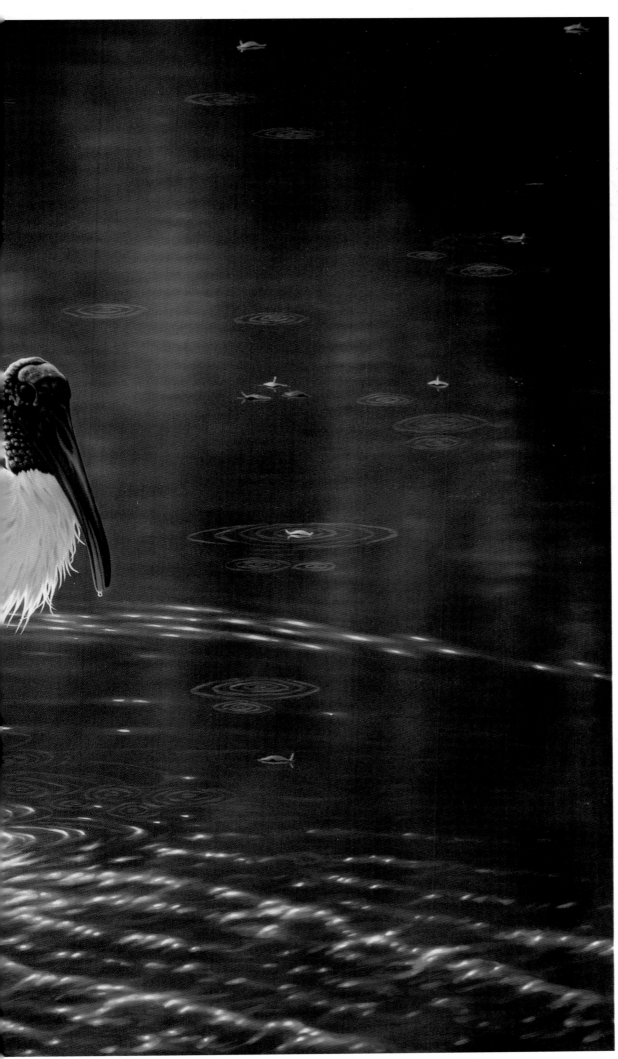

The Best of Wildlife Art

Edited by
Rachel Rubin Wolf

NORTH LIGHT BOOKS
CINCINNATI, OHIO

DAYBREAK AT MRAZEK POND (WOOD STORK) Dee Smith, oil on canvas, 30" x 42" (76cm x 107cm)

John P. Mullane

Other fine North Light Books are available from your local bookstore, art supply store or direct from the publisher.

01 00 99 98 97 5 4 3 2 1

Library of Congress Cataloging in Publication Data

The best of wildlife art / edited by Rachel Rubin Wolf.
 p. cm.
 Includes index.
 ISBN 0-89134-743-7 (alk. paper)
 1. Wildlife art. I. Wolf, Rachel.
N7660.B48 1997 97-7340
704.9'432--dc21 CIP

Edited by Rachel Rubin Wolf and Jennifer Long
Production Edited by Amy Jeynes and Michelle Kramer
Interior and cover designed by Sandy Kent
Cover illustration © Terry Isaac

The permissions beginning on page 139 constitute an extension of this copyright page.

North Light Books are available for sales promotions, premiums and fund-raising use. Special editions or book excerpts can also be created to specification. For details, contact the Special Sales Manager, F&W Publications, 1507 Dana Avenue, Cincinnati, Ohio 45207.

ABOUT THE EDITOR

Rachel Rubin Wolf is a freelance writer, editor and artist. She edits fine art books for North Light Books, working with many fine artists who paint in a variety of mediums and styles. Wolf is the project editor for the *Splash* series, as well as many of *North Light's Basic Techniques* series paperbacks. She is also the author of *The Acrylic Painter's Book of Styles and Techniques* (North Light) and a contributing writer for *Wildlife Art News*. Wolf studied painting and drawing at the Philadelphia College of Art (now University of the Arts) and Kansas City Art Institute, and received her B.F.A. from Temple University in Philadelphia. She continues to paint in watercolor and oils as much as time will permit. She resides in Cincinnati, Ohio, with her husband and three children.

ACKNOWLEDGMENTS

Thanks to David Lewis and North Light Books who, several years ago, were open to taking another look at the field of wildlife art and who sponsored my introduction to this wonderful world, a workshop with Bob Kuhn at the Zemsky/Hines Beartooth Workshops. Thanks to the many wildlife artists I have gotten to know personally, and from whom I have received much insight, particularly Bart Rulon, Terry Isaac and John Banovich. Thanks to Jennifer Long at North Light Books who so efficiently and graciously helped oversee the project, organizing the numerous materials and mailings, and checking the final details. Your help was a critical and sometimes thankless behind-the-scenes part of a project like this. Thanks also to the production editors, Amy Jeynes and Michelle Kramer, for making sure everything got to the printer right, and Sandy Kent for another elegant book and cover design. Special thanks to all of the artists in this book for supplying your transparencies and thoughts. It certainly couldn't have happened without you. Your honesty, down-to-earthness and enthusiasm made it a pleasure.

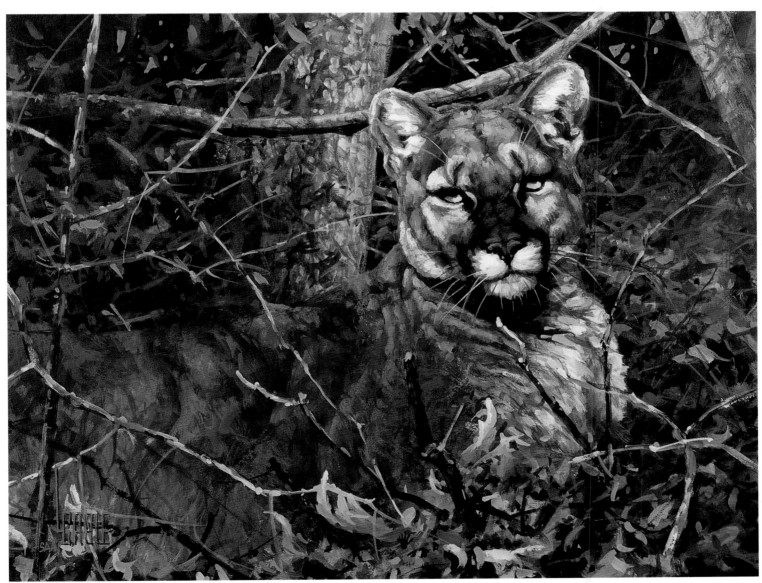

PENSIVE PUMA (COUGAR)
Lee Cable, gouache, 9" x 12" (23cm x 30cm)

TABLE OF CONTENTS

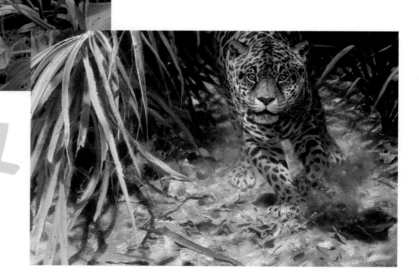
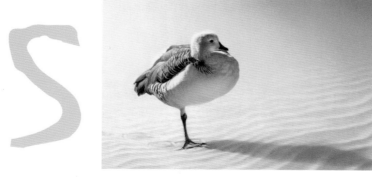

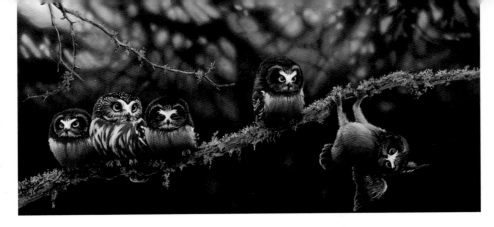

6

ENLIST EMOTION WITH A
PLEASING POSE

page 86

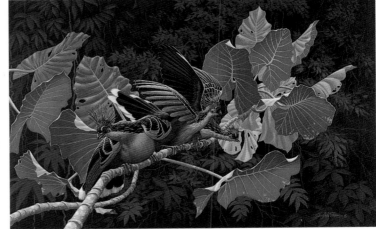

7

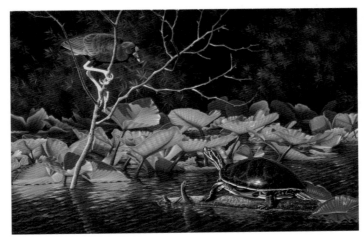

8

HOLD THE VIEWER WITH
TENSION

page 112

9

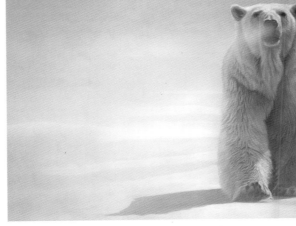

ENTERTAIN THE EYE WITH NATURE'S
CAMOUFLAGE *page 124*

INTRODUCTION

It is with great pleasure that I present to you this beautiful volume displaying some of the best current works of art showcasing wildlife subjects.

It is my hope that this book (along with anticipated future volumes) will do much to further augment the increasing public respect for the field of wildlife art. Wildlife art has developed rapidly over the past generation to reveal a truly exciting and earnest vision.

As these artists raise both their skill and creativity to new heights, the emotions behind the paintings are focused to an even greater strength of purpose. These are not intellectual oeuvres making esoteric (and oh-so-obscure) observations about post-modernism; these are works of passion. It is evident that the artist is both in love with, and in awe of, the subject.

Within the following pages there is a broad range of visions, yet all with a unifying theme. There is considerable variety in painting styles, in art mediums, in subject matter and in presentation. Yet, contained within each brushstroke is the residual passion of perhaps a month, or a lifetime, of the most fundamental kind of human experience—being "out there."

These artists don't just paint. They seek to encounter the natural world and its inhabitants face-to-face and to bring that experience to us through their art. Many travel the world, literally climbing the highest mountains, to observe the quiet wonders of a mountain goat or bald eagle in its natural habitat. Others stay closer to home and thrill to the tracks of a snowshoe hare or the daily routine of a common songbird, seeking to share in their mysteries.

It is this love for the natural gifts we have been given, and increasingly the fear of losing the same, that is the unifying theme of all these works of art. It fuels the sometimes bold, sometimes subdued intensity behind these works. As the artists move away from mere technicality and seek, each in their own way, to enlist the viewer in the emotion behind the art, wildlife art should more and more enter the mainstream of the art world. Then many more will have the opportunity to be moved by these important works of art that express the beauty, drama and fragility of the world around us.

Consider yourself blessed to have the opportunity right now, in your very hands, to be inspired by the scope of vision and passion in today's wildlife art.

—*Rachel Rubin Wolf*

Something Old, Something Blue (Blue Crowned Motmots)
Richard Sloan, acrylic, 24" x 16" (61cm x 41cm)

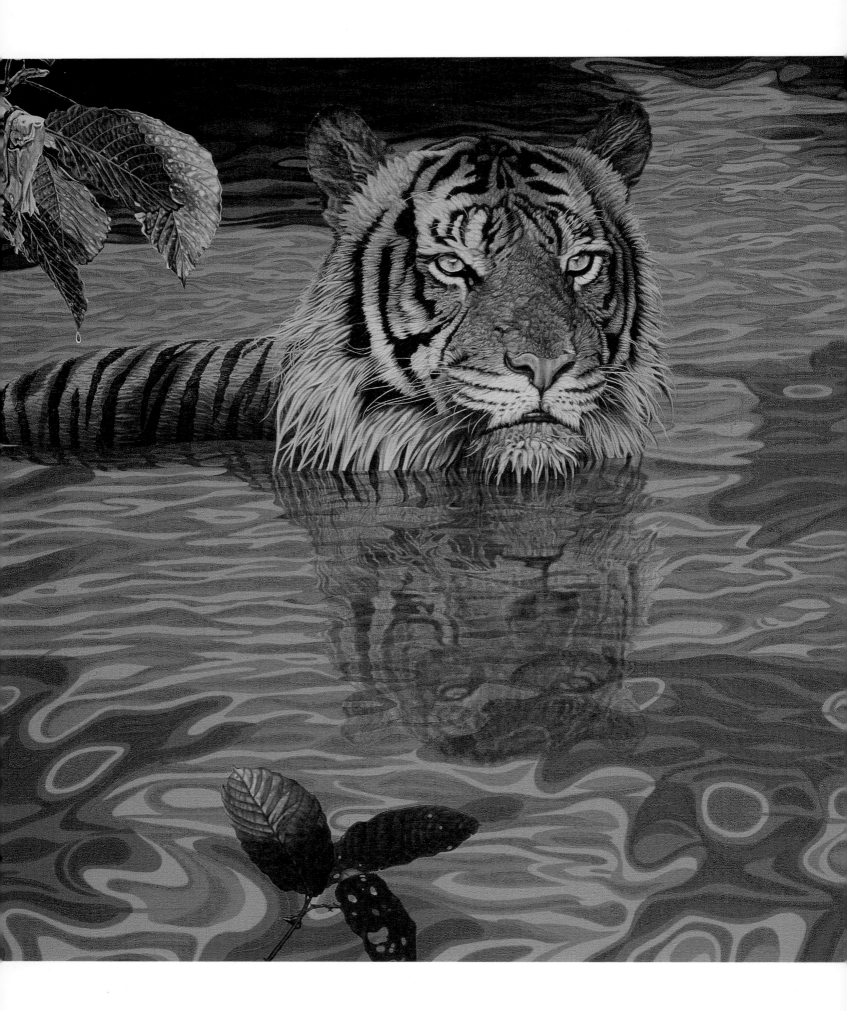

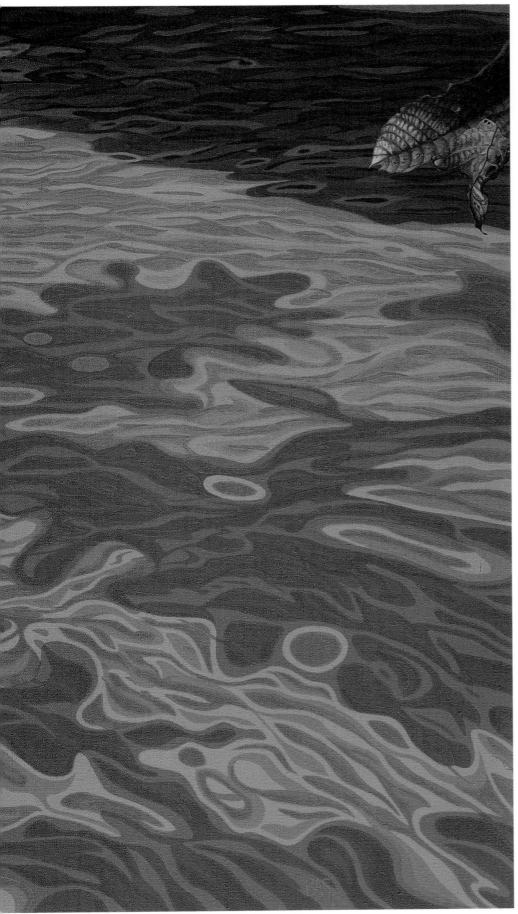

DELIGHT THE EYE WITH

COLOR & PATTERN

BAS

PAINT WATER PATTERNS
USING SURROUNDING COLORS

Amid water and leaf the Sumatran tiger's authority
is unquestioned; its power, grace and beauty are
legendary. In *Rain-Forest Regent* the water dictates
the design and color scheme. The water forms
derive from isolating the three dominant colors of
the Sumatran highland rain forest and utilizing
them in a fluid design: earthy red soil, surrounding
green foliage, and the reflected blue sky piercing
the tree canopy. The oil paint is applied *alla prima*,
or wet-in-wet, and is worked onto white canvas
without underpainting. This technique maintains
the purity of the color, maximizes light and enables
blending.

THE RAIN-FOREST REGENT (SUMATRAN TIGER)
oil, 26" x 40" (66cm x 102cm)

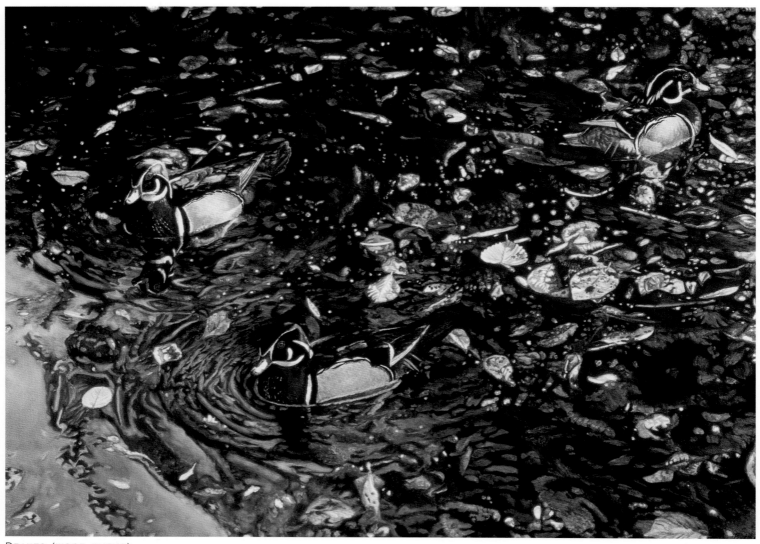

DRAKES (WOOD DUCKS)
oil on canvas, 32" x 44" (81cm x 112cm)

HANS PEETERS

AN "ORIENTAL CARPET" DESIGN

The visual combination of the brilliant ducks and the leaf-dappled
water reminded me of a sumptuous oriental carpet. The haughty
drakes, seemingly indifferent to each other, provide not only an
element of tension but also a solid design for an otherwise diffuse
composition. Although this is an oil painting, I essentially used a
watercolor technique. First, the canvas was covered with five to six
coats of diluted gesso which obliterated the "tooth" of the cloth and
produced a smooth working surface. Having drawn in the images
with a hard pencil, I began painting in the upper left corner, working
diagonally across, and thinning the paint with turpentine until it
produced a transparent film (pigments which are inherently opaque
will not work with this technique). I carefully saved pure white areas
for highlights. I use white pigment very rarely, and then only to
mute an aggressive color.

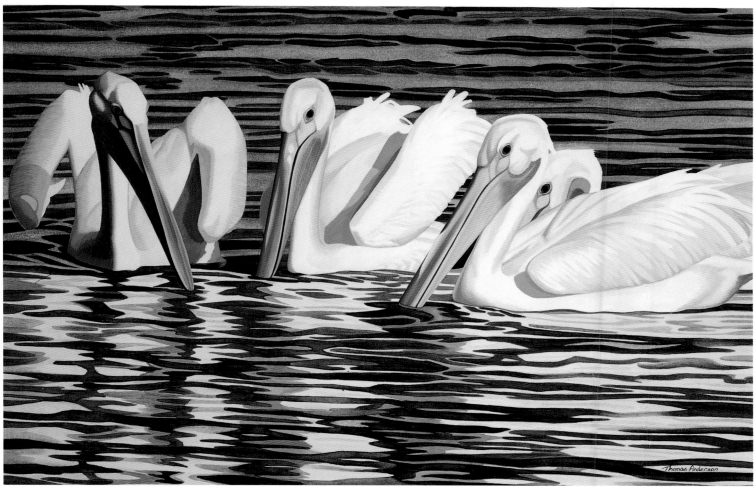

WHITE PELICANS
watercolor, 19" x 30" (48cm x 76cm)

THOMAS ANDERSON

TAKE ADVANTAGE OF CURIOUS ACCIDENTS

White pelicans migrate to southern California every winter. Because of their large size, white plumage, prominent orange beaks and their method of synchronized group fishing, they dominate one's attention wherever they appear. I photographed this small group on a hazy January afternoon at the Bolsa Chica Ecological Reserve in Huntington Beach. In some of my bracketed photos from that day, I noticed that the incorrect exposure accentuated the water's reflection of the brownish smoggy sky behind the birds. A curious accident, this lent a warmth that unified the colors of the beaks and their reflections with the background. The decorative rendering of the rippling surface of the water combines with this background to establish an interesting atmosphere that dramatizes these magnificent glowing birds.

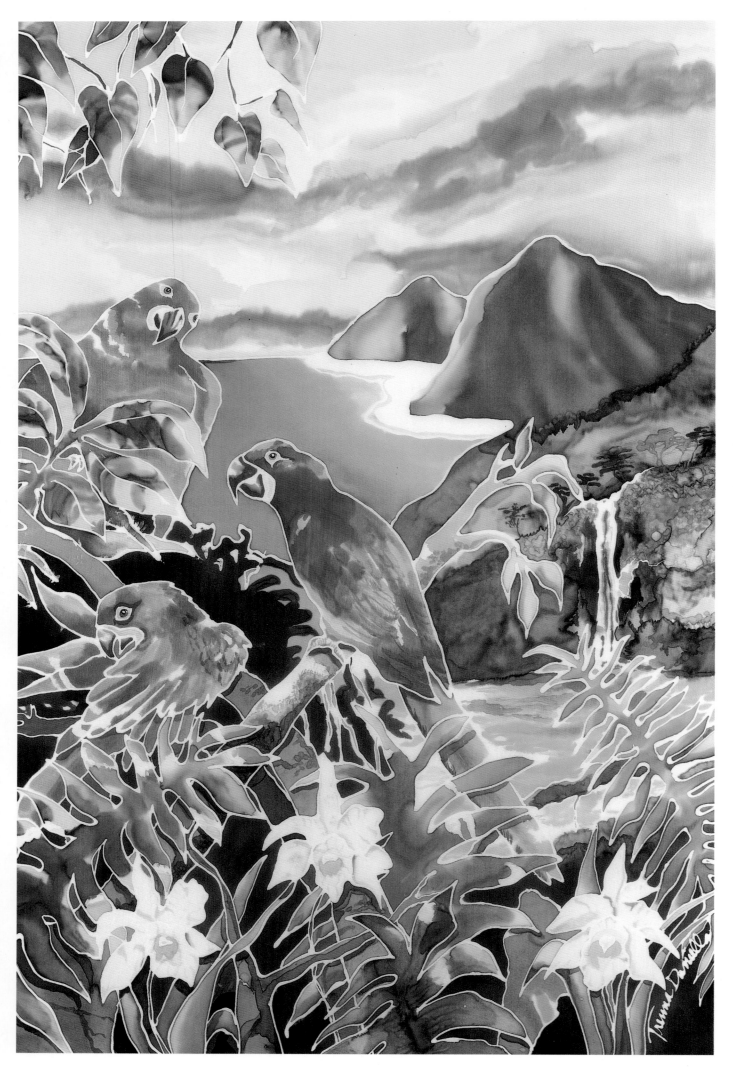

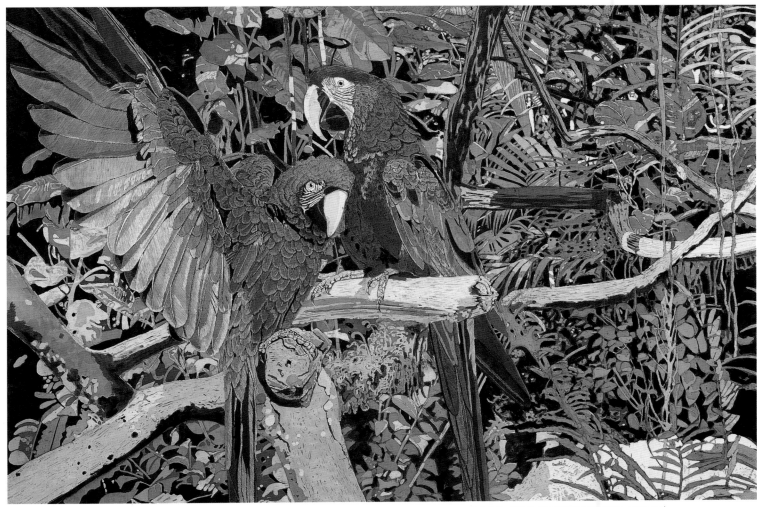

Costa Rica (green-winged macaw)
batik on silk, 40" x 60" (102cm x 152cm)

TRENNA DANIELLS

A VIBRANT SKY INTENSIFIES BIRD COLORING

Silk painting is not a static art form but a reflection of the movement and the fluidity of the dyes on this diaphanous fabric. To me, this medium more than any other captures the mood and the vibrant colors of the tropics. Painting on silk is an exercise in forced spontaneity and immediacy. Flowing with the freedom of the medium, I frequently mix my colors right on the silk. I often have a paintbrush loaded with different colors in each hand and one handily stuck in my mouth. I bleed the colors side by side and watch them do their magic. When I see an effect that moves me, I freeze the moment by speeding up the drying process with a hair dryer. In the painting *Hyacinth High* I wanted to capture the animated movements of the macaws. The movement of the light through the jungle leaves accentuates their preening and comical behaviors. I chose a vibrant sky to intensify and stress the unique color of these unusual birds. My inspiration for this piece comes from being innately envious of the vantage point that birds enjoy and desiring to communicate the perspective they experience while roosting in the canopies of a tropical paradise.

Hyacinth High (hyacinthine macaw)
French dye on silk, 31" x 44" (79cm x 112cm)

JOHN M. SOULLIERE

EXTEND THE BOUNDARIES OF BATIK

I am constantly trying to extend the boundaries of traditional batik by experimenting with form, space, texture and strong contrasts of light and dark. The inspiration for this piece came from a trip to Costa Rica. I was especially impressed with the darkness of the rain forest—the canopy creates a heavy, humid world of its own. In *Costa Rica*, I attempted to recreate this feeling. I chose a very black-green background to depict the dark, solitary mood of the forest. Several lighter shades of green were then used to depict the lush, steamy, dense foliage of the jungle. Finally, lighter teal green shades were used to depict islands of light resulting from fallen trees (called gaps) that permit light to stream through the forest. The red in the macaws appears to further deepen the greens; and since red is complementary, the birds virtually jump off the silk at you, as if you were surprised by them while walking through the forest.

PLATE-BILLED MOUNTAIN TOUCANS
watercolor on board, 22" x 28" (56cm x 71cm)

JANETTA GEE

ELIMINATE BACKGROUND FOR AN AIRY FEELING

The subjects of this painting caught my eye with their playful antics and brilliant coloring. These active birds provided a challenge in capturing details in working sketches. The painting was composed using notes and drawings obtained from observation and photos taken for reference. I decided to eliminate the background to help create a light, airy sense and thus not distract from the main subjects. I used watercolor paint straight from the tube for a final opaque coverage, building up from light washes of color as a foundation to establish areas of light and dark. I composed this design with an emphasis on simplicity, based loosely on a triangular shape. This allows the viewer's eye to remain in constant motion within the image. The branch is neutral in color and simple in detail, serving as a subtle perch for the birds. My overall goal was to convey the playful attitude of these subjects while rendering these beautiful birds in realistic detail.

MICHAEL JAMES RIDDET

CONTRAST BRIGHT COLOR
WITH GEOMETRIC PATTERN

Parsnip Field originated from my fascination of the abstract geometric patterns that can be created by the interlocking, skeleton-like stems and seed heads of the wild cow parsnip plant. Using untempered masonite as a support, I began by painting the entire panel with acrylic gesso tinted with Payne's Gray. In the studio, plant specimens were arranged until a suitable composition was created. I then transferred the final drawings to the panel. A pair of cardinals would have sufficed in adding a contrasting visual impact, however, the inclusion of a second male introduces an element of tension to be interpreted by the viewer.

PARSNIP FIELD (NORTHERN CARDINAL)
acrylic on Masonite, 32" x 24" (81cm x 61cm)

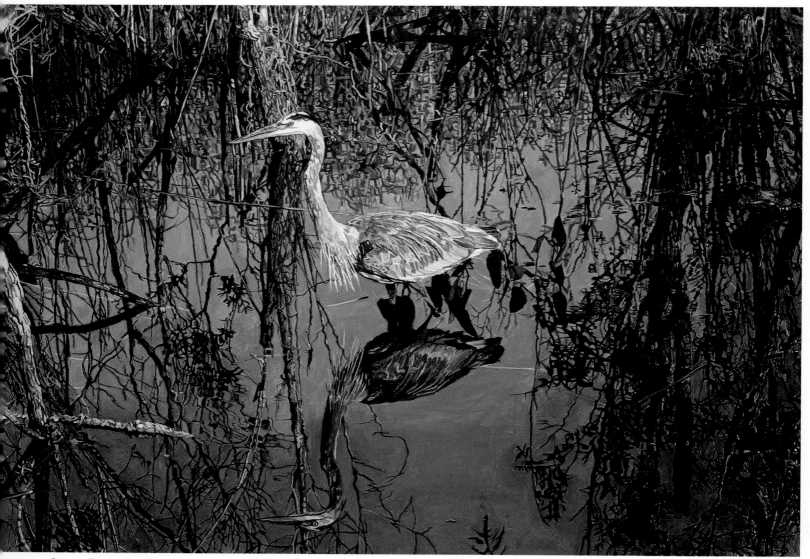

GREAT BLUE HERON — PRIVATE WORLD — EVERGLADES
oil on canvas, 30" x 44" (76cm x 112cm)

MARY LOUISE O'SULLIVAN

A RICH, STAINED-GLASS QUALITY

Usually I work on a toned canvas—either an umber or neutral gray gessoed surface. In this case, the subject was already surrounded by such a vibrant hue that I thought the end result might be too dark and opted to start on white. I felt that the pattern of limbs and specks of leaves, filled in with the rich cobalt blue, would give a kind of stained-glass quality enhanced by the white canvas shining through. I wanted to communicate the feeling of solitude and privacy this bird seemed to experience. I took many photos of the heron as he moved along, but I found something satisfying and permanent about the design as he and his reflection passed between the tapestry of reflected branches emerging in the blue. This bird was moving so slowly and without agitation that it seemed right to put him halfway between where he was going and where he had been. A day later, this same heron was in a fight with a younger version over territory. Neither won because they were surprised by a hungry alligator and both left the scene abruptly.

M.C. KANOUSE

STRONG CONTRAST SPOTLIGHTS
FLAMINGOS' ELEGANCE

The Chilean flamingos and all other long-legged birds lend themselves to elegant design through the dignity of their body language and grace in movement. In the area where they were observed, the crustacean diet was limited, allowing for a naturally heightened light and dark value contrast. This was the main attraction for the design of the painting. Numerous on-site sketches were made, as well as photographs taken. After many thumbnail sketches, the actual painting is started by placing a resist over the white birds. Numerous washes are applied to create the background value and color. Reflections and water movement are achieved by gently scrubbing out background pigment. When I am satisfied with the abstract or semi-abstract quality of the background, the resist is removed. The birds are completed using appropriate color and shadow.

CHILEAN FLAMINGOS
watercolor, 28" x 20" (71cm x 51cm)

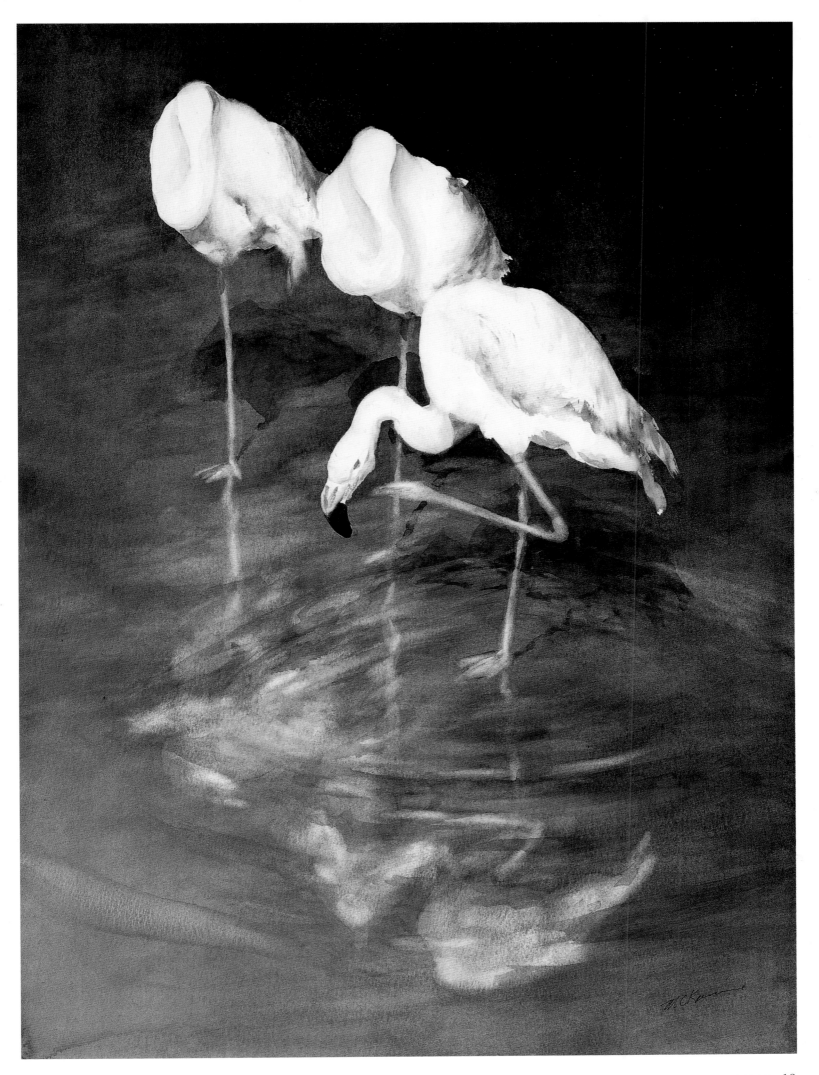

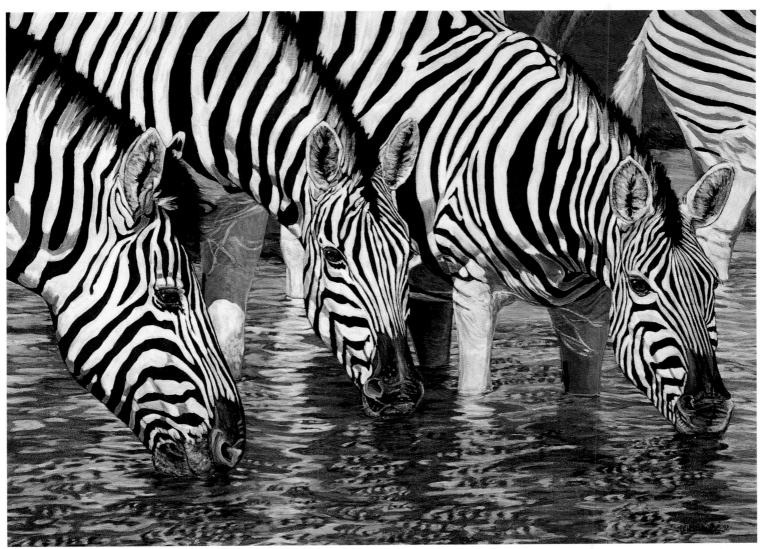

BURCHELL'S ZEBRAS
batik/mixed media on Japanese raw silk, 42" x 56" (107cm x 142cm)

JENNIFER BELLINGER

CONTRAST BOLD VERTICALS WITH
SOFTER HORIZONTALS

The design phase of creating a painting is my favorite part. I choose subjects for their shapes and patterns, so zebras are a natural. Using photos for reference, I sketch each element on a separate piece of tracing paper and move these around until I get the composition I want. I often let this rough sketch rest a few days. Taking a fresh look at the sketch reveals any weak areas, and the separate pieces allow for easy adjustments to the design. In *Burchell's Zebras* I contrasted the bold vertical stripes and strong values of the zebras with the horizontal water patterns. To keep the focal point on the animals, I softened the values in the water areas.

Over the past eight years I have developed a technique for overpainting on a finished batik. The batik is stretched on foamcore board using 3M Durapore tape. I use stiff scrubber brushes to apply Neopaque and Lumiere fabric paints in a manner similar to the scumbling technique used in oil painting. It's a slow process because the fabric absorbs a lot of the paint, but the finished effect is very rich in color and texture, much like pastel on paper.

JO ANNE ROMERO

CREATE IMPACT WITH SIMPLICITY

There is something to be said about the beauty of space and the power of containment. Believing that simplicity creates the strongest impact, I used a more abstract approach. The sweeping rhythms of the buriti palm allowed me to fragment and define new shapes of interior space, while the unique beauty of the hyacinthine macaw gave me the opportunity to build the rich depth of color displayed in *Blue Splendor*. Without the use of preliminary sketches or frisket, I move directly onto the painting surface. The Strathmore 100 percent rag illustration board I use is vacuum mounted onto acid-free foam core, which allows me to apply numerous washes without warping and lends itself extremely well for the push and pull technique I use. The cold-press surface of this board is also excellent for layering pigments, giving a soft, delicate quality to the overall composition.

BLUE SPLENDOR (HYACINTHINE MACAW)
watercolor on board, 27" x 23" (69cm x 68cm)

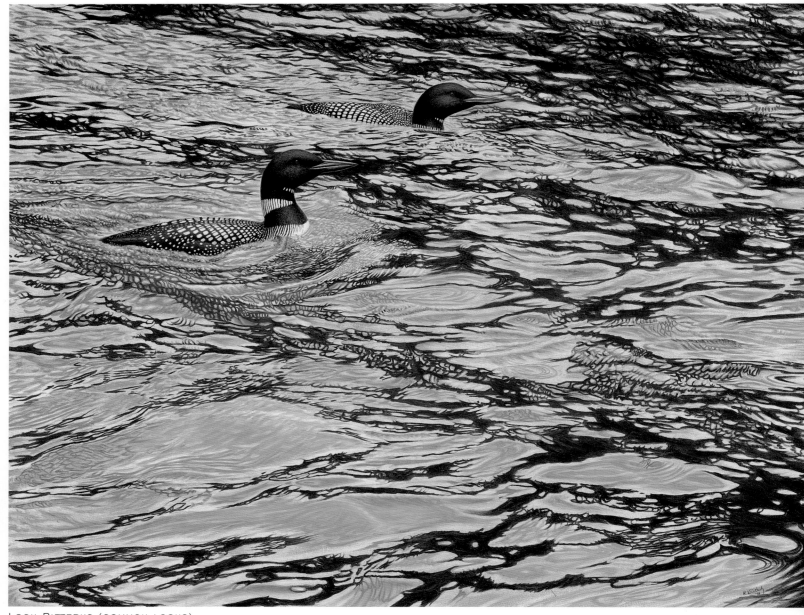

Loon Patterns (common loons)
oil on canvas, 30" x 40" (76cm x 102cm)

RICHARD WEATHERLY

CREATE MOVEMENT WITH STYLIZED DESIGN

I found these loons on Jordon Pond in Maine and followed them, quietly sketching, all of one morning. The gray, featureless water on this overcast day lent no suggestion of a painting until the birds swam into a little bay that was surrounded by conifers. Immediately, the scene was transformed, as around the loons the reflection of the forest repeated the patterns and the colors of the birds. Essentially, the painting is of water. I have always admired the ability of Chinese artists to portray fluidity and depth in water without attempting realism. To make marks, either stylized or realistic, on a flat sheet of white paper and beguile the eye into believing it sees water is the ultimate illusion. I decided to attempt to create water in my painting by using the patterns and colors of the loons to design "movement" in the water. As I drew, I found that the more stylized I made the water, the more it came alive.

BAS

INTEGRATE ABSTRACT SHAPES

Presunrise on the Luangwa River, Zambia, the waters are set ablaze by the promise of the rising sun. Like rock forms in liquid lava, hippos maneuver amongst each other, finding a resting place after their night's feast. The fiery waters will provide a cool refuge from the heat of the day. The painting relies on the ability to analyze shapes, to see shapes within shapes and distill their significance. The viewer sees in an instant the composition within a scene, the integral abstract forms—in this case the hippos—relate to one another in a powerful and cohesive design. The river is finished with an orange-red glaze over a lighter underworking, reflecting the ambient color and light of an African dawn.

River Horse Dawn (hippopotamus)
oil, 36" x 24" (91cm x 61cm)

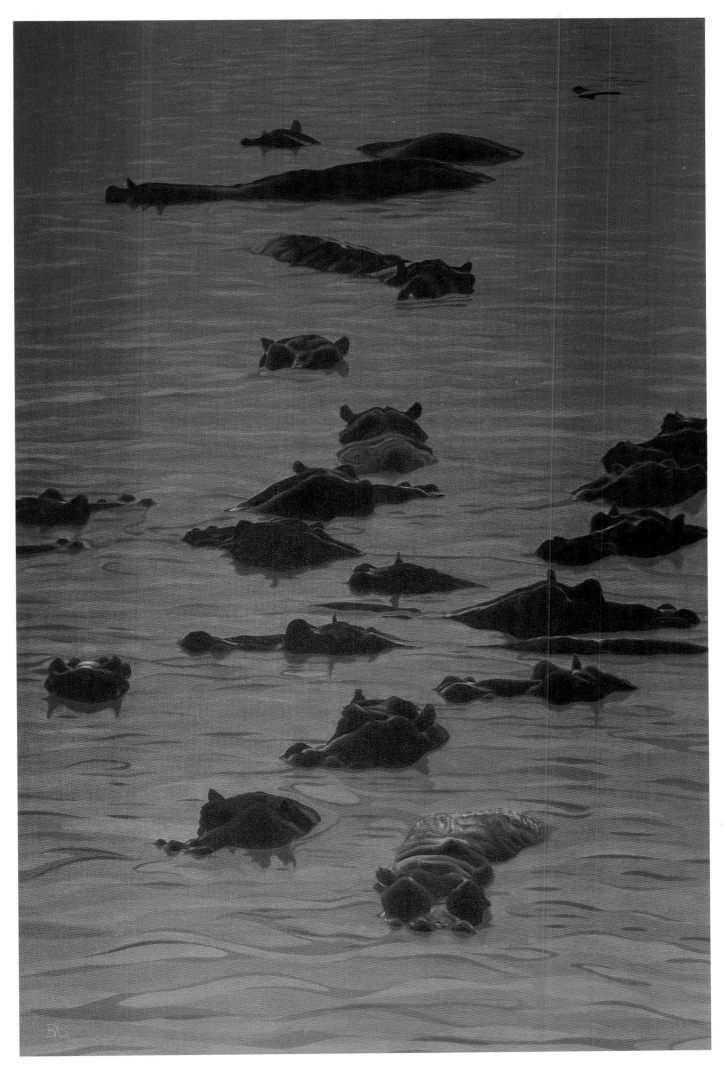

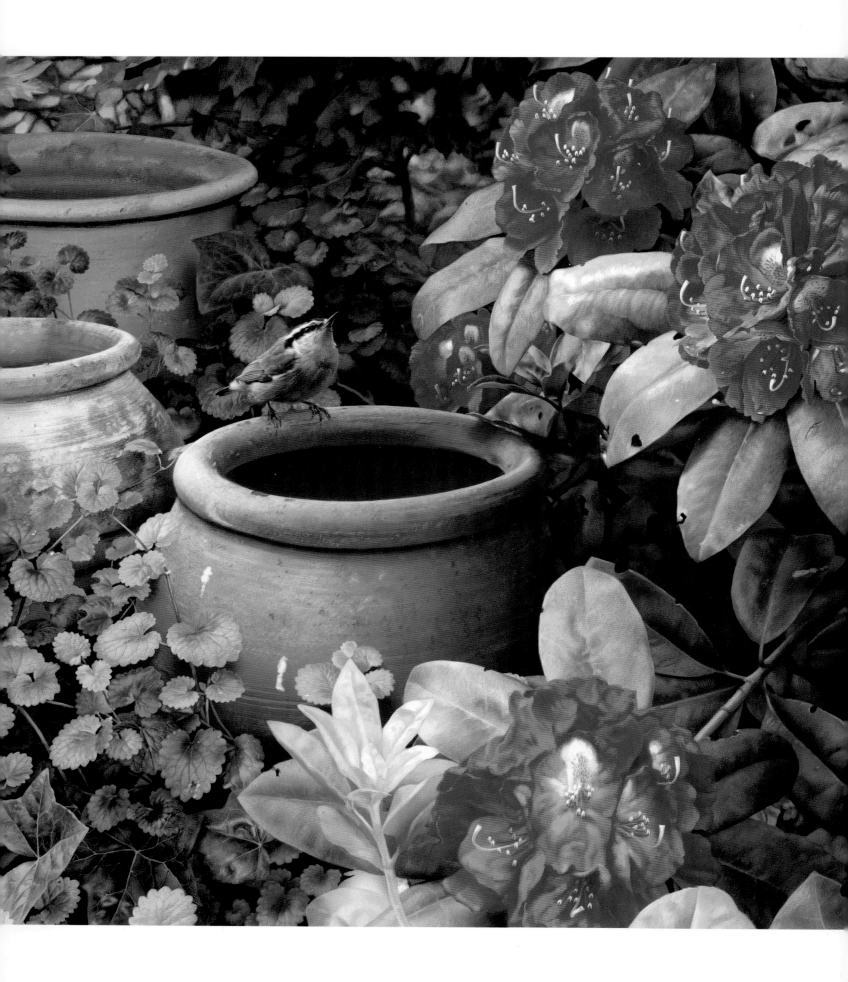

THE GARDEN VISITOR (RED-BREASTED NUTHATCH)
gouache and watercolor on illustration board, 23½" x 36¼" (59½cm x 91¼cm)

2

FASCINATE THE VIEWER WITH

EXQUISITE DETAIL

CARL BRENDERS

PAINT OBJECTS AND TEXTURES THAT INTEREST YOU

The challenge in my work is detailed texture, so I introduced into the painting one of my many passions: terra cotta jars. My rhododendrons made a perfect background for the little nuthatch, one of my favorite backyard birds.

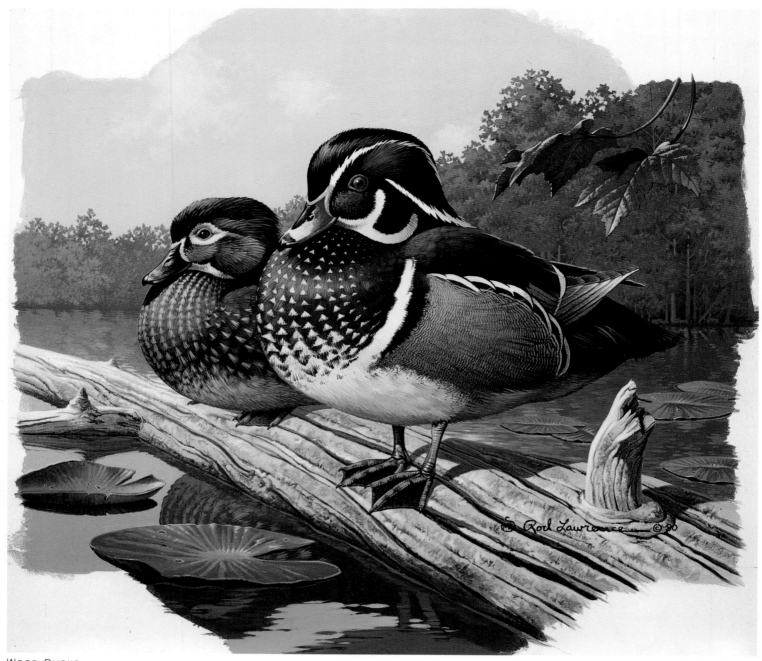

WOOD DUCKS
acrylic on hardboard panel, 7" x 9¾" (18cm x 24½cm)

ROD LAWRENCE

BUILD DETAIL SLOWLY WITH LAYERED WASHES

I begin my paintings with thin washes of acrylic paint and build up the paint into more opaque areas of color. I also work over the opaque areas with more washes and build on them. This allows me to make subtle color changes and "draw" with my paintbrush. For example, I built up the side pocket of the male wood duck with paint washes until it was quite solid and opaque. With thin washes of a darker value I then can "draw in" faint suggestions of the fine lines of vermiculation. I will build these up in several layers to darken some and lighten others. My final step is to use a light value paint wash on the top of the side feathers to soften the vermiculation and suggest a highlight. Wood ducks are perhaps my favorite duck to paint. The males in full plumage are strikingly colorful. I have several nesting boxes about 20 yards outside my studio window, with a creek that flows nearby. One box is always occupied by a female wood duck and her family, while another box has become a black squirrel condominium. Squirrels are one of the major predators of wood duck eggs, so it is interesting to me that they coexist in boxes only a few yards from each other.

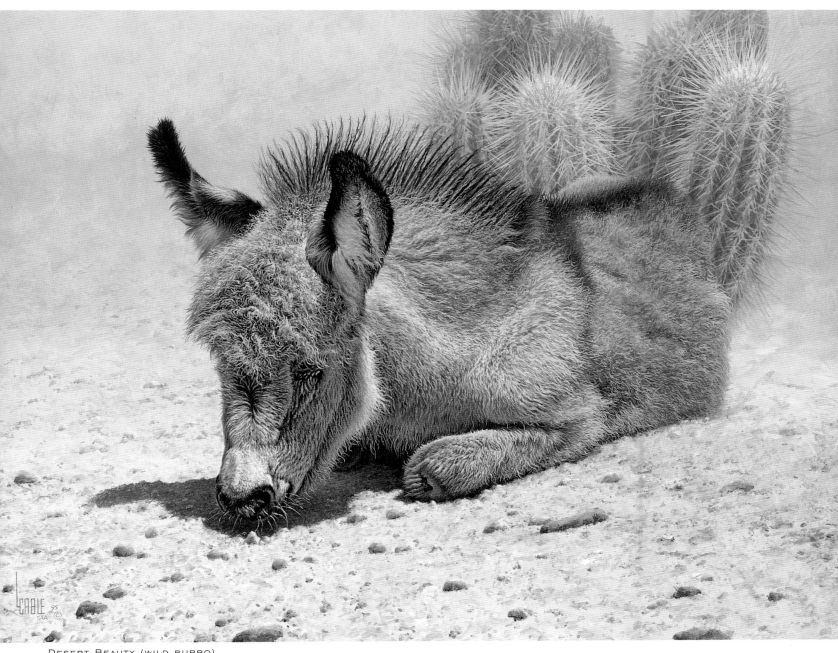

DESERT BEAUTY (WILD BURRO)
gouache, 16" x 22" (41cm x 56cm)

LEE CABLE

TRY GOUACHE FOR RENDERING BRISTLY HAIR

This little burro was observed in the California desert. Since it inhabited a very dry and hot region, I chose the color scheme of yellow and gold to convey the sense of heat. The ground is painted with little detail except for a few pebbles, thus stressing the dryness and bleakness of the desert. The cactus was added to balance the composition. There is more detail around the head and less toward the back to call attention to the face—to reveal a sleepy or pensive look. Gouache is a great medium because it allows me to render the illusion of hair so quickly. Its opaqueness means I can create a hair or whisker with only one brushstroke, whereas oil and acrylic require many repeats of the same line.

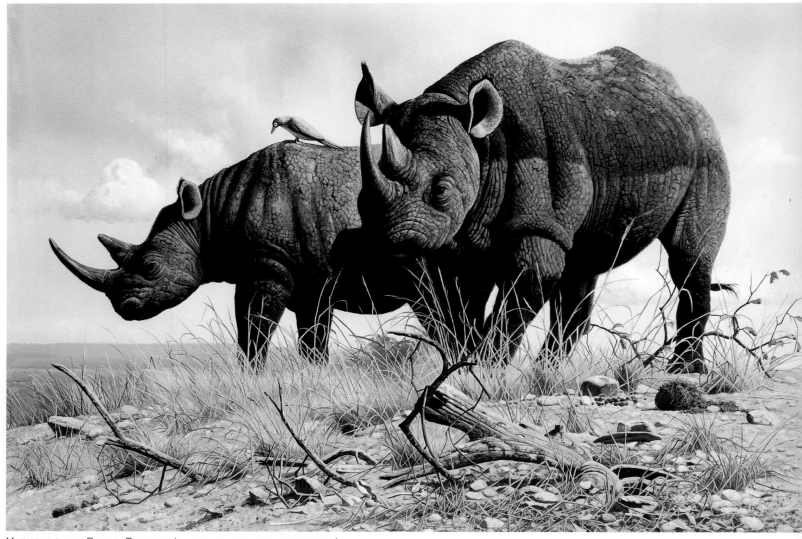

MATUSADONNA RHINO REFUGE (BLACK RHINO AND OXPECKER)
oil on canvas, 24" x 40" (61cm x 102cm)

CRAIG BONE

MAKE THE WHOLE ENVIRONMENT IMPORTANT

As an ultrarealist painter, I believe it is not only the animals that are important in wildlife painting but the whole environment. I want to show the habitat and the wilderness as it has existed for thousands of years. I want collectors who have been to Africa to say, "That's Africa—that's exactly how I saw it." I am an active supporter of the Black Rhino Survival Campaign and Friends of Conservation and will do anything in my power to preserve my African homeland. Poaching has drastically reduced the number of black rhinoceroses in the Zambezi Valley over the past five or six years so that only a few remain in this location. These animals are extremely territorial and mark their domains by forming dunghills around their areas. They are also more aggressive than their cousins, the white rhinos. Red-billed oxpeckers feed off ticks found mostly in the ears, nostrils and under the tail of their hosts and even eat scabs and drink blood from fresh wounds. They act as a warning signal, alerting nearby animals of the approach of lions and other predators.

TERANCE JAMES BOND

DON'T LET DETAILS OVERWHELM
YOUR FOCAL POINT

All my subjects are painted life-size, so this is a big painting with practically half the area taken up by the subject itself. Painting in this realistic and illustrative way enables me to exploit the wonderful shapes and patterns on the plumage of this incredible bird. With very few exceptions, most owls' plumage displays highly detailed cryptic markings that serve to break up the general outline and shape of the bird when at rest. Often these patterns run in a contrasting direction to the bird's anatomy, making them very frustrating to paint. Reinforcing the detailed theme, I have included a complex piece of pine with several cones as a foil to the amazing feather patterns of this owl. As detailed as this painting is, however, the viewer is still drawn to the focal point of the composition—those wonderful orange eyes.

EUROPEAN EAGLE OWL
acrylic, 40" x 30" (102cm x 76cm)

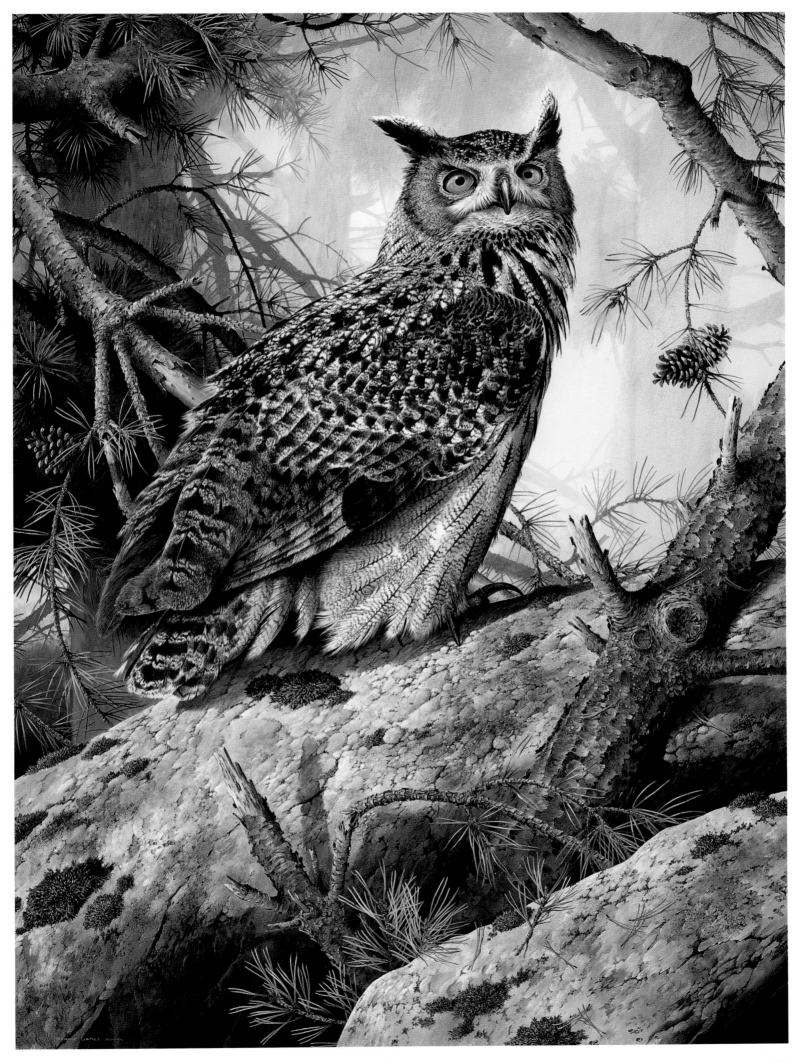

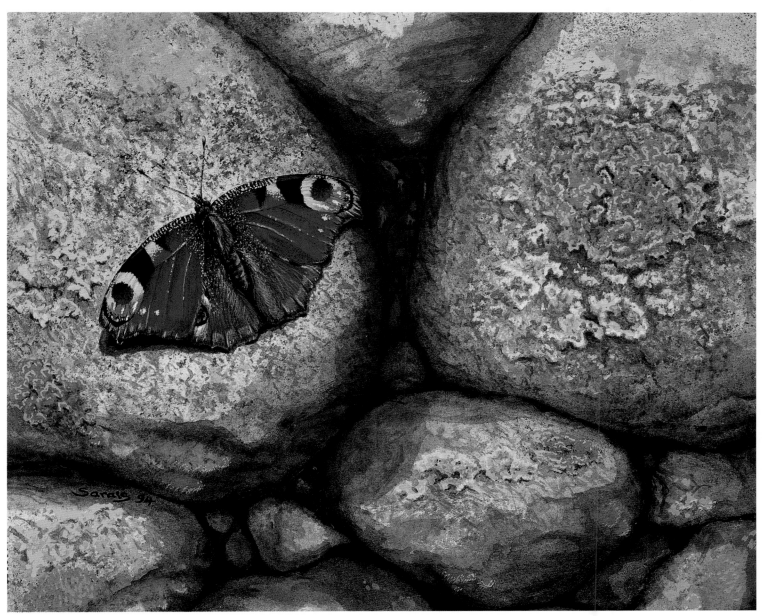

Peacock Sunning on Stones (peacock butterfly)
gouache, 8" x 12" (20cm x 30cm)

SARAIS B. CRAWSHAW

CONTRAST FLEETING WILDLIFE
WITH AGELESS STONE

The peacock butterfly is a frequent summer visitor to my garden, and on hot afternoons I often find one "sunning"—basking with wings spread like solar panels—on an old stone wall crusted with lichens. I had the idea of contrasting this colorful short-lived creature with the ageless weathered stone and lichen. The fine details of both are best appreciated close-up, with strong shadows conveying a feeling of sun-baked warmth. The painting is in gouache, laid first in fine washes. Over dry layers I added texture with a damp natural sponge, and drybrush details with a fine sable brush. The strength and opacity of gouache allows me to add color and fine details in layers, and work from dark to light. This suits my style of fine textural detail, and I often use acrylic for the same effect.

RICHARD WEATHERLY

CLASSICAL COMPOSITION SUGGESTS
A DETAILED TECHNIQUE

While strolling on Araganui Beach in Mimosa Rocks National Park, I came upon a wild geranium plant with one red and one yellow leaf. Immediately, the presence of the third primary color suggested itself. Superb fairy wrens, common at Araganui, are puff-balls of avian energy dressed in tuxedos of black and white, decorated with electric sashes of blue. The construction of *Primary Colours* is based on the old Renaissance quadrant design, with opposing busy and vacant sectors bound together with a fluid circular motif. This Renaissance connection suggested the use of a detailed technique.

Primary Colours (superb fairy wren)
oil on panel, 16" x 12" (41cm x 30cm)

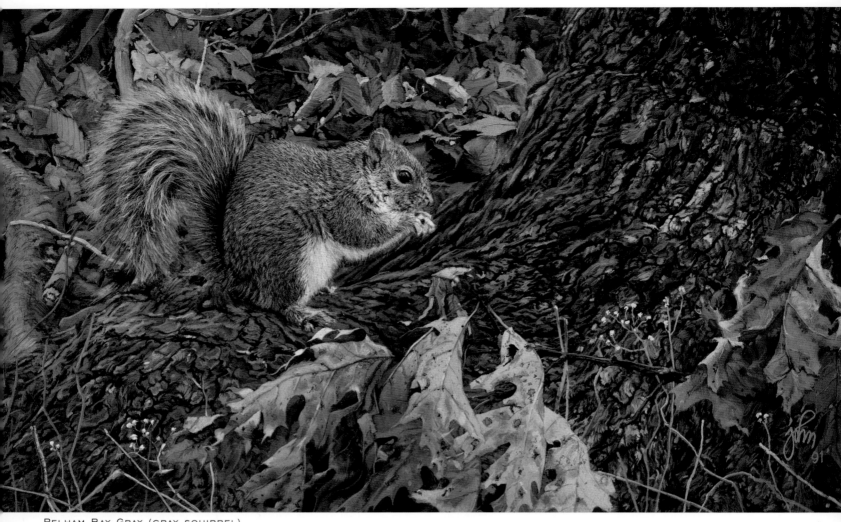

PELHAM BAY GRAY (GRAY SQUIRREL)
gouache and watercolor, 9¾" x 14" (24½cm x 36cm)

JOHN P. MULLANE

GLAZE WATERCOLOR OVER
LAYERS OF GOUACHE

My goal is to portray a realistic moment in nature.
I do this by piecing together many photographs
and sketches like a giant puzzle. I try to make
things as detailed and real as possible, but not
photographic. I like to combine gouache and
watercolor: Gouache is great for fur and feathers
and watercolor is great for glazing. I usually start
with gouache, building up layers from dark to light
and then glazing with watercolor and sometimes
with an airbrush. I sometimes use acrylic mat
medium to fix the gouache so I can overpaint
without reactivating the underlying paint. I never
use tiny little brushes, but prefer nos. 8, 10 and
12. With a larger brush you can hold more paint,
and by rolling the brush you can get a nice sharp
tip to create very fine lines.

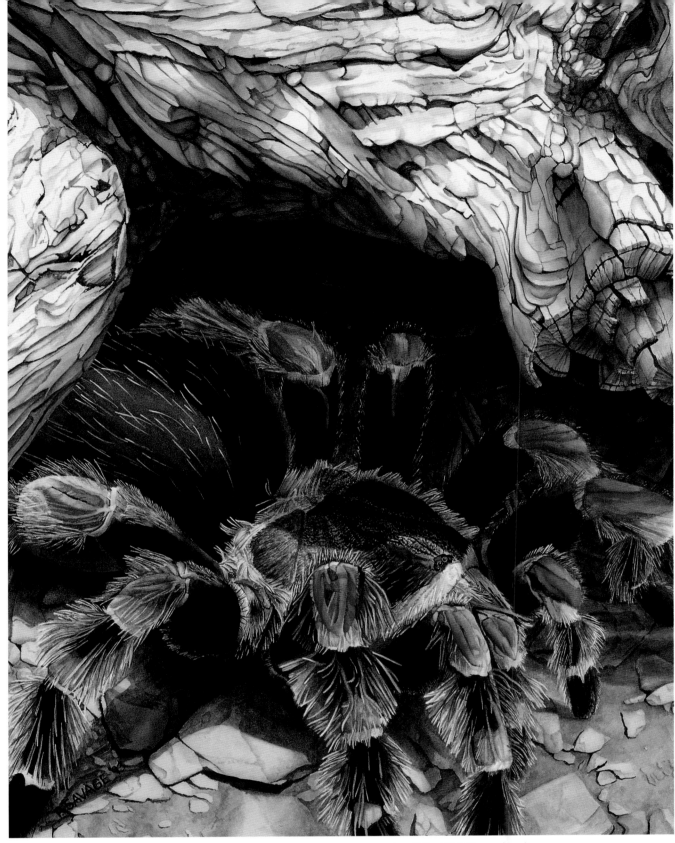

WARM AND FUZZY (RED-KNEED TARANTULA) watercolor, 22" x 17" (56cm x 43cm)

PATRICIA SAVAGE

SOME DETAILS REQUIRE PAINSTAKING RESEARCH

For this painting, ecological accuracy was a must, but I found no photographs in print, no mention in the literature. After contacting many scientists, I finally found live specimens, dissected eyes and a slide of the right desert dirt. Exquisite details come from painstaking research and ecological accuracy. Heavy paper and quality pigments allow me to build layers with a dry-brush technique. Both tree and shadows have complex color layers. I masked the spider hairs with masking fluid and painted around them. After lifting the mask, I softened the edges and painted the hairs. Such intricate light and color can be found in nature if you look.

HIMALAYAN ROYALTY — IMPEYAN PHEASANTS
acrylic, 15" x 30" (38cm x 76cm)

CYNTHIE FISHER

MAKE COLORS "POP" WITH A THIN LAYER OVER WHITE

I work in acrylic on Masonite, quickly covering the gessoed board with a wash indicating the colors and values I want to depict. Because of the brilliant colors in this piece, I tried to keep the layers to a minimum, maintaining the initial impact of the straight pigments. I wanted to minimize detail in the background, as well as to accurately depict the high-elevation potato fields where these birds forage. I established the overall color values on the birds and then accented the really brilliant areas by painting a layer of pure white paint, letting it dry, and brushing a thin layer of bright unaltered pigment, such as Alizarin Crimson or Cadmium Yellow, over the white area. This allows the full impact of the color to come through, which is hard to attain when white is mixed with the color. This technique works well with iridescence on feathers, or in any area that needs to pop out. I had ready access to several captive birds, and I had just finished doing a taxidermy mount of a male Impeyan, so I had lots of reference. I sketched from a videotape of pheasants in the wild to get to know their native habits and environment (they live at 15,000 feet above sea level in the Himalayas). I believe these birds are the most beautiful of all the pheasant species.

FRANK MITTELSTADT

A PLAIN BACKGROUND ACCENTUATES DETAIL IN THE SUBJECT

I enjoy photographing wild birds and animals and occasionally I capture an image that I simply must use in a painting. That's how *Summer Soloist* was inspired. I then photographed fenceposts bathed in the same golden evening light as the meadowlark, gathered a few pieces of grapevine from my backyard and went to work. I decided a featureless background done in the same colors as the foreground would better accentuate the detail I wanted to put in the subject. By applying thin washes of a warm light green over a flat dark green, I fashioned a simple background which suggests a wall of lush foliage beyond a small open field.

SUMMER SOLOIST —
MEADOWLARK
acrylic, 24" x 14" (61cm x 36cm)

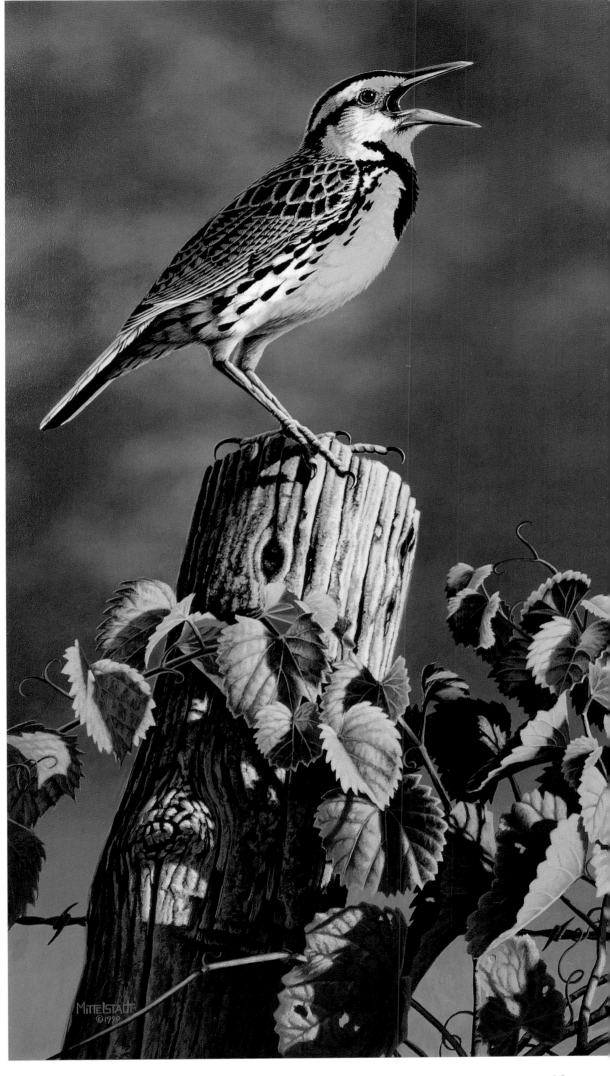

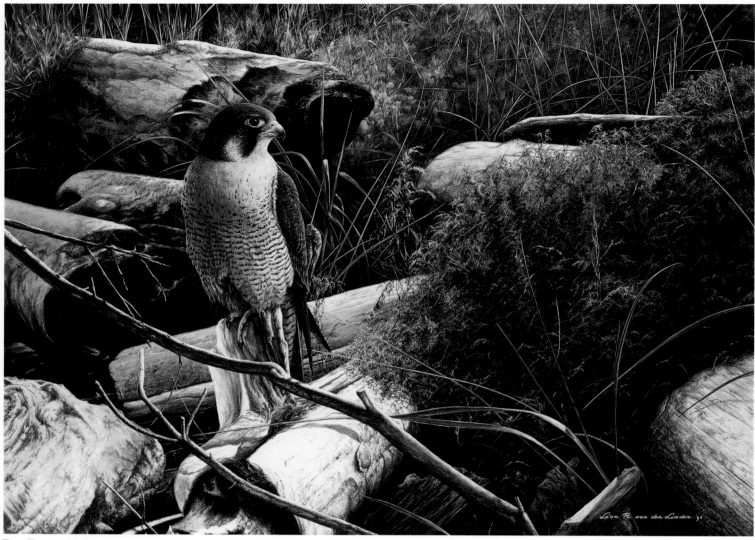

The Traveler (peregrine falcon)
acrylic on illustration board, 24" x 32⅜" (61cm x 83⅜cm)

LÉON R. VAN DER LINDEN

THICK ACRYLIC PAINT CAN MAXIMIZE BRIGHTNESS

I was observing a hunting sharp-shinned hawk on the east coast of Vancouver Island (British Columbia, Canada) when suddenly the bird showed strange behavior. After a period of normal short flights from spot to spot, the bird gave a loud call and flew in a straight line out of sight, clearly frightened. After viewing the area with my binoculars I saw this falcon on some driftwood just a few feet from the water line. With the low position of the sun, this was the most beautiful moment to watch the peregrine falcon. From the top of a piece of driftwood the bird was watching the large flocks of gulls and sea ducks just outside the coast. At that moment I decided to make a painting of this particular view with the challenge of working only from the impression of this unforgettable moment. I used the acrylic paint as thick as possible to maximize the brightness of the colors. Only when I worked on the bird did I use more glazes.

TERANCE JAMES BOND

WITH COMPLEX SHAPES AND SHADOWS, KEEP COLOR RANGE MINIMAL

Painting stones always gives me great satisfaction, particularly in a painting such as this where they present a chance to indulge in the interplay of shapes and forms. Shadows are important in this respect. Not only do they show the shape, they also emphasize the weight of the stones. The inclusion of tiny twigs, grass and other debris results in intricate and complicated shadows running at contrary directions to the shape of the stones, helping to delineate the structure of this complicated background. However, as with all of my complex paintings, the color range has been kept to a minimum to prevent the effect from becoming too fussy.

Waiting for Rain (belted kingfisher)
acrylic, 30" x 24" (76cm x 61cm)

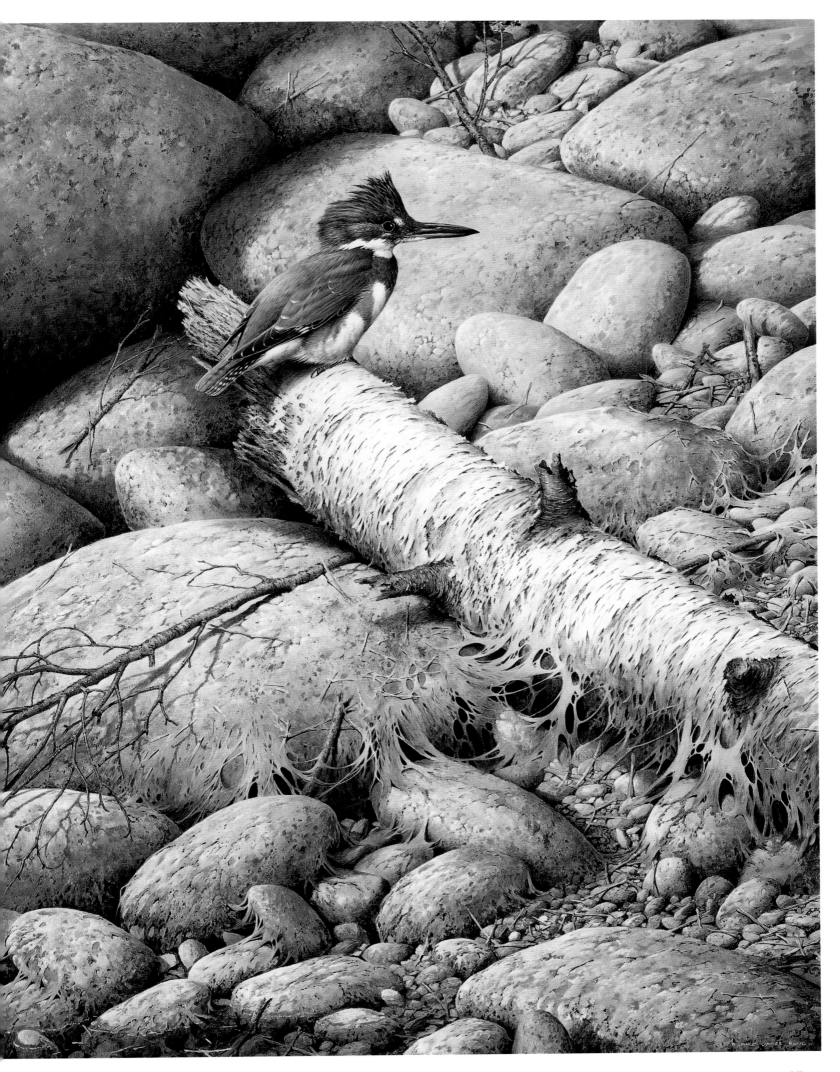

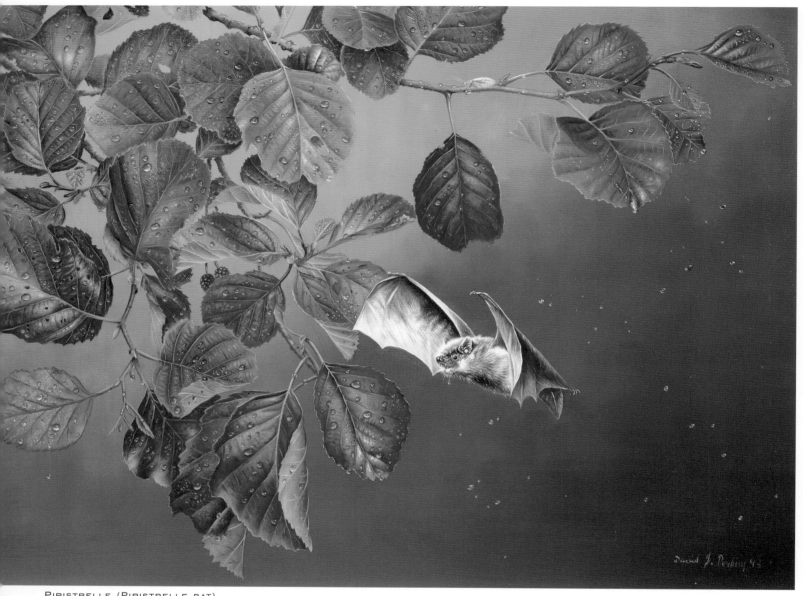

PIPISTRELLE (PIPISTRELLE BAT)
oil on linen, 13" x 18" (33cm x 46cm)

DAVID J. PERKINS

STRETCH LINEN ON A BLOCK FOR A
FINE-TEXTURED, FIRM SURFACE

I try to capture a moment in nature in all its fascinating detail, to allow the viewer time to explore its intricacies at leisure. I paint in oils on linen stretched on a block to give me a fine-textured, firm surface to work on. I use oils without thinning for a fine impasto. The finished work, when dry, is stretched over stretchers in the usual way. The choice of subject and action for this piece came about when I found a male Pipistrelle crawling along a first-floor hallway of my home, a Victorian farmhouse. He was released but found the following morning in the grass wet, cold and barely alive. With advice from the bat society, he was restored to full health, and ten days later I had the pleasure of releasing him back into his territory. The Pipistrelle is the smallest European bat.

BO LUNDWALL

EMPHASIZE DETAILS IN
A NOCTURNAL SCENE

I made the tawny owl life-size to give the viewer the impression of standing in front of an actual tree. The biggest challenge was to give the painting a nocturnal atmosphere and at the same time keep the owl clearly visible. The masterful camouflage pattern of the tawny owl makes this task even harder. Its plumage blends in almost perfectly with the moss-covered branches of the old oak where it sits, eluding detection, with its pitch black eyes registering every detail with crystal clarity.

THE OLD TREE (TAWNY OWL)
oil on canvas, 58" x 30" (147cm x 76cm)

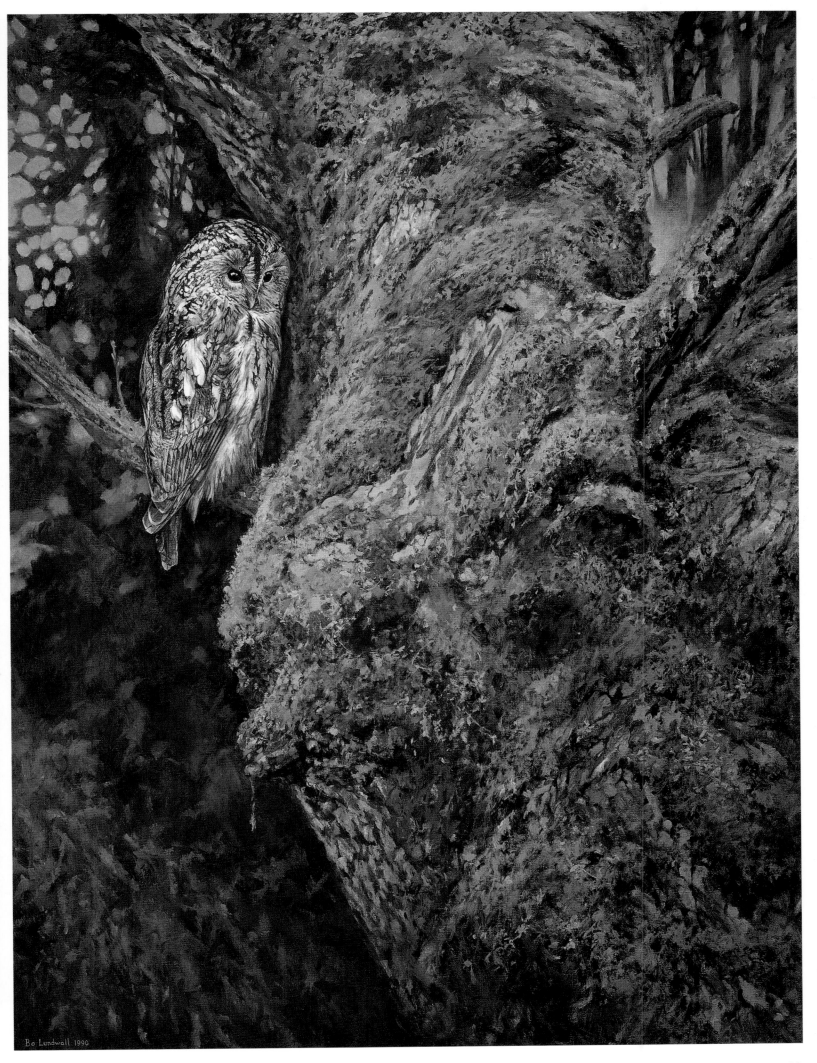

Bo Lundwall 1990

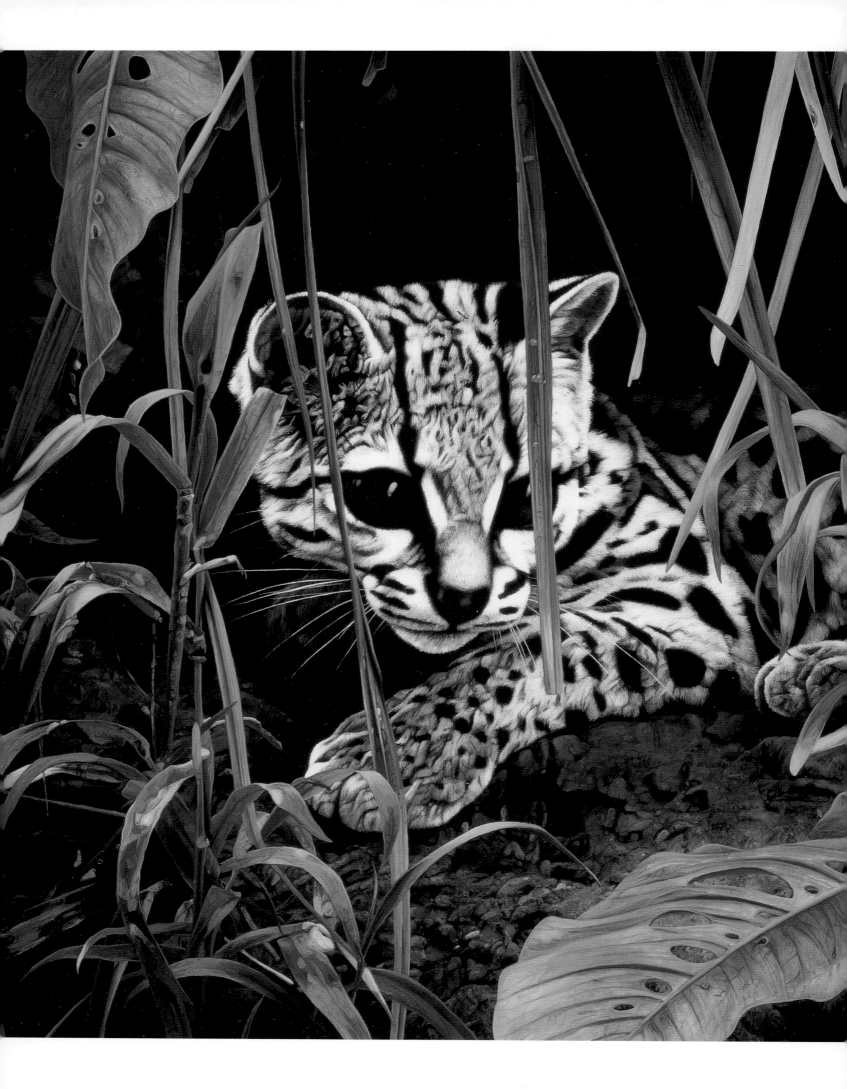

3

DISCOVER A

UNIQUE VIEW-POINT

ROD FREDERICK

THIN LAYERS OF WET-ON-WET OIL
PORTRAY TROPICAL MIST

In Costa Rica I was fortunate enough to see the young ocelot that became the subject of *The Dragonslayer*. To get the feeling of the ever-changing fog and wet tropical mist, I applied thin layers of oil wet on wet with a wide brush. When this background layer had dried, I defined the distant trees and foliage, and then blocked in the foreground areas and the cat. In painting the foreground I sometimes add thin glazes of translucent color over the detail areas using Liquin and turpentine. With these thin layers I can achieve a subtle play of light and color.

THE DRAGONSLAYER (OCELOT)
oil, 21" x 14⅞" (53cm x 37.75cm)

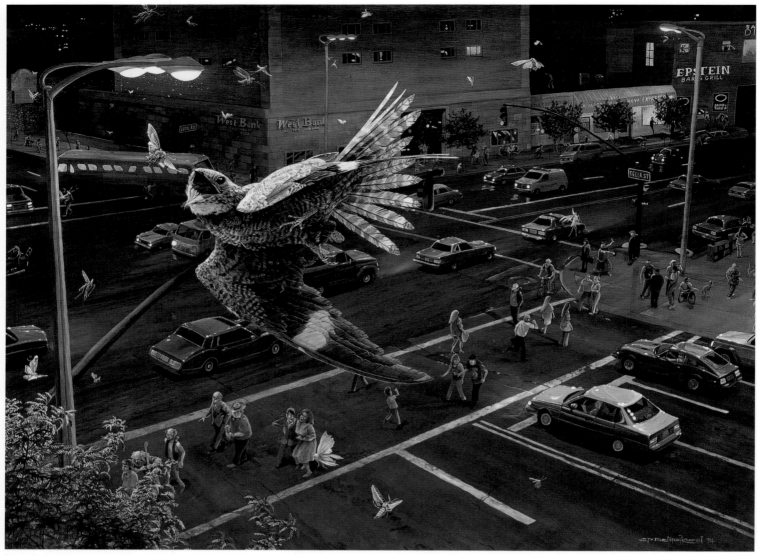

Two Stories (common nighthawk)
acrylic on illustration board, 21" x 30" (53cm x 76cm)

CAREL PIETER
BREST VAN KEMPEN

TAKE A "BUG'S-EYE" VIEW

I love to watch nighthawks catch bugs over the city on summer evenings and have always been struck by the contrast of two worlds: birds above, people below, both seemingly oblivious to the other. Juxtaposing these two elements required a bird's eye view, looking past the bird onto the wider cityscape below. Wishing to depict lots of human activity, I used an intersection as a backdrop and tried to arrange its lines in a way that harmonized with the bird's trajectory. I had great fun inventing the city details as I went, incorporating lame jokes and inside barbs at friends and acquaintances. Close scrutiny even reveals a hint of my own face behind the wheel of the '67 Dodge van that served as my studio/home at the time I painted this. Lighting proved to be the greatest challenge with *Two Stories* and required three separate studies to work out. The nighthawk is lit from above by the cool, green fluorescent light which is warmed considerably as it shines through the tail feathers. A dimmer, secondary source casts red light on the bird from below.

CAREL PIETER BREST VAN KEMPEN

IMAGINE AN "UNHUMAN" POINT OF VIEW

As a boy I spent a great deal of time catching aquatic insects in an oxbow pond near my home. *Gainer* was built from memories of that pond but drawn from a point of view I could only imagine. After determining a horizon and vanishing point, I penciled out a grid to establish the water's surface, then set about designing the piece. The brightest part of the painting, the bird's chestnut breast band, is perfectly centered on the board, interrupting the composition's natural flow from upper left to lower right, simulating the impact against the water. Once the space was laid out, I simply lapsed into recollections from which I drew the various elements.

GAINER (BELTED KINGFISHER AND MOSQUITOFISH)
acrylic on illustration board,
30" x 20" (76cm x 51cm)

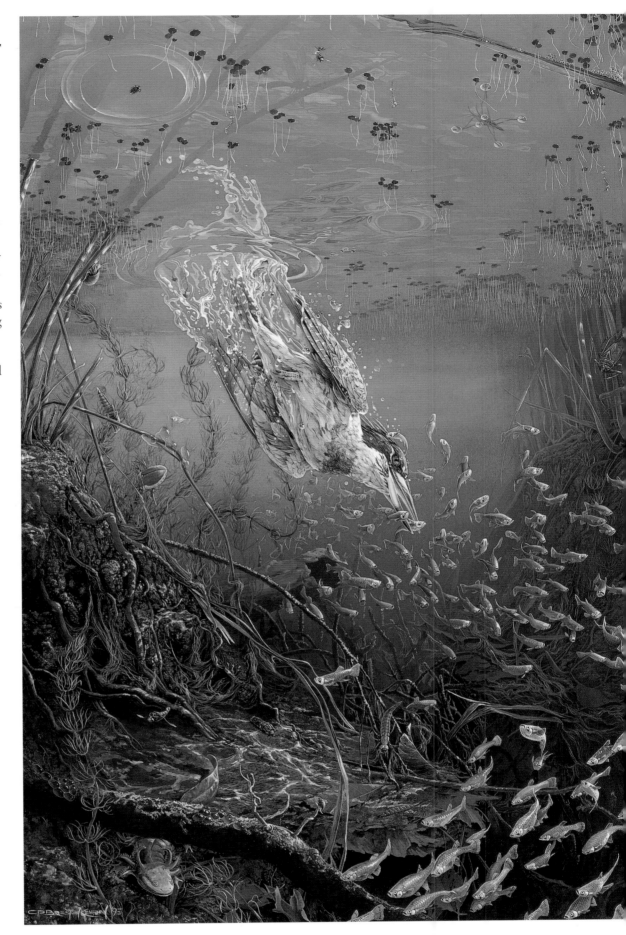

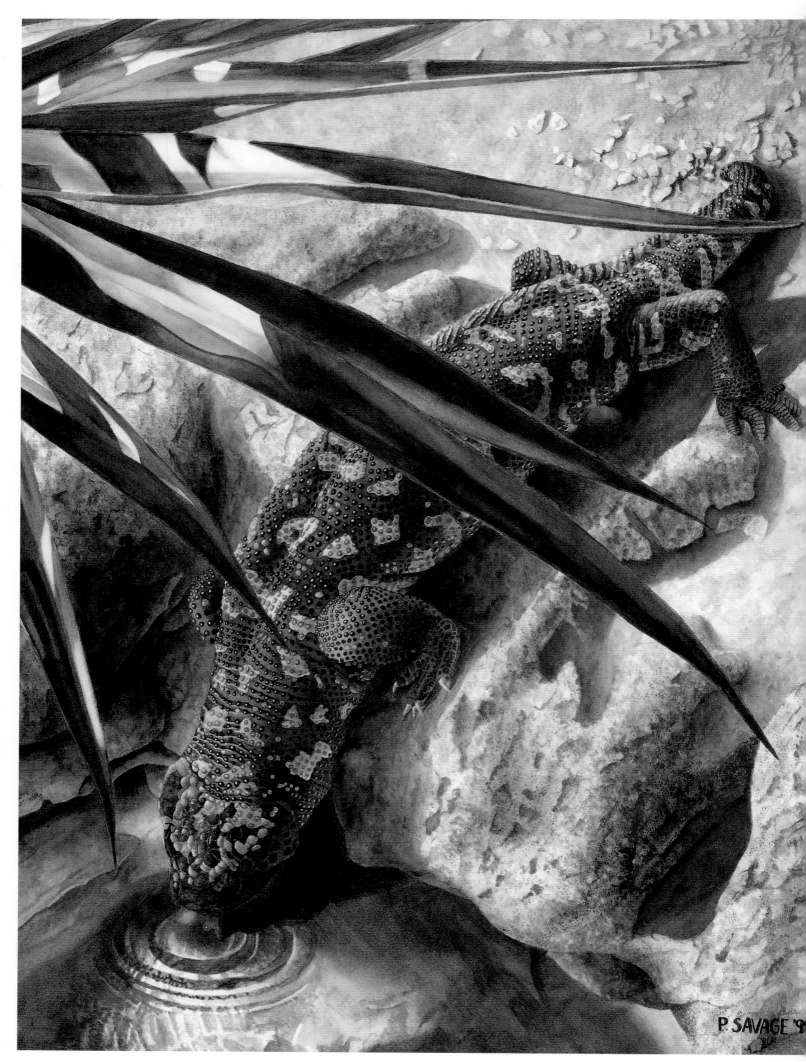

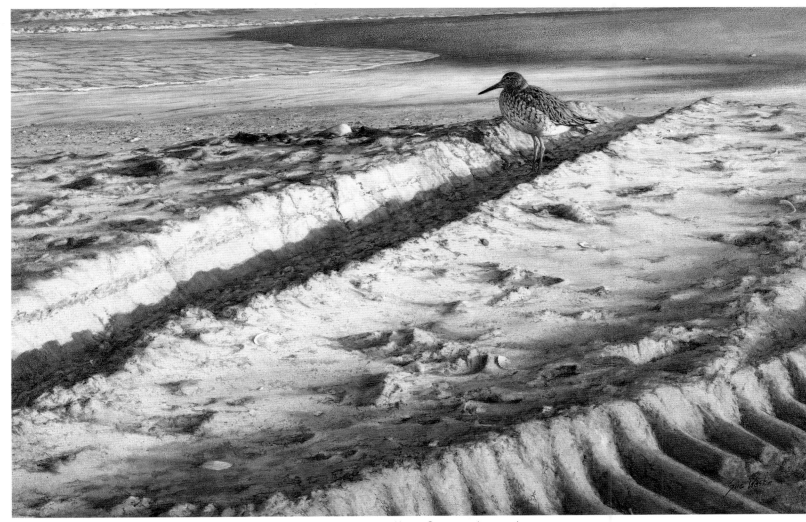

HOLY GROUND (WILLET)
oil, 23½" x 38" (59.5cm x 97cm)

SUE WESTIN

PLACE YOUR POINT OF VIEW
TO MAKE A STATEMENT

In this evening scene from Chincoteague National Wildlife Refuge, I orchestrated the placement of tracks and surf to accentuate both drama and symbolism. This lone willet stood amidst evidence of two powerful forces: God, as symbolized by the natural world, and man, as symbolized by the worn footprints and the tracks of ATVs. By putting the point of view low to the earth, dramatic foreshortening could then accentuate the power and dominance of the tire tracks in the foreground, allowing the viewer to feel the diminutiveness of the bird. In the background the low point of view allowed the sweep of glowing surf to halo the upper part of the bird, which otherwise would have blended with the sandy surroundings. The alternate sweep of dark, wet sand became a large expanse of darkness at the top of the painting, a technique that automatically increases drama.

PATRICIA SAVAGE

ZOOS CAN OFFER
CLOSE-RANGE VIEWS

As I held my breath, my husband (camera in hand) began crawling into the cage. The venomous Gila monster casually walked to his small pool. Who could resist painting a desert creature lapping up water with a purple tongue? The unique viewpoint came from observing this live animal at close range. Seventy-two photographs gave me accuracy, and then I added the yucca leaves to give a feeling of "peeking." The highlights on the beaded and pink areas were masked out with masking film. Once the body was mostly completed and the mask removed, the rest of the lizard was built up with lots of dry-brush layers.

TEA TIME (GILA MONSTER)
watercolor, 22" x 17" (56cm x 43cm)

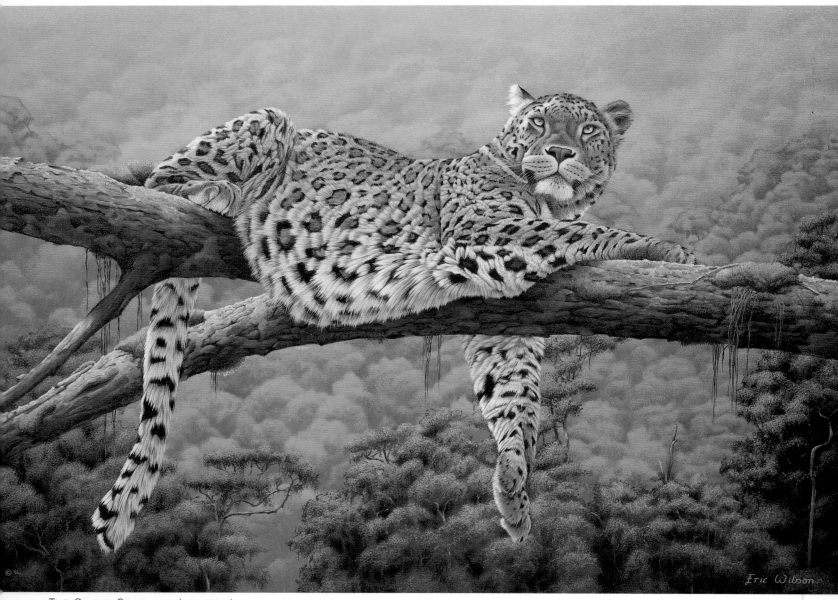

THE SILENT OBSERVER (LEOPARD)
oil, 24" x 36" (61cm x 91cm)

ERIC F. J. WILSON

TAKE A LEOPARD'S POINT OF VIEW

I am fortunate enough to have seen leopards in the wild. Not only in the yellow acacia trees of the Serengeti but also in the pockets of rain forest dotted throughout East Africa. They are an awe-inspiring sight. All the leopards I have seen have been in trees, so for this painting I chose a jungle backdrop that emphasized height and depth and allowed me to express humidity and heat in the haze of the atmospheric perspective. This also seemed to be in harmony with the lazy pose of the leopard. I start with an acrylic underpainting to check that everything will work before painting in oils. I then work in oils from background to foreground, thickening the impasto of the paint in the nearest parts of the painting.

JOHN SEEREY-LESTER

PUT YOURSELF INTO THE ACTION

Unlike other North American bears, the polar bear is an excellent swimmer and is very adept at searching out seals and other prey under ice floes. The hairs of its waterproof coat are hollow; this feature insulates the bear against severe cold and increases its buoyancy while swimming. It can paddle at about six and a half mph with its front feet, its hind feet trailing. It can remain underwater for up to two minutes, making it a formidable predator. Mainly carnivorous because of the scarcity of plant life in its habitat, it has an acute sense of smell and can even detect prey under ice. In my painting the bear is swimming toward the viewer. By allowing the body of the bear to disappear into the darkened water, I'm directing attention to the head which has just submerged, leaving in its wake a disturbed surface and bubbles.

ICE FISHING II (POLAR BEAR)
oil on canvas, 40" x 30" (102cm x 76cm)

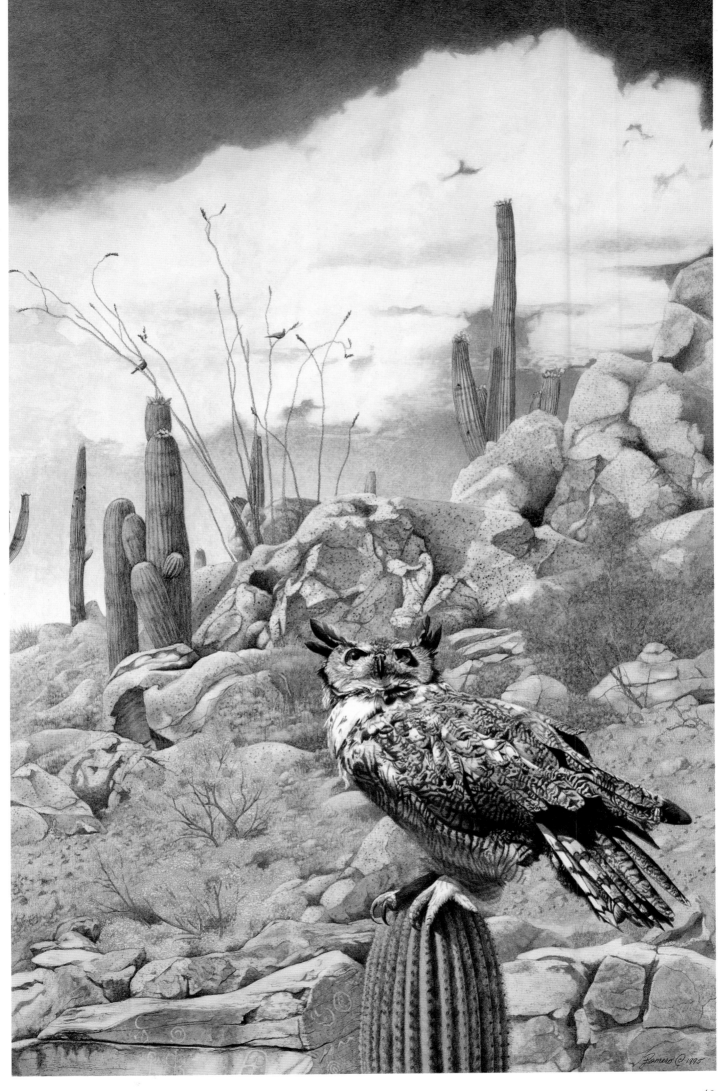

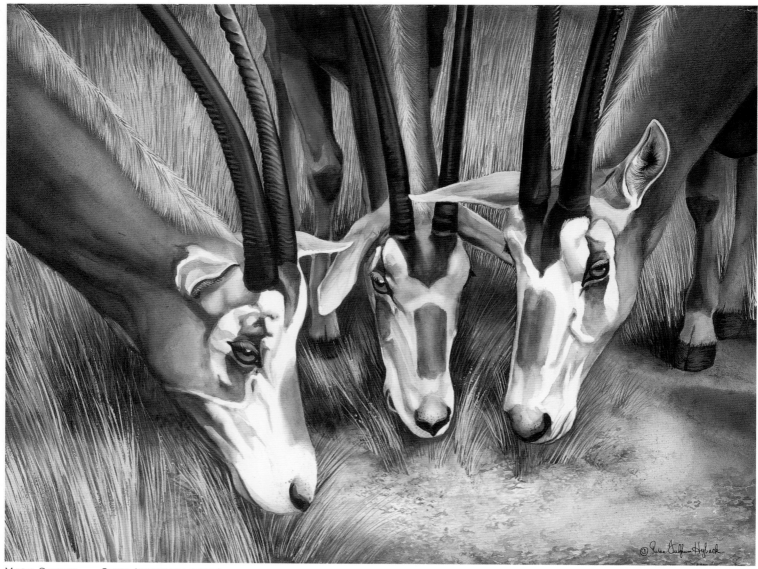

MASK SERIES — ORYX (SCIMITAR ORYX)
watercolor and gouache, 21" x 29" (53cm x 74cm)

SUSAN FULGHUM HYBACK

ZOOM IN FOR AN UNEXPECTED CLOSE-UP VIEW

Usually, pictures of the scimitar oryx focus the viewer's attention on the whole animal or his long, arching horns. While watching this threesome grazing on some tufts of grass, I felt the Vs of their horns compelling my eye to look down at their faces. The patterns in my initial sketches were very graphic—almost a hard-line approach. After beginning in watercolor, I felt a softer, more organic approach would be more appropriate for the gentle expression in the animals' eyes. After laying in background washes of blue and sepias, I added more grasses using white gouache tinted with ochre and green watercolors. The velvety surface quality of the gouache kept the grass subordinate to the oryx and at the same time imparted a consistent depth-of-field to the painting. I turned the most obvious focal point for these animals, the horns, into an arrow directing the viewer's eye to the masks and faces. These animals are now endangered in the wild, and I hope a close-up look at the beauty of the scimitar oryx increases our awareness of his tenuous hold on existence.

ROBERT MCNAMARA

A HARD CLIMB TO A SPECTACULAR BACKDROP

On a trip to Waterton Glacier International Park I spent a good part of one morning bushwhacking to a summit where I had earlier spotted some bighorn sheep. During a painfully slow pitch up a talus slope, five mountain goats came around a ridge and across the slope below me. I decided to forget about the sheep and watch the goats instead. I tracked the goats across talus, through ravines and over cliffs until they finally left me behind on a precipice that I couldn't negotiate. As I sat studying the view and trying to decide if I should start back up again or call it a day, a movement caught my eye. Not over one hundred feet away, two goats were standing against a spectacular Rocky Mountain backdrop staring at me with their characteristic cocked-head posture. That experience became the reference for my painting, *On the Edge of Spring*. The sheer cliffs and patches of snow in mountain goat habitat create dramatic compositions of interlocking dark and light patches.

ON THE EDGE OF SPRING (MOUNTAIN GOATS)
acrylic on Masonite, 24" x 32" (61cm x 81cm)

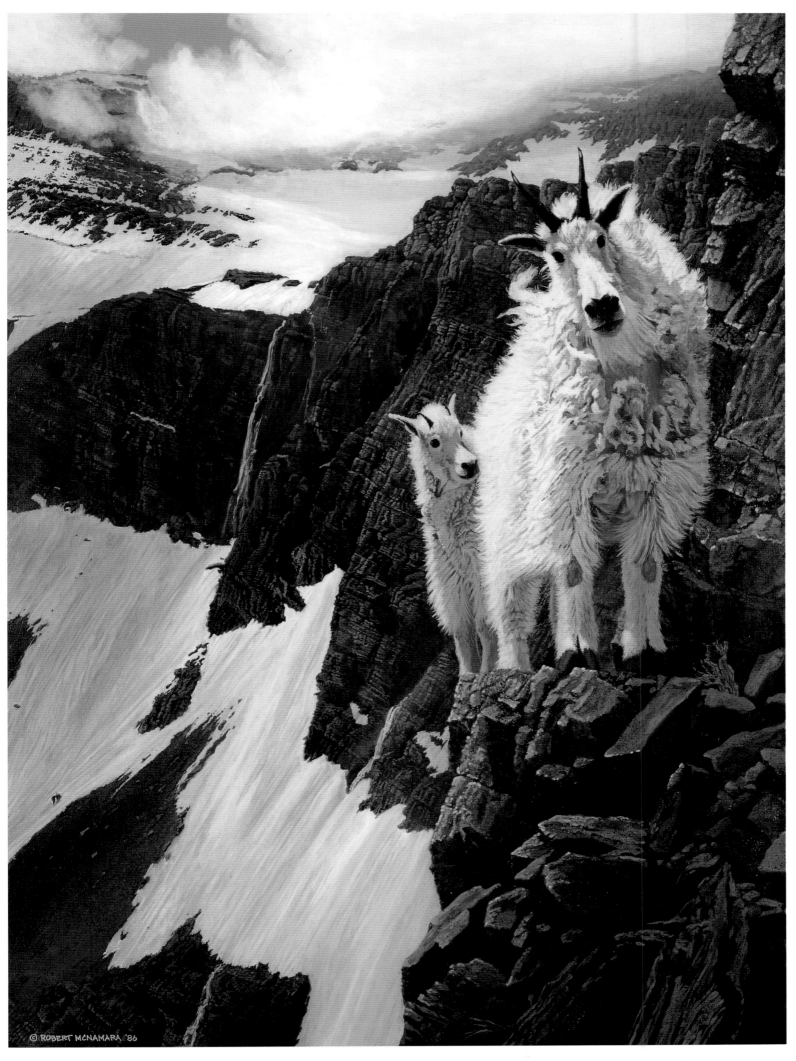

© ROBERT McNAMARA '86

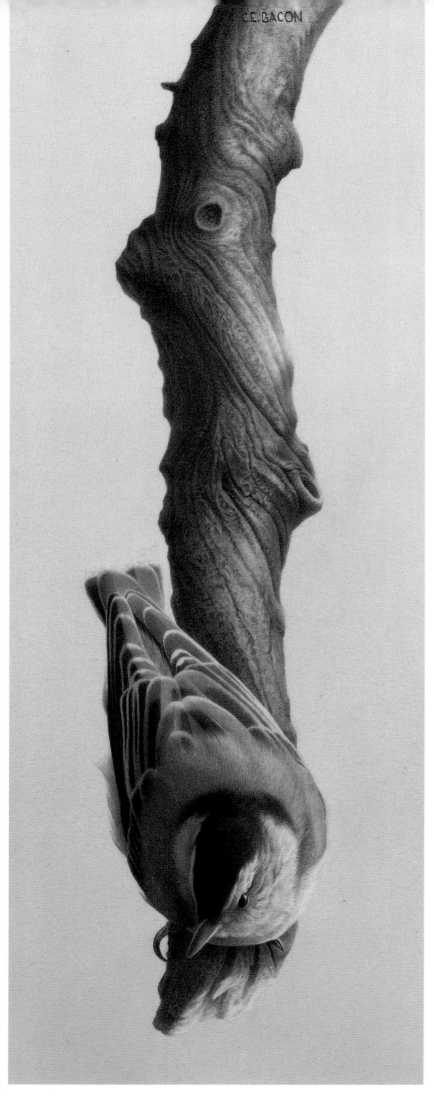

CHRIS BACON

DEVELOP IDEAS FROM UNIQUE BEHAVIORS

The painting *White-Breasted Nuthatch* is my attempt to convey a unique behavioral aspect of this species: Nuthatches forage downward, allowing them to discover what may have been overlooked by "up the trunk" tree foragers, such as small woodpeckers.

This distinctive behavior is an ecological niche adopted to assist them in their search for food. With this composition, I am attempting to communicate the sense of descending spiral motion as the viewer follows the nuthatch down his precarious trail.

WHITE-BREASTED NUTHATCH
watercolor, 8¾" x 3½" (22.25cm x 9cm)

NANCY HOWE

GIVE THE VIEWER A SENSE OF BEING THERE

This particular viewpoint gives dimension and depth to the precipitous habitat common to the Atlantic puffin, as well as giving the viewer a sense of being present among them. A melody is defined as a succession of single notes organized as an aesthetic whole which is repeated throughout a piece of music. The title, *Little Melody*, suggests this painting was composed by arranging the group of birds as the melody and repeating the rhythm of their design throughout the piece. Their soft, rounded forms and the flow of their arrangement are echoed in the background elements, creating harmony. The habitat was a synthesis of what I had seen on the Treshnish Islands off the west coast of Scotland during the spring nesting season.

LITTLE MELODY (ATLANTIC PUFFINS)
oil, 28" x 21" (71cm x 53cm)

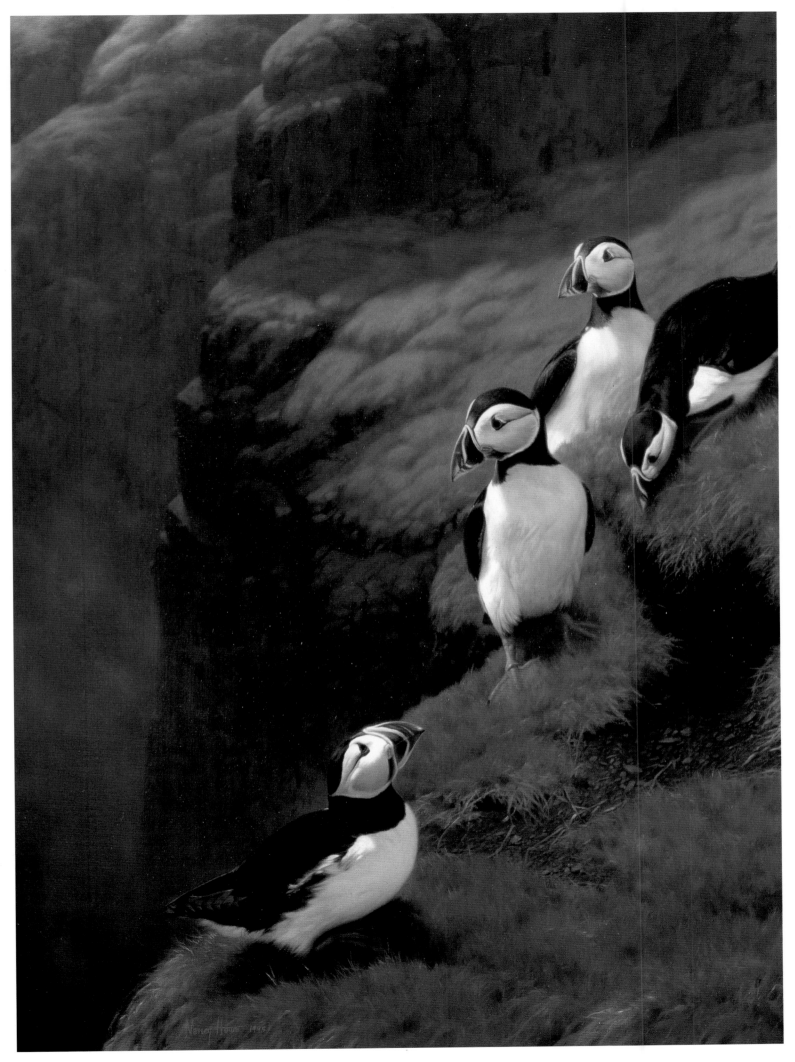

4

GRAB ATTENTION WITH

ACTION

JOHN SEEREY-LESTER

ACTION TELLS A STORY

Painting animals in action is one of the greatest challenges for any artist. Action and movement not only tell a story but are important design elements as well. Action can explain, in visual terms, an animal's behavioral characteristics. In *Into the Clearing — Jaguar* I have painted the cat, the main focus of the painting, in detail while giving a looser feeling to its surrounding to suggest the cat's speed and motion.

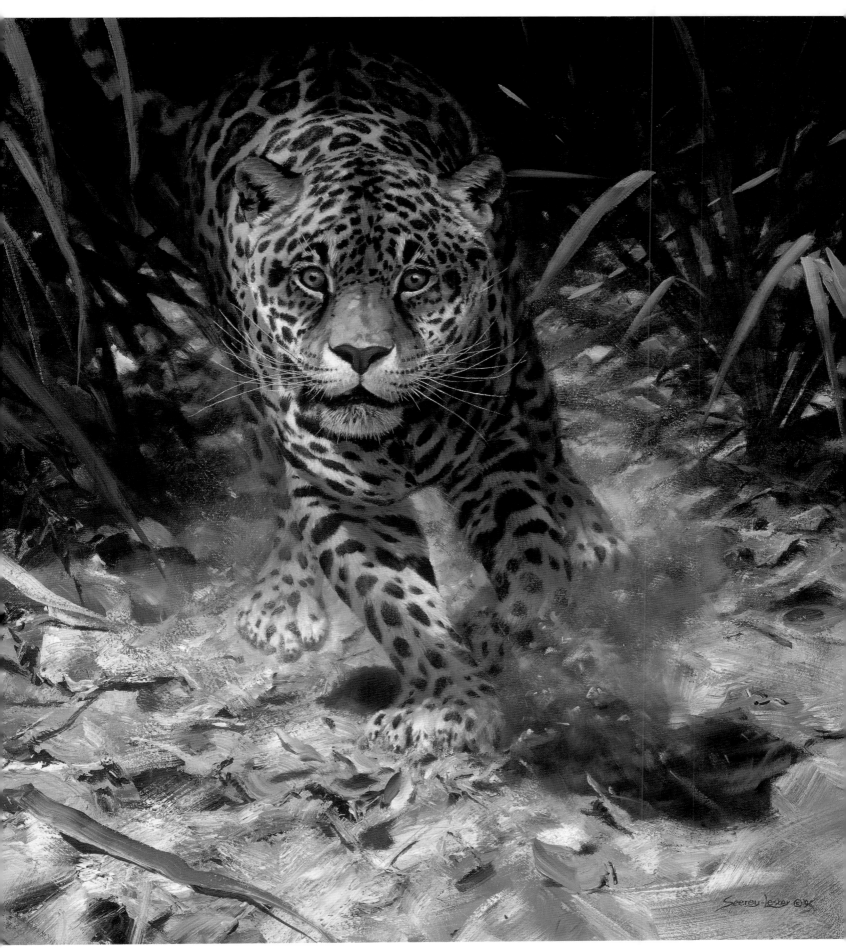

INTO THE CLEARING — JAGUAR
oil on canvas, 24" x 36" (61cm x 91cm)

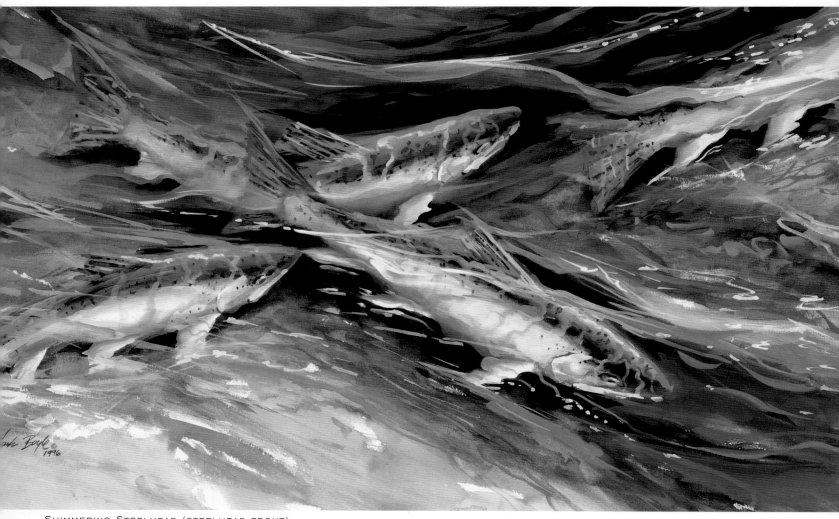

SHIMMERING STEELHEAD (STEELHEAD TROUT)
gouache, 14" x 26" (36cm x 66cm)

MARK BOYLE

PAINT THE FLOW OF A RIVER WITH GOUACHE

Steelheads fin nervously in the shadowy depths of a clear flowing river. Silky blue sky reflections bounce off the liquid surface as moving shapes below are distorted beyond recognition. To interpret this scene you must paint spontaneously from your gut feelings to portray the flow of the river. I start out with idea sketches on tracing paper, then pick the arrangement of fish with the right flow or feeling and lightly transfer the drawing onto watercolor paper. Using gouache I paint midtones and dark areas, checking where hard and soft edges form shapes and shadows. In the final stages I paint light, thin washes of tinted color and blend out selected areas where water distorts objects with fast, yet controlled strokes.

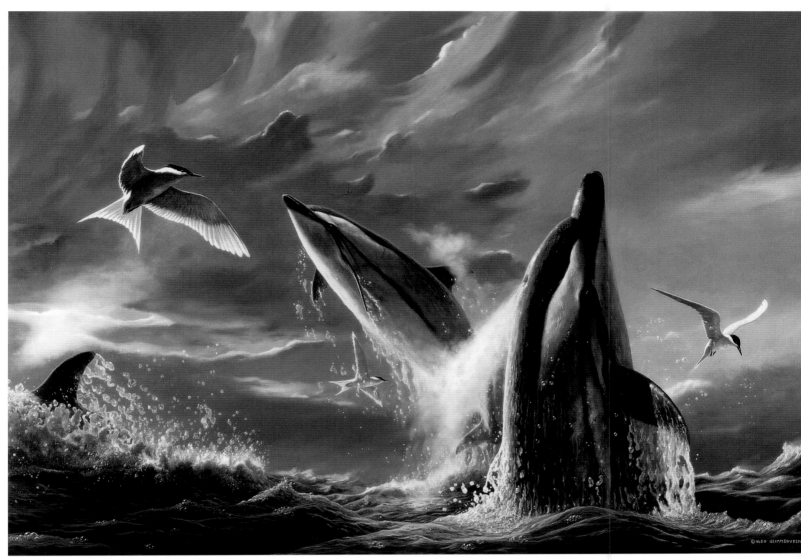

OCEAN BALLET (STRIPED DOLPHINS)
oil on hardboard, 32½" x 49" (82.5cm x 124cm)

ULCO GLIMMERVEEN

LET THE ACTION TOWER ABOVE THE VIEWER

In *Ocean Ballet* I wanted to give the viewer the sensational feeling of being in the water with the striped dolphins—thus the very low point of view. The dolphins explode from the water and tower above the viewer. A third dolphin is suggested by its dorsal fin and the mysterious greenish water being pushed up and broken into spray by its bulk. Although the moment is frozen, the movement suspended—like certain moments in a ballet—it gives the viewer the ability to study details in an action which in reality changes dramatically within seconds. The different-sized terns—one close by, and two farther away—heighten the sense of being extremely close to the scene as well as putting the size of the dolphins into perspective. The sky strengthens the drama and continues the action. The clouds are torn apart by the wind, just as the water is torn apart by the animals. *Ocean Ballet* was painted on gessoed hardboard. Hardboard is light, strong and smooth, and I like to be able to choose the structure of the undercoating—smooth or irregular. I thinned my oils slightly with Liquin to quicken drying.

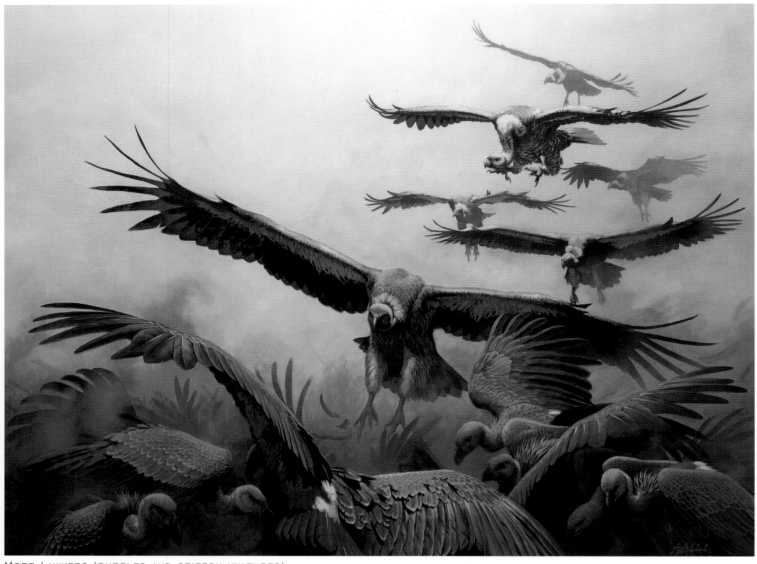

More Lawyers (ruppels and griffon vultures)
oil on linen, 36" x 48" (91cm x 122 cm)

GUY COHELEACH

USE ENOUGH DETAIL TO CAPTURE ACTION

Although this painting looks very detailed because of its size, it is quite loose—but not as loose as I normally prefer. Additional detail was necessary to successfully capture the action of this scene. I wanted to convey the chaotic feeding frenzy characteristic of nature's scavengers, such as these vultures, in their hectic attempt to tear any scrap from the carcass before it is gone. Hence the title.

HENRY BISMUTH

USE DESIGN ELEMENTS
TO EXPRESS MOVEMENT

My interest in this painting was twofold: to create a design, using the repetition of blacks and whites, and to express the swiftness and aggressiveness of magpies, birds that are quite difficult to approach. This painting is part of an ongoing series of works on corvids. My interest in these birds began a few years ago with a sudden overpopulation of these species in my region, allowing me a wide range of study.

Untitled (black-billed magpie)
oil on canvas, 36¼" x 28¾" (91.75cm x 73.25cm)

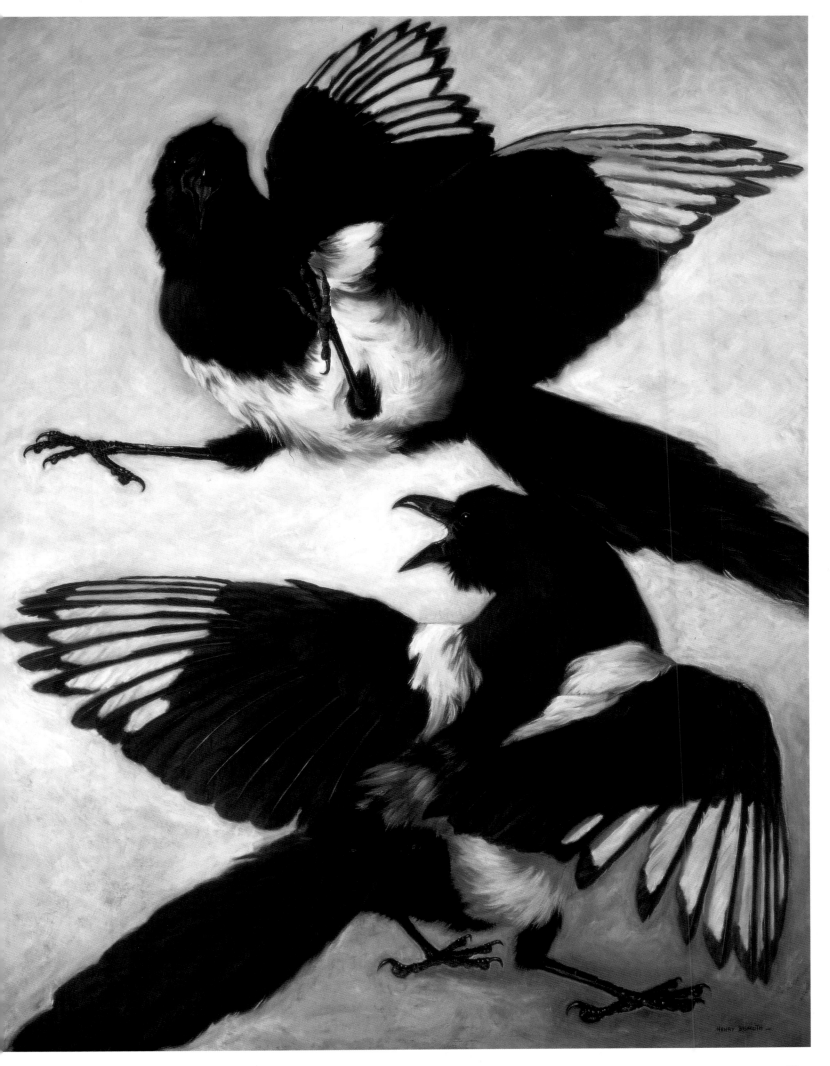

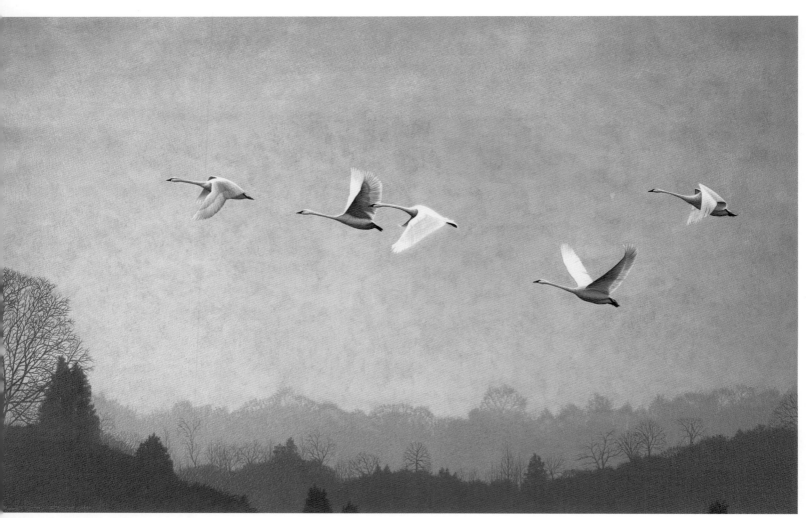

PHANTOMS (TUNDRA SWANS)
acrylic, 22" x 32" (56cm x 81cm)

RUTH RAY

PLACEMENT IS THE KEY FOR TRANQUIL ACTION

The most critical element of this composition was the number and placement of the swans. Too many birds, and the painting would become cluttered, losing the tranquil feeling I wanted to convey. Too few, and it would become empty and uninteresting. I wanted to place these birds in the painting so that they seemed to be just leaving the comfort of a secluded lake. After drawing in the skyline and the basic composition of the landscape, I worked in layers, finishing the most distant landscape elements first and working my way to the foreground. It was difficult for me to envision the birds in the landscape, so I made sketches of five swans in the size I wanted them to be, with their wings in the positions that would be eye-catching against the sky. I then carefully cut these sketches out with a razor blade and experimented with the placement of the birds until I found a pleasing composition.

Joan Sharrock

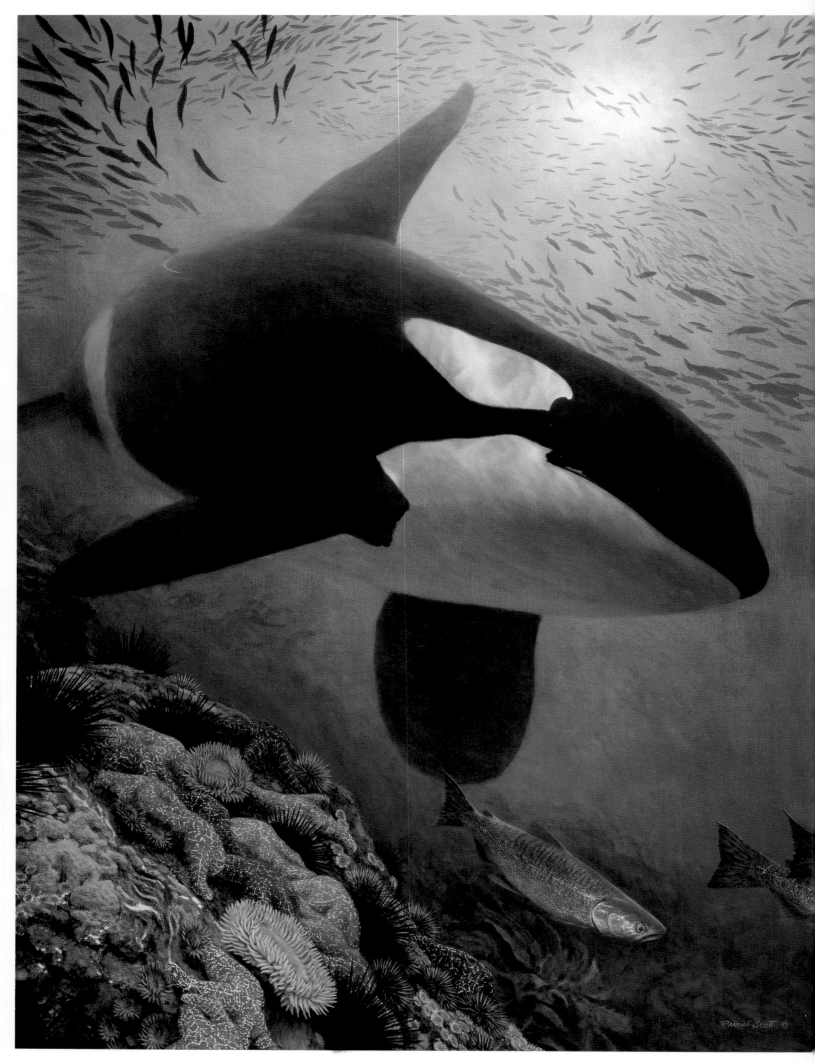

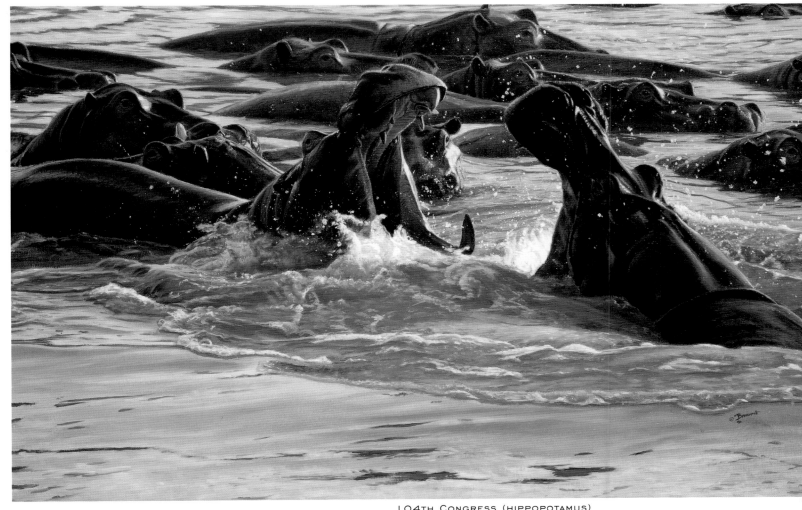

104TH CONGRESS (HIPPOPOTAMUS)
oil on linen, 20" x 33" (51cm x 84cm)

JOHN BANOVICH

104th Congress began with the title. I then chose a pod of hippos as an appropriate subject for the theme: Small, brief skirmishes erupt often amongst hippos, not unlike Congress when it is in session. Traveling to the Luangwa Valley in Zambia I found myself in a hippo hide on the shores of the Luangwa River at 5:45 AM as the creatures began to return to their daybreak resting place after feeding all night on the grassy shores.

I begin each painting with a gray primed canvas, and after working out all the details, sketch directly on the surface. Starting with acrylic, the painting quickly takes on shape and form by establishing values. Overpainted with oil, the acrylic color slowly recedes but shows through to create a wonderful sense of light. Action is portrayed through the open mouths facing each other, but the water creates the movement. The shape of the surface as well as the subtle waves and splashes give the animals posturing life. The main focus, action, was enhanced by placing the central contrast (the boldest light and dark) at the open mouths. A further focus was achieved by placing the only hippo who faces the viewer in between the sparring bulls.

RANDALL SCOTT

CREATE AN UNPHOTOGRAPHABLE SCENE

Though I did not witness this scene, part of the challenge with painting is creating a scene that is generally unphotographable. I chose an upward view to silhouette the school of salmon and killer whale against the sunlit water. Positioning the whale above the viewer shows his dominance. The Orca's mastery of the liquid realm is revealed by his powerful, diving glide as he skims the steep rock face in his quest to catch the quick and numerous pink salmon. The greatest challenge to conveying action was to portray the salmon exploding in opposite directions, yet seemingly connected, as if they were part of a ballet.

SALMON HUNTER (ORCA WHALE)
acrylic, 38" x 30" (97cm x 76cm)

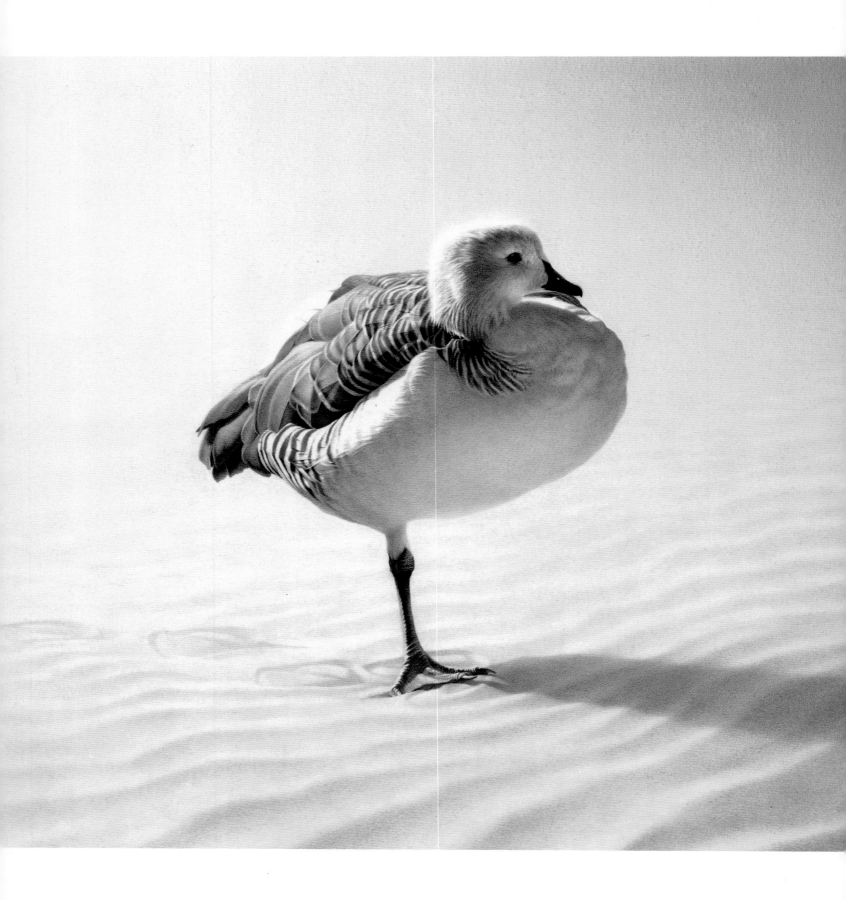

LIGHT-WAVES (MAGELLAN GOOSE)
watercolor, 12" x 19" (30cm x 48cm)

SET THE MOOD WITH

EXPRESSIVE LIGHTING

CHRIS BACON

OVERALL LIGHT PRODUCES A CALMING EFFECT

By using light as a medium to enhance the soothing wave-like patterns on the sand's surface, I have attempted to instill a calming effect in the viewer. Light is also being used as a conduit or "projection" of inner peace spilling from the subject itself, thereby creating a connection between the subject and the viewer.

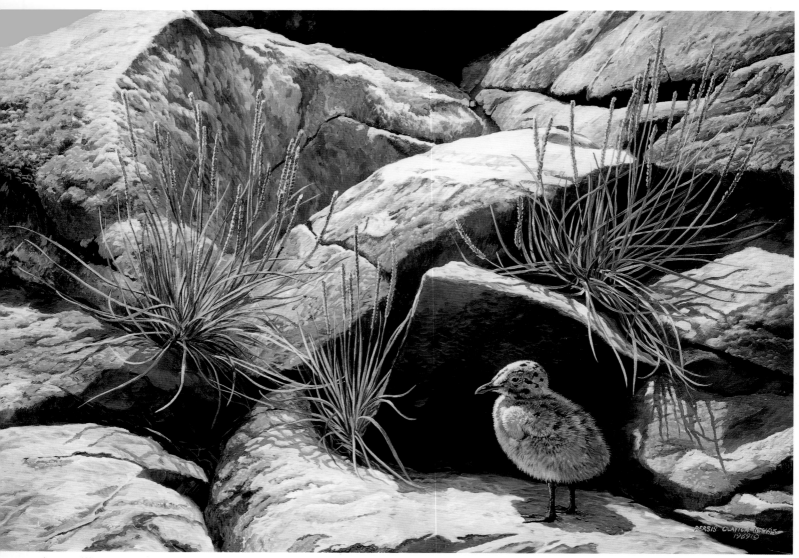

LITTLE WANDERER (HERRING GULL)
acrylic, 20" x 30" (51cm x 76cm)

PERSIS CLAYTON WEIRS

WARM MIDDAY SUN GIVES A COMFORTABLE FEELING

The reference for this painting was a photograph I took on the rocky shoreline of an island in Penobscot Bay on the Maine coast. The island was a nesting ground for a colony of herring gulls. It was covered by a low dense growth of wild raspberries, rugosa roses and bracken that had been transformed into a maze of tunnels leading to and from gull nests. The young gulls, like playful children at a daycare center, scampered around their area and popped in and out of their neighboring tunnels. Those whose nests were closest to the shore often wandered down onto the rocks. Though there was no baby gull in my reference photo, it was easy to recreate one. I chose the warm sunshine of midday to give this "little wanderer" a comfortable, secure setting.

SHARON RAJNUS

VALUES ARE CLOSE IN MOONLIGHT

In a night scene, values can be very close, so it is essential to carefully study what happens to color under moonlight. In this painting, the moon reveals gilt-edged clouds, a path in the water and some foreground illumination. The moon itself is hidden so as not to dilute the effect. I prefer a fairly smooth linen canvas or a tightly-woven cotton; I stretch my own when I can. Onto this primed canvas, toned with a warm foundation color, I transfer a loose representation of my thumbnail sketch. Basic values are blocked in with a thin oil wash, and the painting progresses lean to fat and dark to light. This scene is a specific spot on the Columbia River in Oregon. I had been looking for sites along the Oregon Trail to document and this was one of my favorites since it is in this very spot that pioneers using the river for passage could have seen Mt. Hood for the first time, a sentinel for their final destination.

MOONLIGHT ON THE COLUMBIA (CACKLER GEESE)
oil on canvas, 30" x 40" (76cm x 102cm)

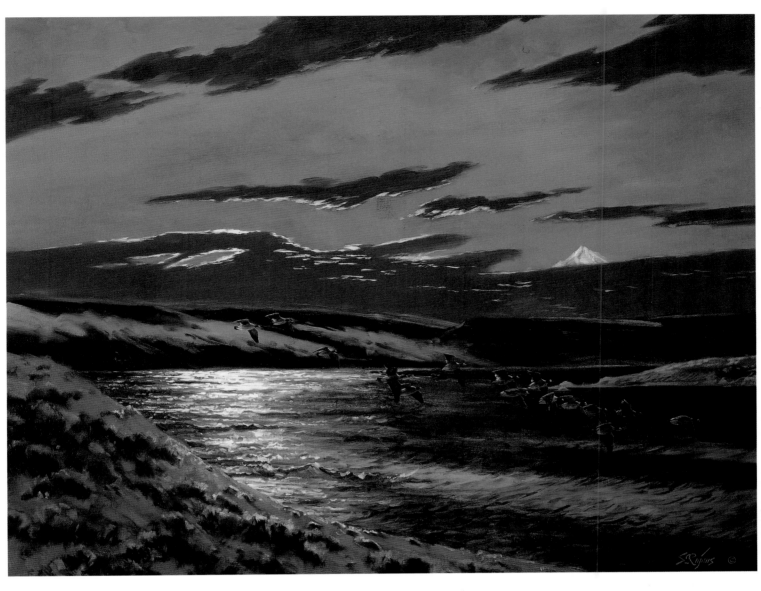

PASSING SHOWERS — GREAT WHITE EGRET
oil on linen, 13" x 31" (33cm x 79cm)

BRADLEY J. PARRISH

A SPOTLIGHT EFFECT FOR
CONTRAST AND ELEGANCE

While in Florida, I was inspired by the great white egret's graceful flights over the inlet waters. The striking contrast of its brilliant white feathers against the lush green of the vegetation moved me. In this piece I wanted to convey more than just the beauty of the egret in flight; I wanted to achieve a mood characteristic of its habitat. I have often experienced showers coming in off the coast which last only minutes and move on as quickly as they come. Because of the humidity brought on by these showers, light and all that it reaches has a mysterious appearance. Portraying this steamy weather allowed me to capture the lush feel of the surroundings, to showcase the beauty of the bird against the misty background and to deliver the serenity I was after. I chose to view this piece from slightly above the egret to dramatize and accentuate the beauty of its domain—to allow the viewer to see the habitat as the egret sees it.

MICHAEL BUDDEN

EVENING LIGHT IN ACRYLIC LAYERS

I believe in getting out and experiencing nature firsthand—this is where great ideas are born. I witnessed this scene while on a trip to the Edwin B. Forsythe Wildlife Refuge in New Jersey. A feeling of calmness and inner peace came over me watching these geese prepare for evening while blanketed by this beautiful reflection. I tried to convey this message both visually and poetically in the title. My acrylic technique is to slowly and patiently build the painting in several stages, alternating washes and opaque overlays. When I'm done, I give the painting a coat of matte varnish for soft, light-colored paintings and a gloss varnish for dark paintings.

SANCTUARY (CANADA GEESE)
acrylic, 29" x 21½" (74cm x 54-1/2cm)

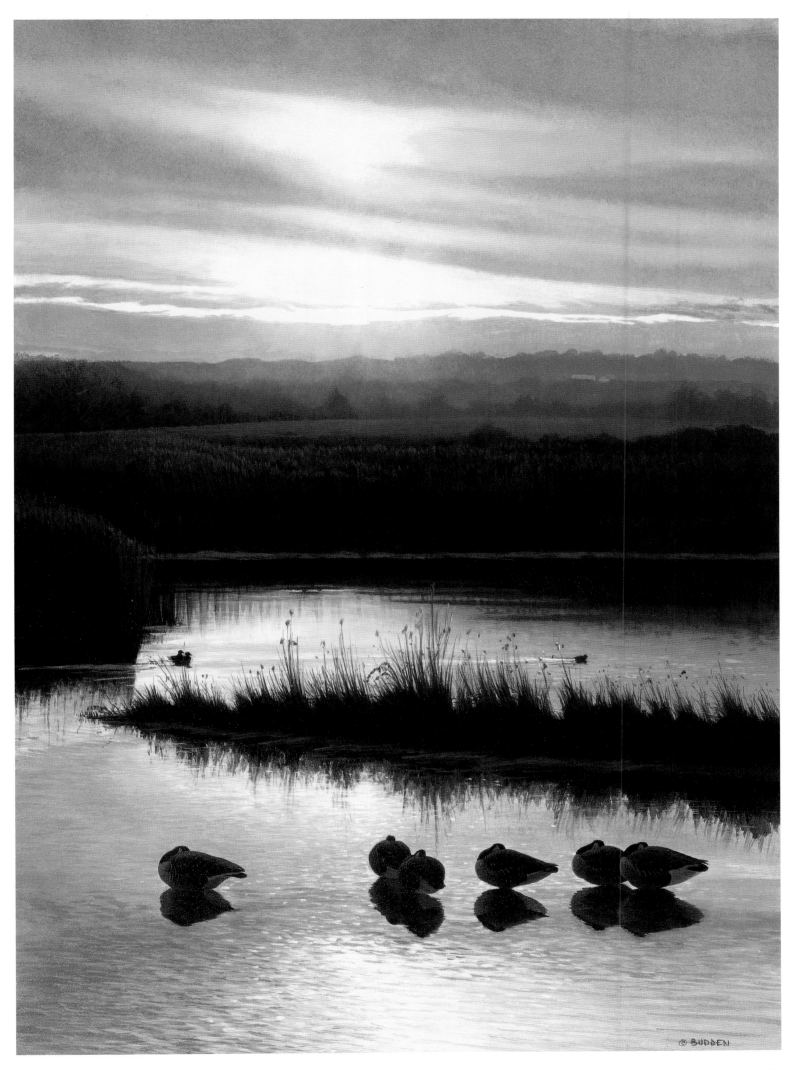

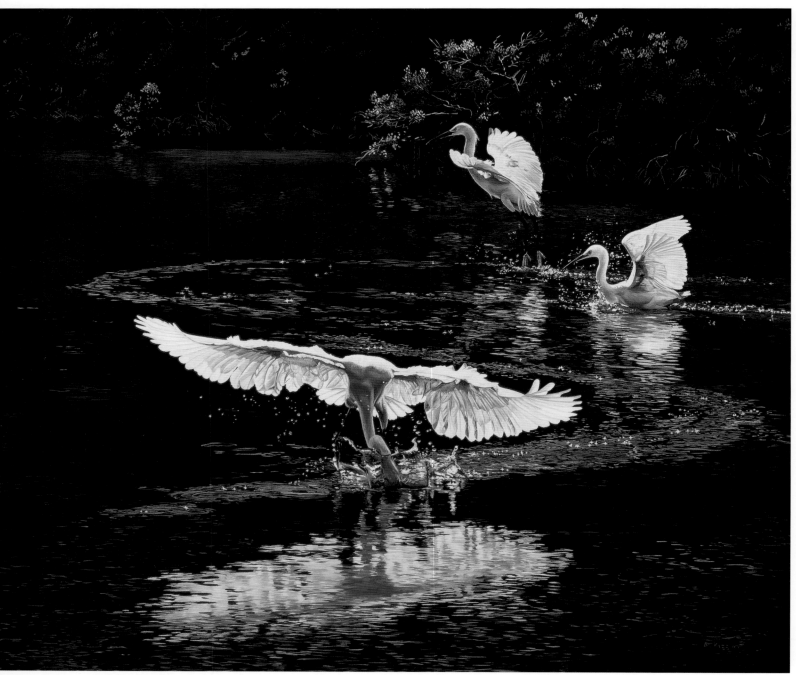

AFTERNOON BALLET (SNOWY EGRETS)
oil on canvas, 30" x 36" (76cm x 91cm)

ANDREW KISS

BACKLIGHTING CREATES UNSURPASSED DRAMA

Afternoon Ballet has many special meanings to me. The light in the painting represents an experience that added a certain brightness to my life. My history teacher of thirty years ago, after viewing my work in galleries across Canada, contacted me and invited me to his home in Florida. We spent two weeks together in search of different species of birds. On one typical sunny day in the Everglades we came across the majestic snowy egrets. The beauty of their movement and the light that surrounded their "dance" was angelic. The effect of the backlight creating a contrast between the translucent feathers against the dark mangroves was breathtaking. I found a challenge in showing a strong representation of the "ballet" of the egrets together with the strong effect of the light, without taking away from the actual subject of the painting. I painted the mangroves and the water darker than I had actually seen them to give a higher contrast to the droplets, the disturbed water and the feathers. This gives the painting a three-dimensional effect, adding depth between the front egret and the ones in the background. Without the strong use of light this effect would not have been achieved.

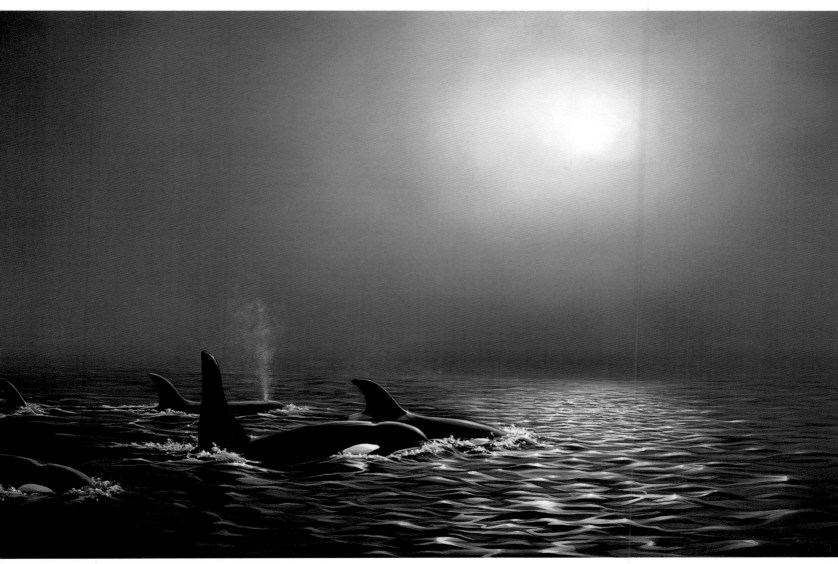

THE FOGCUTTERS (ORCA WHALES)
oil on canvas, 30" x 48" (76cm x 122cm)

PACO YOUNG

DRYBRUSH OIL FOR SUNLIGHT THROUGH FOG

Anyone who has spent time whale-watching knows that after long periods of staring at often flat, quiet water, pods of whales can appear almost magically and then, just as quickly, be gone again. With that idea in mind, I began this painting relying on my memory of a rather scary yet peaceful moment off the southwest coast of Florida: Briefly lost in a heavy fog bank, we drifted quietly in our boat as the sun became an eerie orb glowing through the thick mist. To this scene I added a pod of orcas surfacing—similar to those I had watched off Alaska's Kenzi Peninsula—the silence broken only by the spray from their blow holes. I chose oil on canvas because of its blendability. It allowed me to soften the scene by drybrushing to create the feeling of the sun burning through the fog. Also, I felt no other medium would give me the rich black that oil paint would, and I wanted the whales to be very black, creating strong design elements.

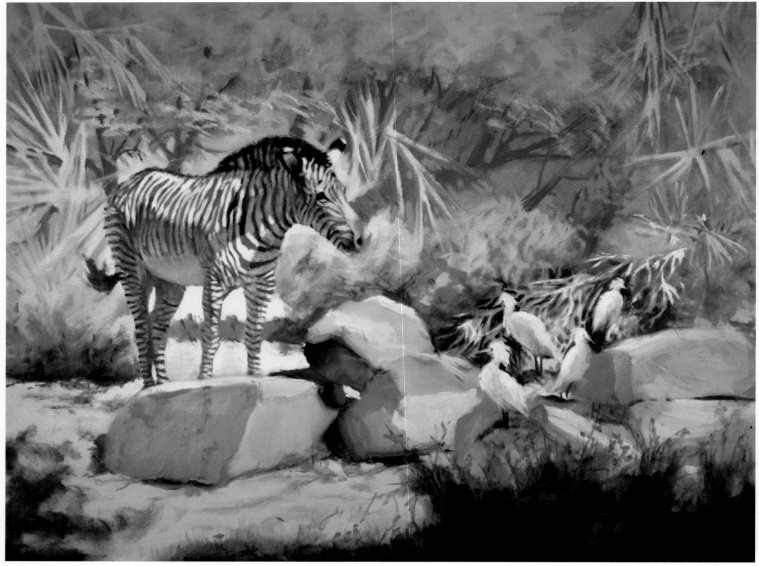

Brief Encounter (zebra and egrets)
oil, 18" x 24" (46cm x 61cm)

JULIO PRO

BRIGHT TOP-LIGHTING PRODUCES TRANQUILITY

One way to establish a mood or atmosphere in a painting is to manipulate the way light falls on the subjects. A face with light underneath is sinister; the long shadows of a sunset are peaceful. This painting is one of tranquility with bright top lighting in the middle ground, muted light in the background, and a dark foreground. My technique in building a painting usually involves doing a series of thumbnail sketches and then a color study with a very limited palette. I use a cool and a warm of the three primary colors, a few earth colors, and alkyd white for faster drying. I do a rather detailed pencil drawing on a canvas or gessoed Masonite and spray it with fixative. I then put a thin wash of Burnt Sienna and Ultramarine Blue over the whole image. While the painting is still wet, I "rub out" the light shapes with a rag or a brush. I then can go in with my darks and start modeling the forms. When dry, this underpainting can be scumbled with color and glazed with thin washes. When finished, I look for an area around the central figure to pop in a "hot spot" of light to accentuate the mood I hoped to achieve.

LANEY

A LOW SUN INTENSIFIES DRAMATIC CLOUDS

I only paint landscapes or animals with which I am intimately familiar from field trips. The artist must absorb something beyond the visual elements to create a powerful painting. Once I have an excellent photographic reference, I begin to visualize a story I can tell about the animals. The landscape and habitat seem to come together all on their own. The most important image I wanted to express in this painting was a feeling of the high plains: long vistas, dramatic clouds and bright colors that are heightened in intensity by having the sun low in the sky. There is nothing that surpasses the smell of wet sagebrush and damp soil, and a cool breeze after a brief storm. I think I had that smell and feel in mind the entire time I was painting this composition. Water is the limiting factor for any animal living in a semi-desert area, but the animals know where rainwater will collect. The antelope are painted in a peaceful activity, feeling no threat from predators or from the dramatic storm clouds above.

RAINWATER (ANTELOPE)
oil, 30" x 19" (76cm x 48cm)

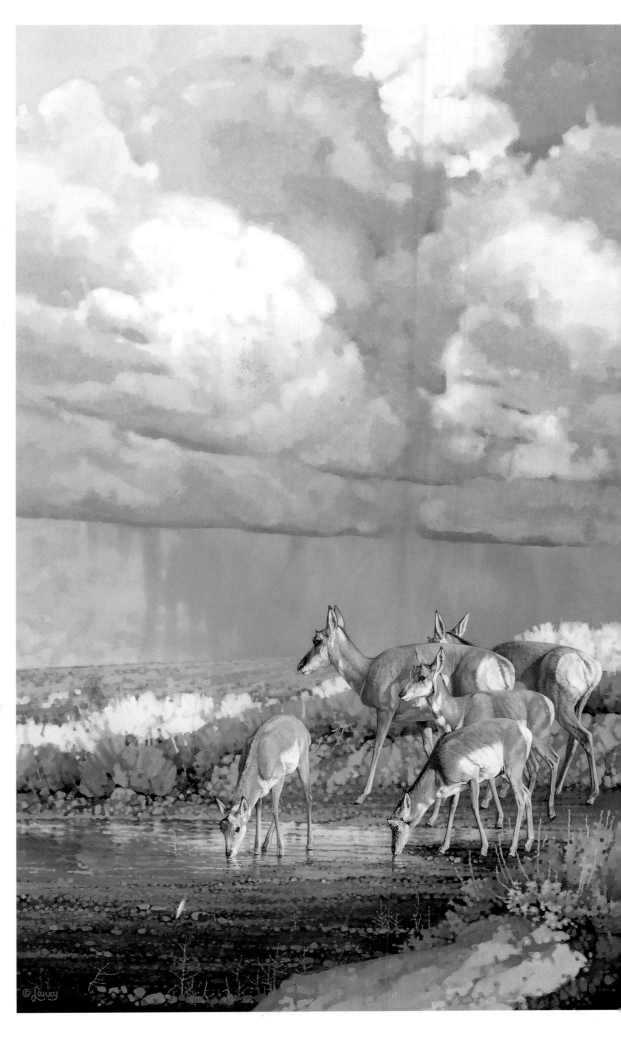

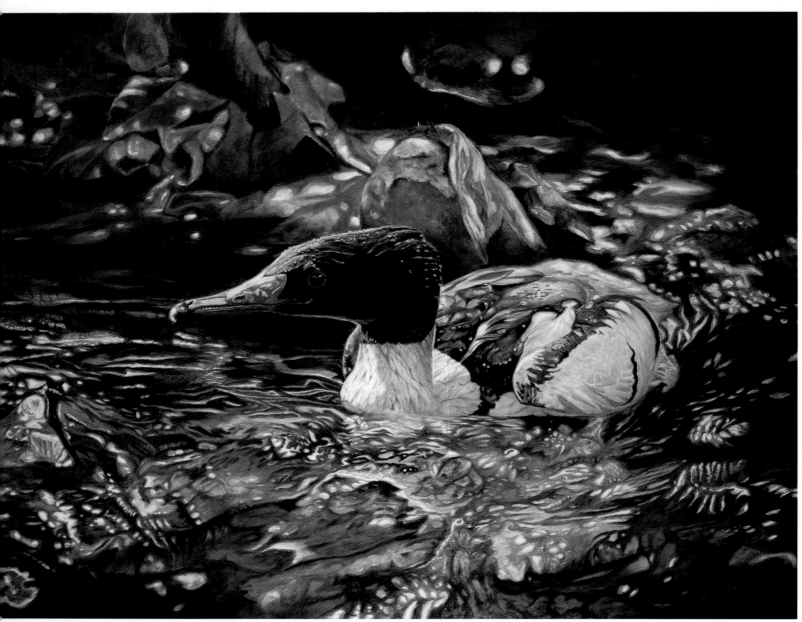

PLACER (COMMON MERGANSER)
oil on canvas, 36" x 48" (91cm x 122cm)

HANS PEETERS

SAVE WHITE AREAS FOR HIGHLIGHTS
ON MOVING WATER

For this painting I used oils in a watercolor technique, applying thin films of transparent pigments to a smooth gesso ground, and saving white areas to produce highlights rather than using white pigment for that purpose. This technique works especially well to depict the lively quality of moving water, in this case an autumn-colored creek in the California foothills where in the past, miners panned for creek gold—"placer" gold. The foliage-broken light striking the bird makes it appear like spotlighted royalty, as does its prominent placement within a simple, straightforward composition. This duck was actually captured by my trained falcon who happily traded it for a piece of chicken. The bird was then sketched, photographed and released unharmed.

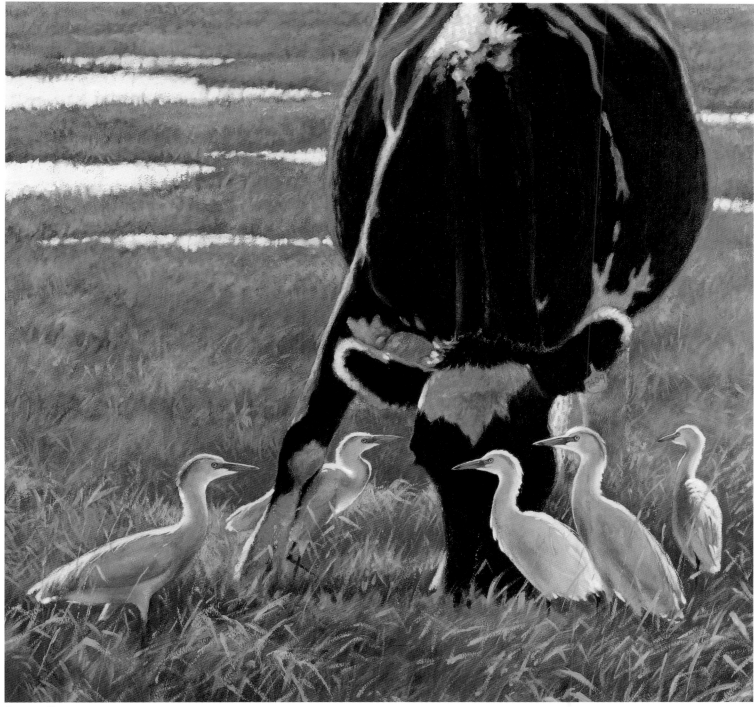

CATTLE EGRETS
acrylic on linen, 34" x 36" (86cm x 91cm)

GIJSBERT VAN FRANKENHUYZEN

RIM YOUR SUBJECT WITH A GOLDEN GLOW

I witnessed this scene in Kenya at a local farm where I was spending some time. I spent half a day sketching the birds, planning on using the egrets with a buffalo, rhino or elephant. But the more I thought about it, the more I liked using the cow—after all the bird is called a cattle egret. The cow suggests human influence—it has a number tag in its ear—and shows wildlife adapting to man. There was only one way to treat this subject—with backlight. All dark areas are kept transparent, while all sunlight areas are put on thick. Rimming all of the birds with white mixed with Cadmium Yellow and orange made the backlighting work.

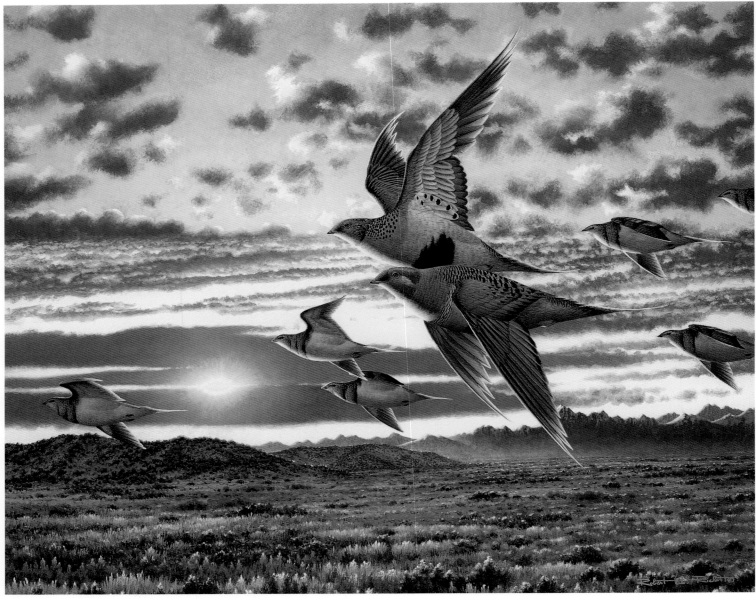

SUNRISE, SANDGROUSE (PALLAS AND PIN-TAILED SANDGROUSE)
acrylic on board, 24" x 30" (61cm x 76cm)

ROBERT A. RICHERT

A DRAMATIC SUNSET OFFSETS AN UNUSUAL SUBJECT

Sunrise, Sandgrouse was an adventure into uncharted territory. I was commissioned to do this painting by Mr. Loren Grueber, who has studied and photographed these birds in Asia. He supplied me with a wealth of knowledge, and the more I learned, the more engrossed I became with this little known species. In the foreground is a pair of pallas sandgrouse, the male having more red coloration. Flying across the background are pin-tailed sandgrouse, which range from the Mediterranean Sea to Kazakhstan, in central Asia, where the two species share habitat, often a harsh desert environment. The female has three breast bands, the male two. With their sharply attenuated wings they may fly as far as one hundred miles in a single day in search of water. In order to avoid huge, violent dust storms, they can fly long distances at speeds exceeding one hundred miles per hour. To create an exciting composition, I posed the birds in flight against a dramatic sunset, which bathes the subjects in a rich orange glow. Backlighting emphasizes the unique sandgrouse shape, especially their sharp, pointed wings. The landscape is derived from a photograph taken in the high desert of Kazakhstan, while the sunset is based upon a slide that I shot in Long Beach, California. I applied thin layers of acrylic color, one on top of another, until I achieved the desired results. This technique allows me excellent control over value, hue and detail.

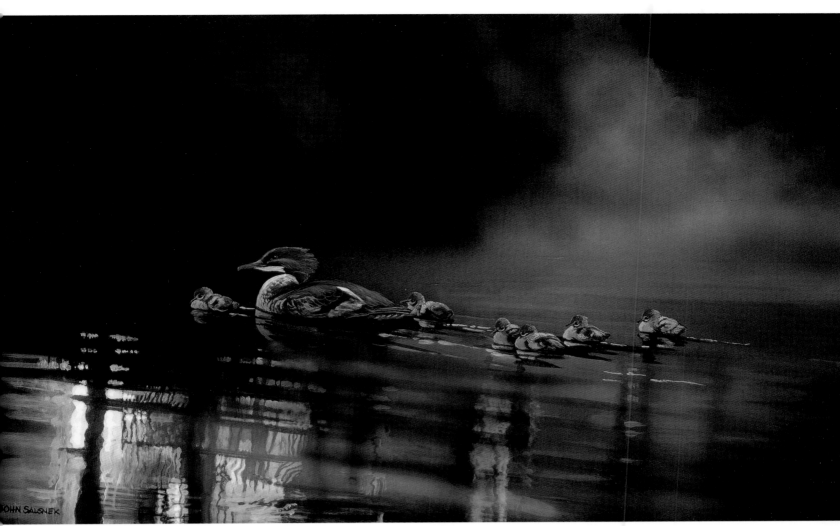

DAYBREAK (MERGANSER FAMILY)
acrylic, 11½" x 20" (29cm x 51cm)

JOHN M. SALSNEK

WATCH LIGHT INTERPLAY WITH WATER

I tried to express that the mood was the dominant feature of this painting and the mergansers were secondary. I used both light and color to create this atmosphere. The idea came to me from early mornings spent fishing at home in Canada, watching the light play and interact with the water and the mist. The strong colors were inspired by a favorite postcard. I completed the background first, then transferred a reworked and polished drawing of the birds to the artboard. The birds are layered in washes, with which I explored the variations of color, culminating in the finished painting. The few areas of detail take very little time in comparison.

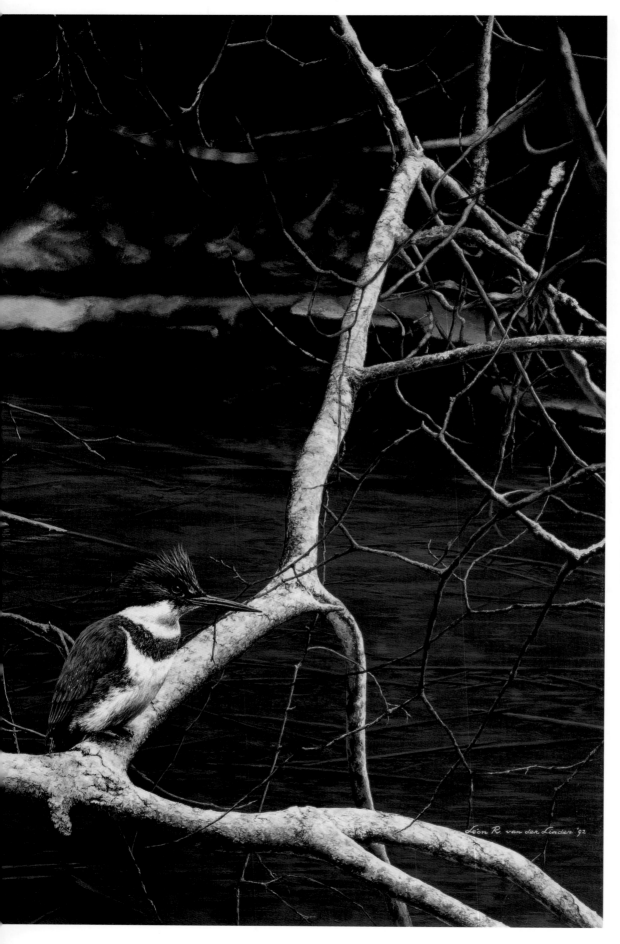

LÉON R. VAN DER LINDEN

While roaming the mountains and lakes just north of Kamloops in the heart of British Columbia, Canada, I was watching a pair of belted kingfishers. I made the sketches for this painting on the site. When I was searching for an appropriate background for a belted kingfisher sitting on a few sunlit branches, I found an old abstract painting I had done in the seventies. After a few changes to the old painting, it worked fine. The main subject of this painting is the kingfisher, but the forms of the branches are almost as important. I decided to paint these branches with all the details I could find such as the lichens and the patterns of the dead wood.

CLEARWATER FISHER
(BELTED KINGFISHER)
acrylic on illustration board,
26" x 18" (66cm x 46cm)

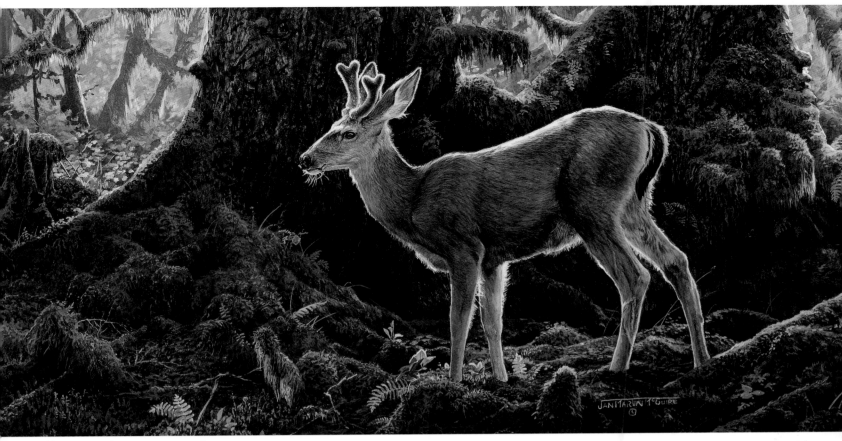

EVENGLOW (BLACKTAIL DEER)
acrylic on Masonite, 8" x 16" (20cm x 41cm)

JAN MARTIN MCGUIRE

SOFT BACKLIGHTING FOR A CATHEDRAL-LIKE EFFECT

This painting was inspired by the Olympic National Park in Washington State—the only temperate rain forest in the lower forty-eight states. The area is like a cathedral—the light coming through the mosses and ferns is as beautiful as any stained glass; the croaking of the ravens, a magnificent choir. I love backlighting and frequently utilize it in my work to create dramatic effects. However, it does have a tendency to "flatten" work so it is imperative to give depth by looking for subtle colors in the shadows such as greens, blues and violets.

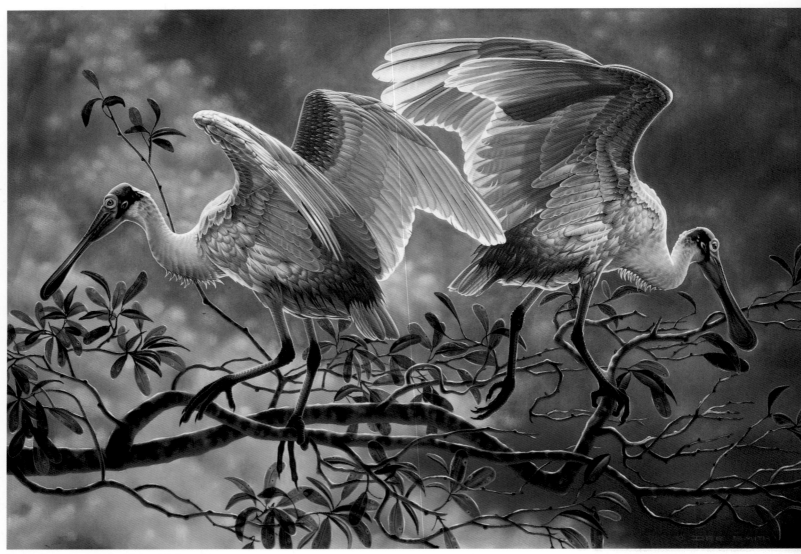

ROSE ADAGIO (ROSEATE SPOONBILLS)
oil on canvas, 24" x 36" (61cm x 91cm)

DEE SMITH

THIN OIL GLAZES CREATE SOFT LIGHT

During the mating season I observed two roseate spoonbills with
their brilliant wings open, moving gracefully around each other
through the mangrove branches as if they were performing a ballet.
The brilliant rose colors of their plumage, most vivid during the
mating season, captivate the eye immediately, but I wanted to cap-
ture this "dance" as the posturing of the birds created elegant and
unusual poses. Consequently the painting is titled *Rose Adagio* from
the classical ballet *Sleeping Beauty*. Of all the birds I've painted, I find
the roseate spoonbills the most challenging. From a distance they
seem to just be pink, but when seen up close and with creative light-
ing, the pinks become a myriad of hues. To achieve this pink I mixed
Cadmium Red and Zinc White. I mixed my oils thinly and used
many glazes, warming the pinks with light yellow and cooling them
with blue grays. To make the detailed birds stand out, I drybrushed
the background to soften it.

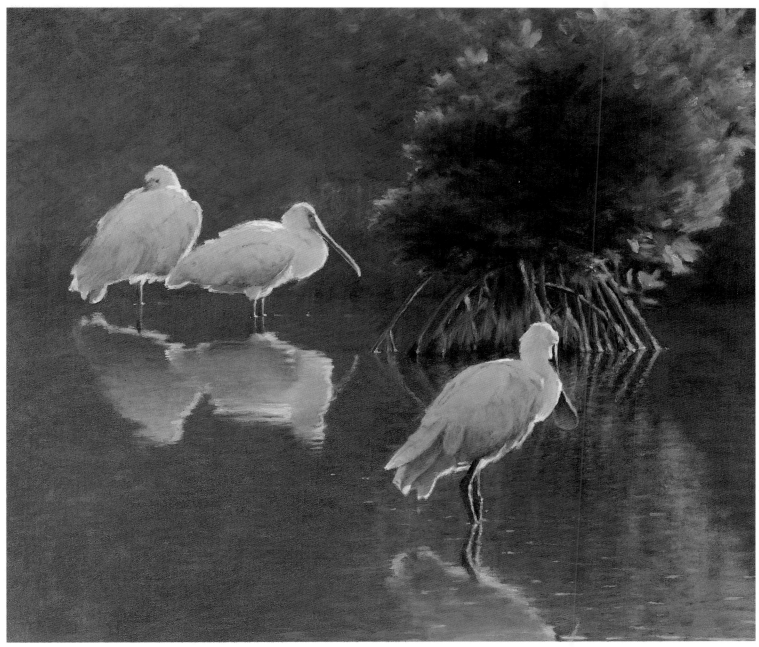

SLOW WATER, SOFT LIGHT (ROSEATE SPOONBILL)
oil on linen, 30" x 35" (76cm x 89cm)

JOHN FELSING

LOOSE BRUSHWORK ALLOWS COLORED GROUND TO SHOW THROUGH

I never tire of painting roseate spoonbills. Their soft pinks and off-whites are alive with ambient color in the complementary green landscapes of southern Florida. In this painting, the rather spontaneous brushwork of the landscape allows much of the colored ground of the linen to show through. This keeps the green towards neutral and leads to the sparkling quality of the birds. The composition, though looking rather simple, actually is a bit more complicated. I was very conscious of the geometry of the elements within the painting and how one's eye traveled through it. If you do not begin with a strong design, you will rarely end with one. In the end, the most important part of any painting is emotion—where the spiritual transcends the technical. Painter Max Weber said, "Emotion is as the sunlight to the seed of art, and the seed in time is fruit."

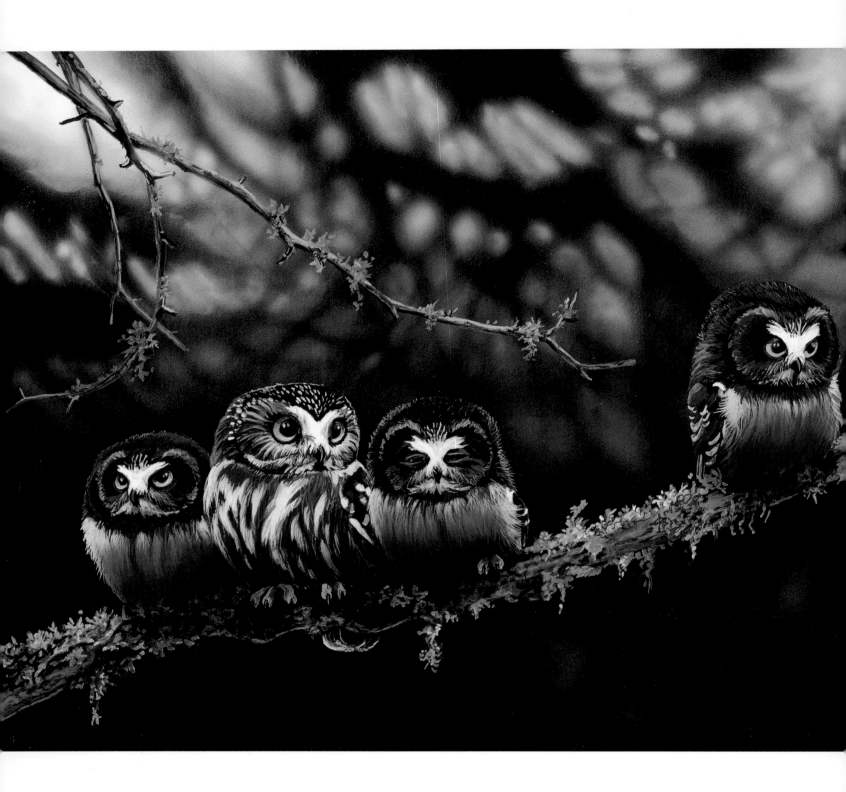

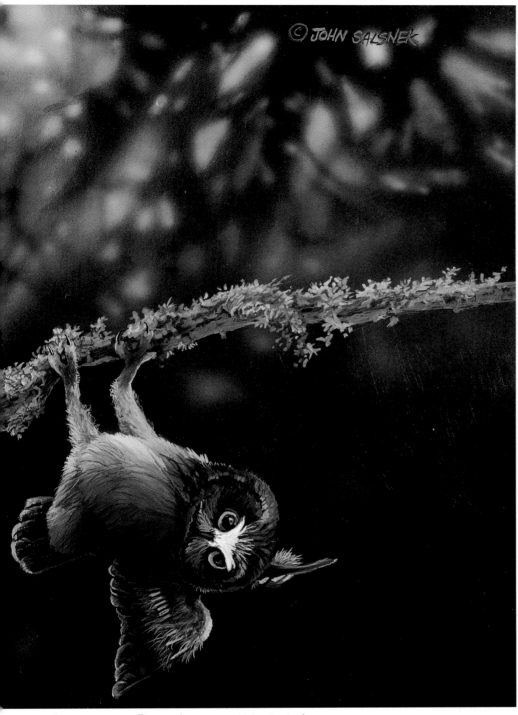

LEARNING THE ROPES (SAW-WHET OWL FAMILY)
acrylic and gouache, 10" x 20" (25cm x 51cm)

6

ENLIST EMOTION WITH A

PLEASING POSE

JOHN M. SALSNEK

CATCH IMMATURE BIRDS AT PLAY

This painting reflects a mental image from childhood when we used to crawl among the branches of trees where the light was almost completely filtered out. Only small specks of outside brightness gave any illumination, resulting in a sort of sanctuary—cozy, yet somehow eerie. This is saw-whet owl country. This image is a common one in nature. The miniature owls frequently lose their balance and end up hanging by their legs or falling to a lower branch.

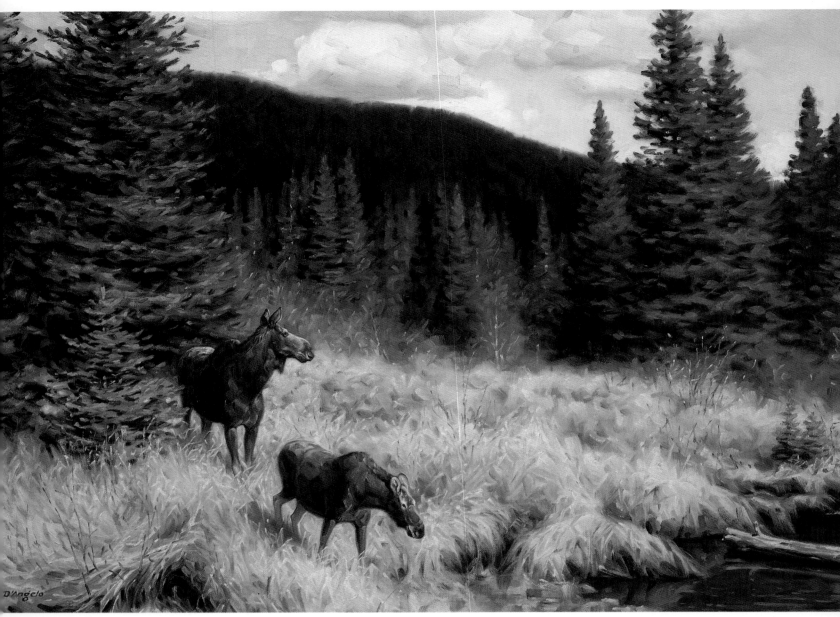

A Fine Spring Day—Moose
oil on linen, 18" x 26" (46cm x 66cm)

CLAUDIO D'ANGELO

ENJOYING A SPRING DAY

One of my most important goals is a successful marriage of landscape and animal subject. Ambient light that is direct or reflected from the surrounding landscape elements affects the nuances of the animals' color in that landscape. For example, reflected light from the tall dry grasses casts a warm glow on the belly and flanks of the moose. To achieve a unified effect I also try to paint all the elements more or less simultaneously. I let the wet paint meld to various degrees at the edges of all the elements. In this case the landscape initially peaked my interest, and having often observed cow moose and their yearling in spring, I opted for this as the focal point. I portrayed them in a period prior to heavy molting when they take on a particularly shabby appearance. Soon this yearling moose will be forced by its mother to strike out on its own. But for now with the warm sun and mild breezes in the air, this calf continues to benefit from its mother's watchful eye.

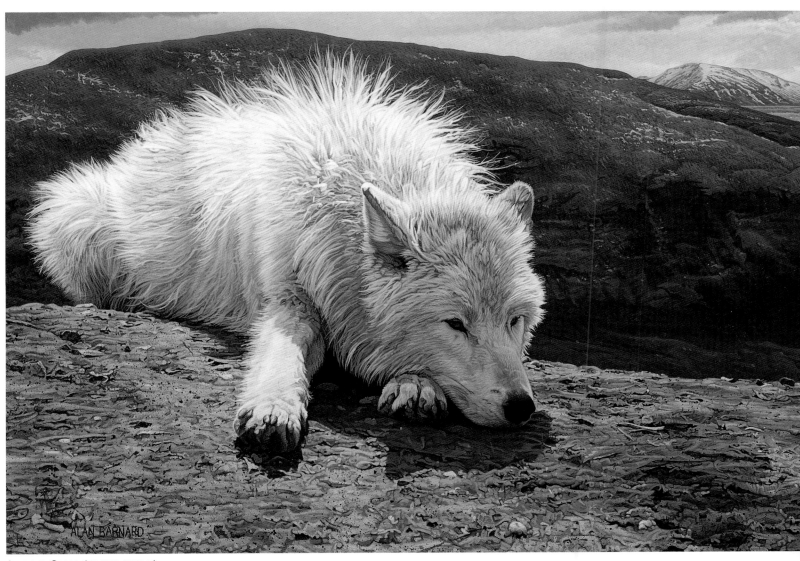

ARCTIC CALM (WHITE WOLF)
egg tempera on board, 8" x 12" (20cm x 30cm)

ALAN BARNARD

PORTRAY A WOLF IN A LESS "NOBLE" POSTURE

I have wanted to paint an arctic wolf for some time, but not a cliché of the noble wolf standing aloof, surveying its domain. Instead I wanted a more intimate portrait. This pose emphasizes the wolf's close kinship to the dog, while the landscape reminds us of how different their lifestyles are. At first I depicted the wolf asleep, but the piece seemed too calm. I then repainted the wolf's head, showing the eyes partly open to create a bit of tension. Egg tempera has a unique look which is subtle, flat and earthy. I purposely chose this medium to depict the terrain of northern Canada because it captures the flat dryness of the North perfectly. Since egg tempera does not require varnish, there is no gloss or sheen to affect the painting's matte finish.

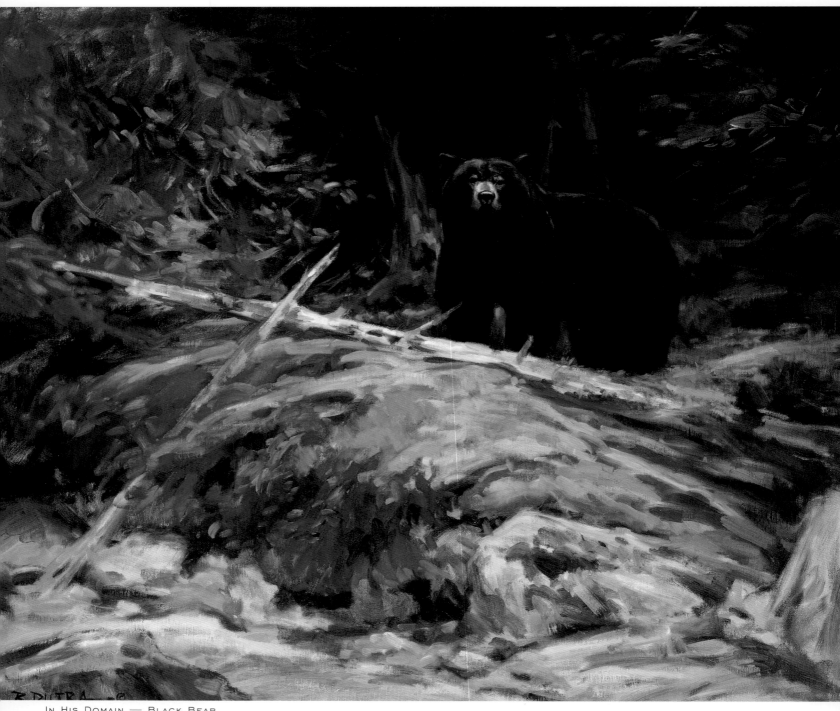

In His Domain — Black Bear
oil on Belgian linen, 24" x 30" (61cm x 76cm)

RANDAL M. DUTRA

MAKE THE SUBJECT MELT INTO ITS ENVIRONMENT

Part of an animal's mystique is its innate ability to become one with the environment. The black bruin can melt into forest shadows at will; only a tan muzzle betrays his presence. Bears can be extremely curious about their surroundings. While touring his domain, something has piqued this black bear's interest. I am from the school of the broad-but-accurate stroke. Suggestion, in the arts, is more powerful to me than delineation. To hold a little something in reserve somehow seems more fulfilling. I also pay careful attention to lost and found edges; it helps create mystery and interest in a work, as do carefully placed objects emerging from darkness.

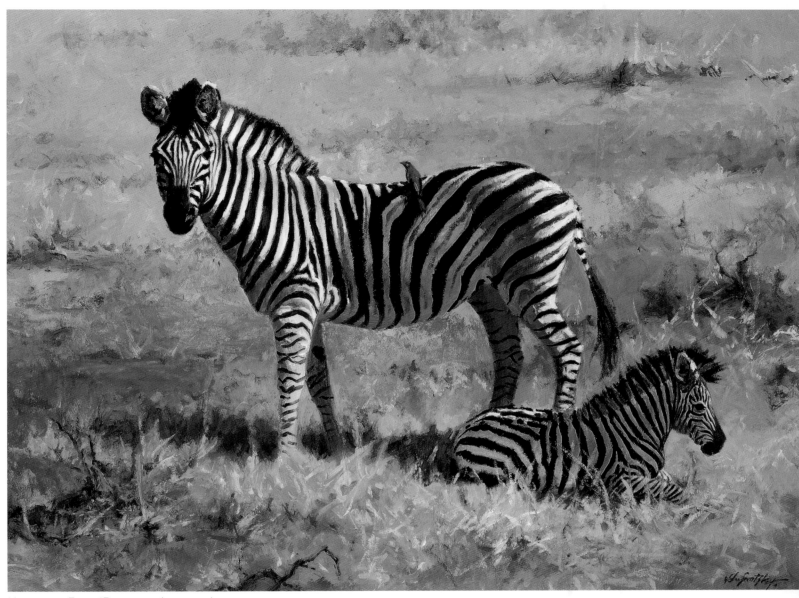

MARE AND FOAL (BURCHELL'S ZEBRA)
oil, 22" x 30" (56cm x 76cm)

JOHN SWATSLEY

SHOW THE LINK BETWEEN MOTHER AND OFFSPRING

An animal mother's concern for, and protection of, her young is an accepted fact of nature. However, on the African savannas it is absolutely essential. Frequently preyed upon by lions, hyenas and wild dogs, the zebra mare's vigilance and keen eyesight provide an early warning system for her foal. This piece shows the sensitive link between the two while hinting at the underlying tension that is felt in the African wilds. This pair was originally observed in Zimbabwe in semi-open woodland of Mopane scrub. It was a pleasant scene, but I felt that the solitude and vulnerability of their situation would be better shown by placing them in an open setting. To direct the viewer's attention to the pair without distractions, I went to a simple background of soft-focus bands of grass and bare ground. Horizontal shapes project a calm mood in any composition. The circle of grass tufts in the background helps to move the eye around the painting and back to the figures.

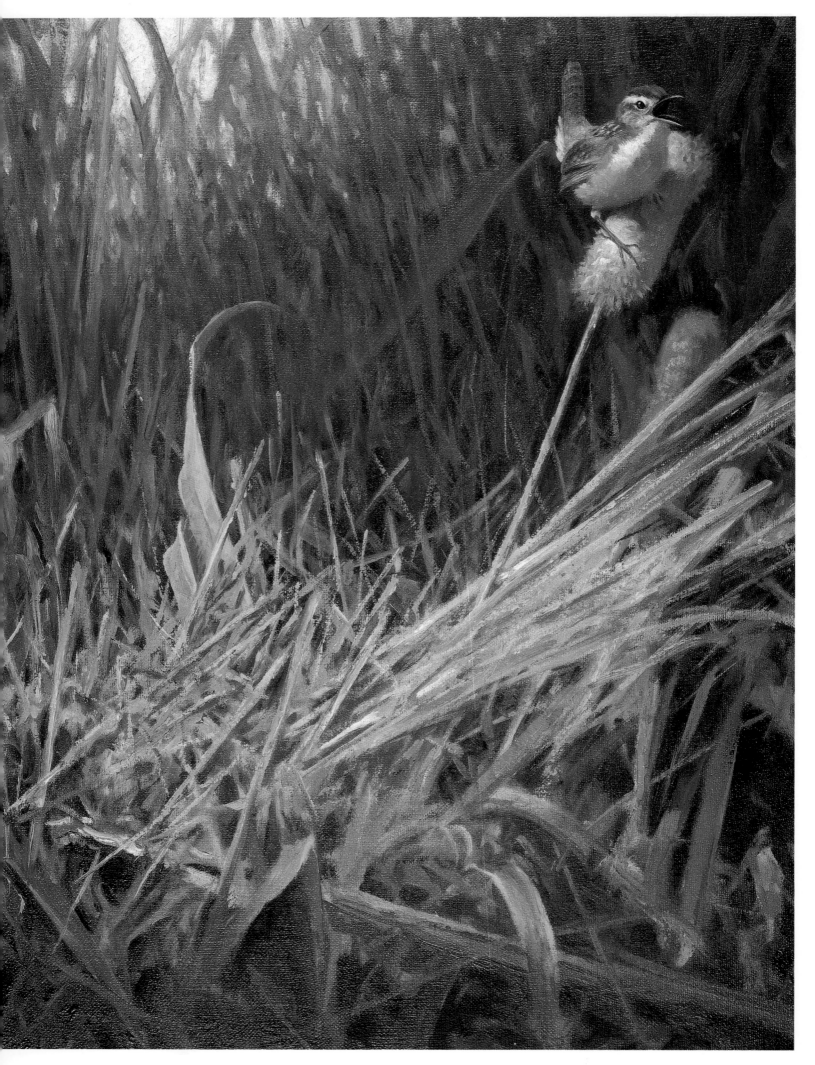

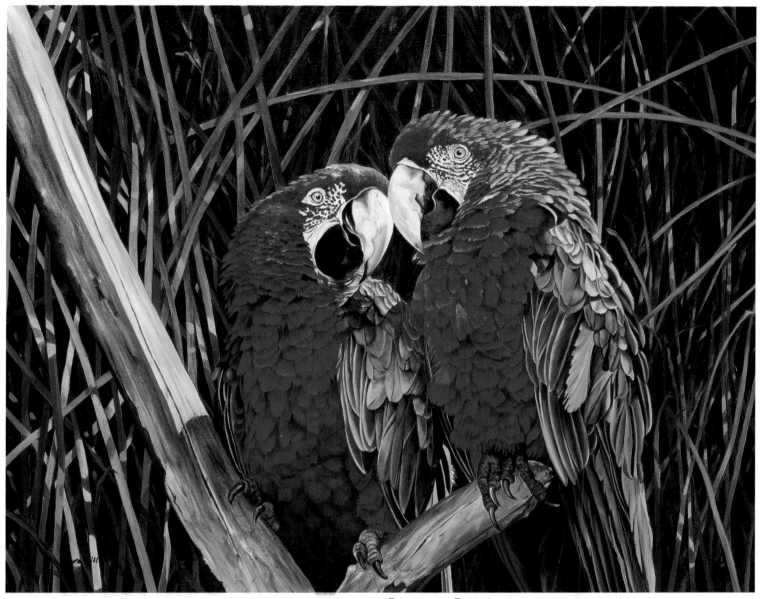

Rollo and Ruby (red and green macaw)
oil on canvas, 24" x 30" (61cm x 76cm)

DWAYNE HARTY

TYPICAL BEHAVIOR SPARKS WARM FAMILIARITY

In my youth the prairie marshes were a frequent after-school retreat. Spring was my favorite time to explore amongst the cattails and reeds. I'll never forget seeing my first marsh wrens and watching their hide-and-seek antics. They would disappear down into the tangle of roots and stalks only to reappear further away atop a cattail, announcing their new location with a bubbly chatter, as if wound up like a toy. It was there that I discovered groups of their false nests and was finally rewarded with a nest of the most gorgeous sienna brown, speckled eggs. I returned many times to watch these charming characters nesting in colonies along the water's edge. *Long-Billed Marsh Wren* is simply a portrait of typical wren behavior. The entrance hole to the nest is well concealed and in this painting appears only as a dark accent in the lower left-hand corner. The male, tail cocked and "rattling," balances the busyness of the nest by being strongly lit against a more simplified background.

LONG-BILLED MARSH WREN AT NEST
oil on linen, 20" x 16" (51cm x 41cm)

LAURA GILLILAND

RELATE SUBJECTS TO ONE ANOTHER

I spend countless, quiet hours observing my models, photographing their behavior. I feel I must know the moments which precede and follow the one I wish to capture on canvas so I may create a three-dimensional story that conveys a beginning, middle and end, but in two dimensions. I begin by transferring to my canvas the images I've chosen to paint from the photos I've taken—sometimes combining landscapes, models and other details. I first paint my subject's eyes. As with human beings, the eyes are the portals into the soul and in placing that eye on canvas, my painting takes on "soul." My model, in essence, watches over and leads me through its own creation. This technique is what allowed me to offer the viewer a glimpse of Rollo and Ruby greeting one another with ineffable delight, sharing this tender, ephemeral moment.

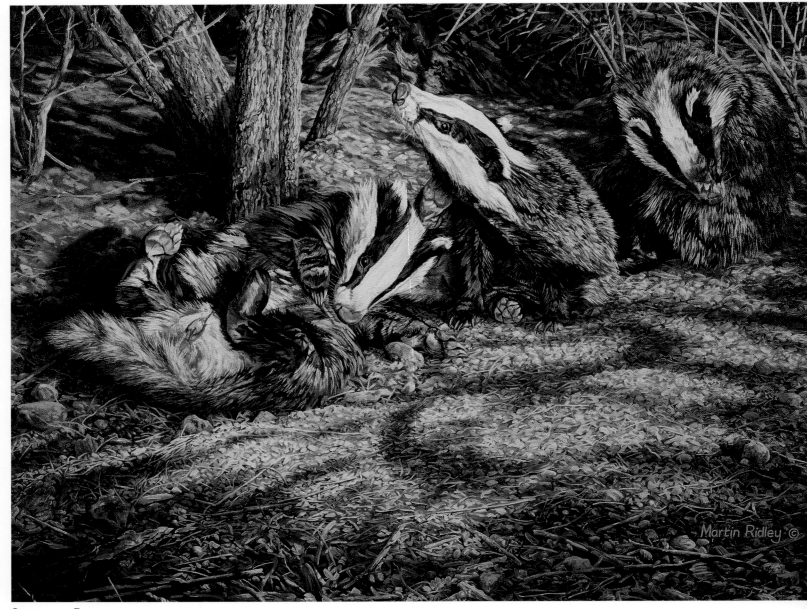

GROOMING BADGERS
oil on canvas, 20" x 24" (51cm x 61cm)

MARTIN RIDLEY

GET TO KNOW YOUR SUBJECT TO UNDERSTAND TYPICAL BEHAVIOR

Badgers are a species which I have studied closely for the last ten years. In the process of letting this family group adjust to my presence, I came to regard these three young badgers as outdoor companions. They would come running to a humming noise I made, then allow me to follow them around the woods, watching their antics and relaxed behavior. I learned that badgers will not emerge and settle to grooming until they have checked for danger. However, if they hear another badger grooming they tend to conclude that the checking has already been done and are less wary. I soon realized that by simulating this scratching sound, the badgers would relax and set about grooming. I work primarily in oils, the medium I feel is most versatile for experimenting with color. In this painting I have used a very warm pigment for the earth, resulting from my nocturnal observations using a red flashlight. I rubbed in a ground of pale Venetian Red which I then worked into. This base color influences the whole painting.

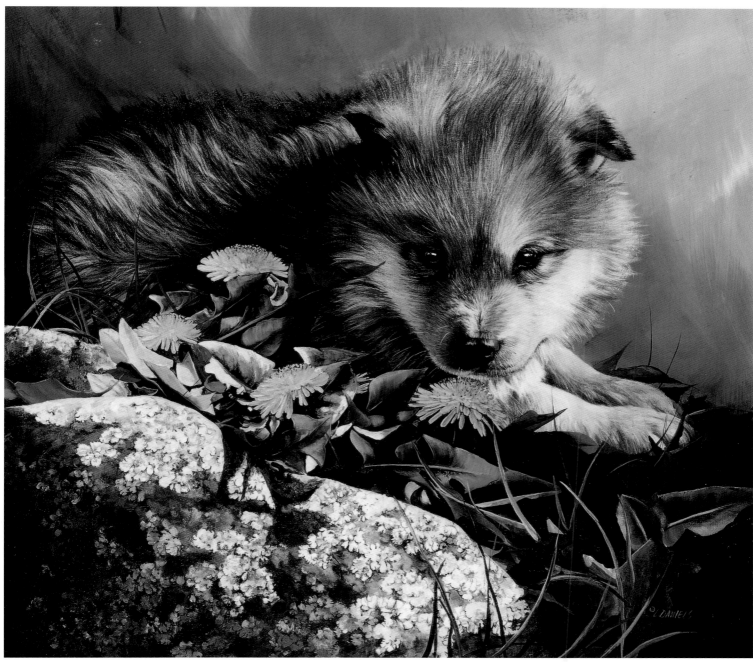

DANDELION — WOLF PUP
acrylic on watercolor board, 14" x 16" (36cm x 41cm)

LINDA DANIELS

SHOW A YOUNG ANIMAL'S CHARACTER

I had the opportunity to study a litter of wolf pups on their first day away from the den. Like any children they were fearful of the new world, although Mom was only a short distance away. This particular pup was a little bolder than the rest, cautious but very curious. I wanted to show his bravery while still maintaining his innocence and chose to place him half hiding behind a wildflower that we all know so well we can determine the pup's size in relation to it. The pup's detailed surface fur is created with altered round brushes of different sizes—the ferrules are crimped with pliers causing the hairs to fan out, then clipped with a small scissors to make an irregular edge. This makes a round fan brush which creates random hairs of various textures depending upon how wet or dry the paint is.

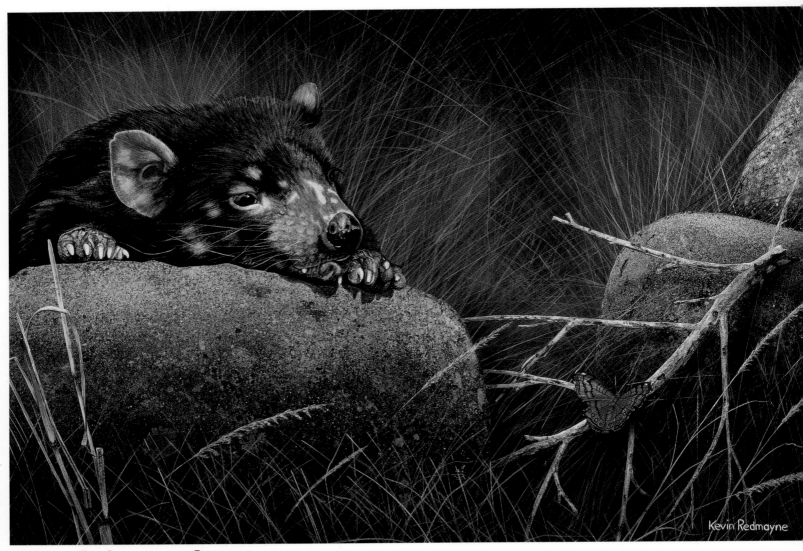

INTRIGUE — THE DEVIL AND THE BUTTERFLY
(AUSTRALIAN TASMANIAN DEVIL)
mixed media, 14" x 21" (36cm x 53cm)

KEVIN REDMAYNE

CREATE BEAUTY BY ASSOCIATION

More than once I've heard wildlife artists say, "I paint what I want."
Well, so do I. Simultaneously however, I want to be painting what
someone else wants, and I try to accommodate this in the initial
planning. The above came to mind when I thought of my
Tasmanian devil painting. Probably because of its bad public percep-
tion it was a neglected creature artistically, but one I very much
wanted to paint. As I was consciously aware that the public was gen-
erally intolerant of their own perception of the devil, I proceeded
with my equally valid vision—the devil in repose. I wanted to appeal
to its gentler side and accentuate its docility. After a struggle, I made
a drawing with which I was satisfied. To broaden the appeal of the
painting and create an affection for this animal, I thought to try
beauty by association, and the idea of the butterfly dawned.
Suddenly all my components seemed to come together and I was
able to put the devil to rest.

KATHLEEN E. DUNN

CATCH BIRDS IN UNLIKELY POSES

When looking for or stashing food, a nuthatch assumes incredible poses, as if gravity is suspended while he stores a seed behind a paint chip on our old, witchy shed door. Incredibly active, his masked face makes "Hatch" the perfectly costumed sprite for October 31st. I experimented a lot with this painting: scratching paint chip outlines into the partially dry blue-gray sponge coat, applying texture with crumpled tissue, blending and softening the wood grains with cotton swabs soaked in turpentine. Finally, after outlining each chip in white, I used glaze to quiet everything down.

OCTOBER 31ST
(RED-BREASTED NUTHATCH)
oil on board, 33½" x 20½"
(85cm x 52cm)

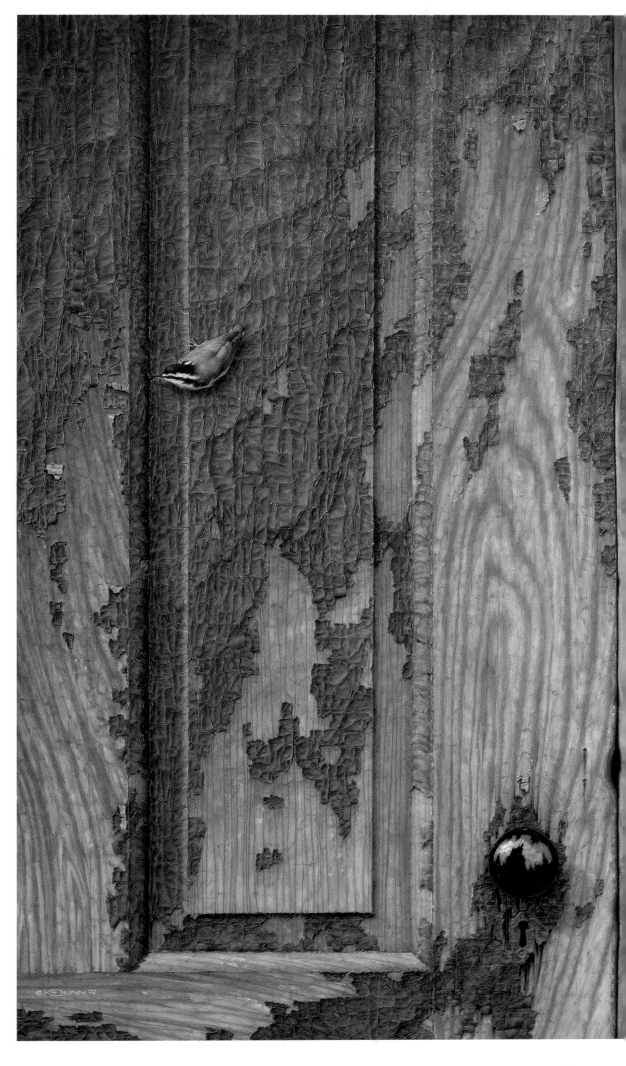

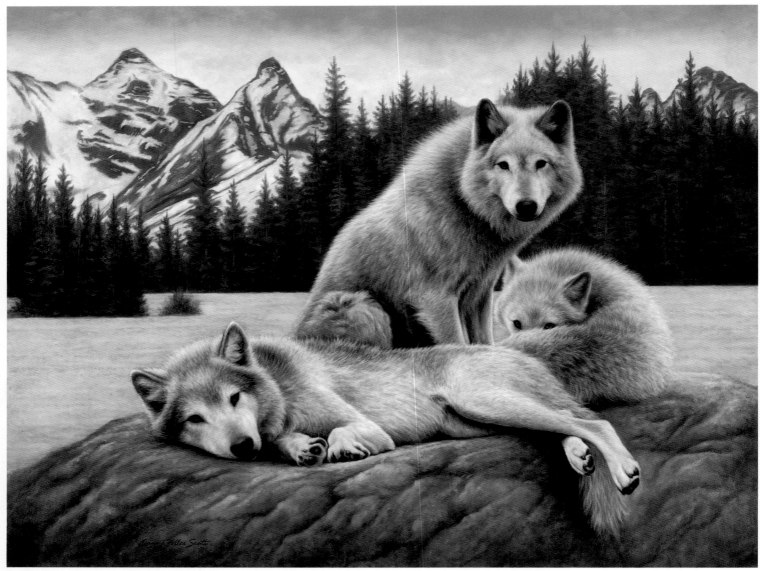

Mack and the Boys (timber wolves)
oil on canvas, 33" x 44" (84cm x 112cm)

JEANNE FILLER SCOTT

OBSERVE INTERACTION AMONG YOUR SUBJECTS

This painting was inspired by several trips to a wolf behavioral study park run by Purdue University, where a pack of wolves allowed me to move near and study them. I spent many hours sketching, photographing and watching the pack. The comfortable camaraderie between three of the wolves attracted my attention, and I eventually painted them in a Canadian Rockies landscape derived from color sketches I had done a few years before in Alberta, Canada. The title comes from the James Steinbeck novel, *Cannery Row*, and was the nickname for a group of loafers who hung around together, lived off the land, and avoided unnecessary activity. That description fit the three wolves. I enjoy portraying animals in their everyday lives, doing what comes naturally to them. I paint in oils, in an Old Masters technique in which I create a detailed underpainting using only black, white and shades of gray. When this is dry, I apply many transparent colored glazes, one layer at a time. When the glazes are thoroughly dry, shadows and highlights are reestablished, and impasto added as a finishing touch. The varied depths of color, in which the underpainting is seen beneath many layers of transparent glaze, achieves a unique, lifelike quality.

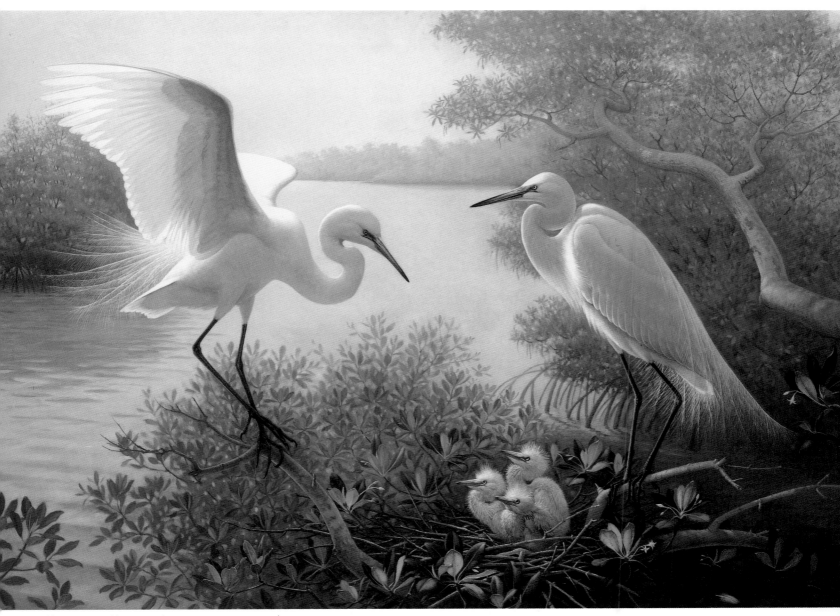

Mangrove Miracle (great egret family)
oil, 38" x 56" (97cm x 142cm)

DIANE PIERCE

CAPTURE FEEDING-TIME ACTIVITY

After a half-century of pursuing, observing and raising birds, and thirty-five years of painting avian species, I still place them at the top of my admittedly long list of favorite things. Life without birds would be very sad. Their grace and beauty, character, ability to fly, their individual lives, the places they dwell in and around, all fire the imagination. I love to paint light effects, though it is frustrating to try to capture sunlight which is a thousand times more intense than the whitest canvas! One learns to "lie to tell the truth," employing Impressionist techniques to bring the sun to the canvas. It is difficult to separate my love of birds from my fascination for light. They are one and the same to me.

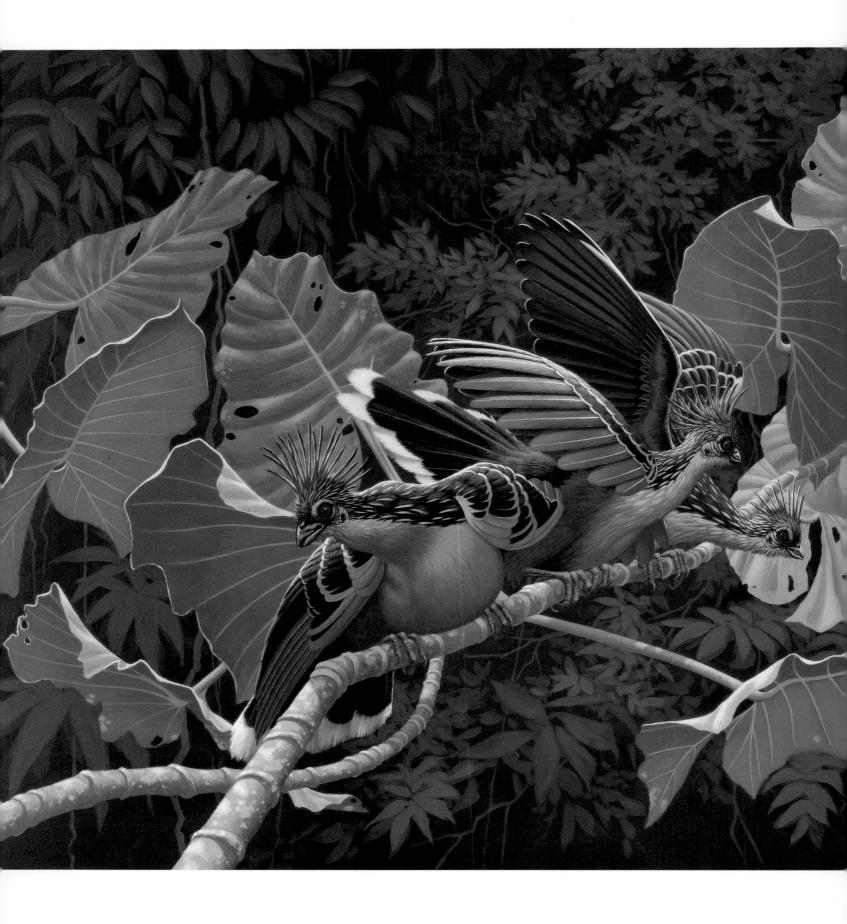

CAPTURE AN ANIMAL'S

CHARACTER

RICHARD SLOAN

LOONEY-LOOKING BIRDS CALL FOR CHAOTIC FEEL

Hoatzins are an ancient species of bird. They live in the Amazon Rain Forest, in colonies from six to as many as thirty individuals, and exist on a diet of leaves exclusively. With their pheasant-size bodies seeming to be in constant motion, they raise and lower wings and tails in cadence with their rasping, wheezing call. Red eyes and a permanently erect crest give them a sort of crazed appearance. The challenge with this painting was to convey a sense of animation and capture the character of these looney-looking critters! By using a lot of tension points in carefully overlapping the birds and then the leaves of one of their favorite food plants, Montrachardia, I've created a chaotic feeling throughout the composition. Nothing static here!

THE WILD BUNCH (HOATZINS)
acrylic, 20½" x 32½" (52cm x 82.5cm)

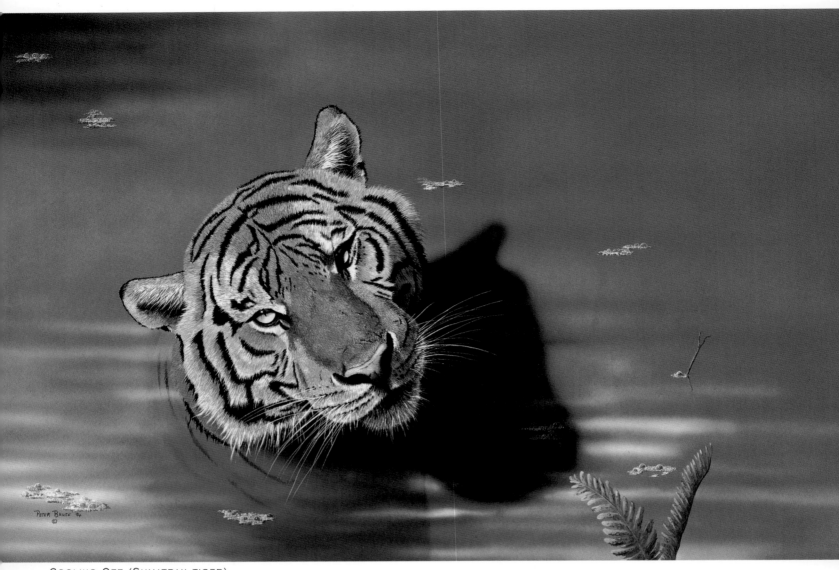

Cooling Off (Sumatran tiger)
gouache, 20" x 32" (51cm x 81cm)

PETER BRUCE

CATCH A DISTINCTIVE PASTIME OF YOUR SUBJECT

I am fascinated by the fact that tigers feel at home in the water and can often be found lying in a pool during the heat of the day to cool off. Coming from Africa, I am familiar with our big cats which usually only get wet when absolutely necessary, as during a chase, but do not seek out water like tigers do. I tried to capture the look of contentment that the tiger was obviously feeling. The simplicity of the background helps bring out the main theme. I currently work mainly with pastel and gouache, sometimes on their own and sometimes as a mixed media. Both mediums are of an opaque nature and combine well together. In this painting I chose to use gouache only with the use of an airbrush to obtain the water effects and shadow. For the tiger, I first blocked in the basic color and then brought out the detail with a fine brush. The tiger is the largest, and to me the most magnificent, of all the cats. It is so sad to know its numbers are declining and even within our lifetime they could become extinct in the wild.

HANGING ON (RED-EYED TREE FROG)
batik on cotton with acrylic overpaint, 10" x 14" (25cm x 36cm)

BETH ERLUND

DEPICT A CONFRONTATIONAL POSTURE

I may dye my pieces thirty to fifty times to achieve all the colors needed for my level of detail. A no. 1 tjanting is my favorite tool, but I occasionally use brushes to achieve special effects. I work from light to dark, overdyeing each color. Planning in every stage is essential. A direct, confrontational, head-on pose can often make a piece stand out. When depicting a predator, it can be used to add a threatening feeling. In the case of this little red-eyed tree frog, I wanted to convey the feeling of surprise, as if the viewer had just invaded the frog's world and he is as curious about you as you are about him. Positioning him in an erect posture gives him a feeling of confidence that adds to his confrontational demeanor. As in most close-up animal portraiture, the nature of the eyes is going to give the animal its character. Because this frog has extremely vivid red eyes adjacent to a bright green body, there is an extra color advantage to making a powerful statement. Special attention was paid to shading the eye itself since this was such a predominant feature, necessary to making this frog come alive. The creamy color of the spathe flower was intentionally positioned to increase the contrast between the focal point and the background.

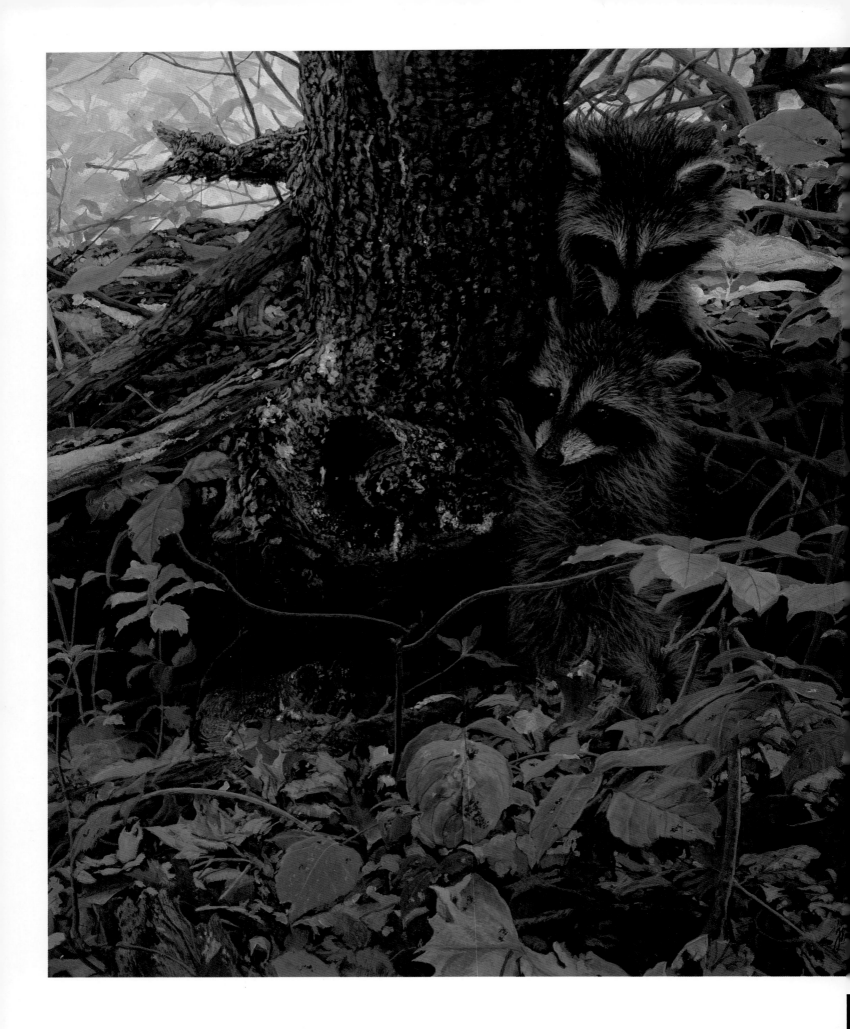

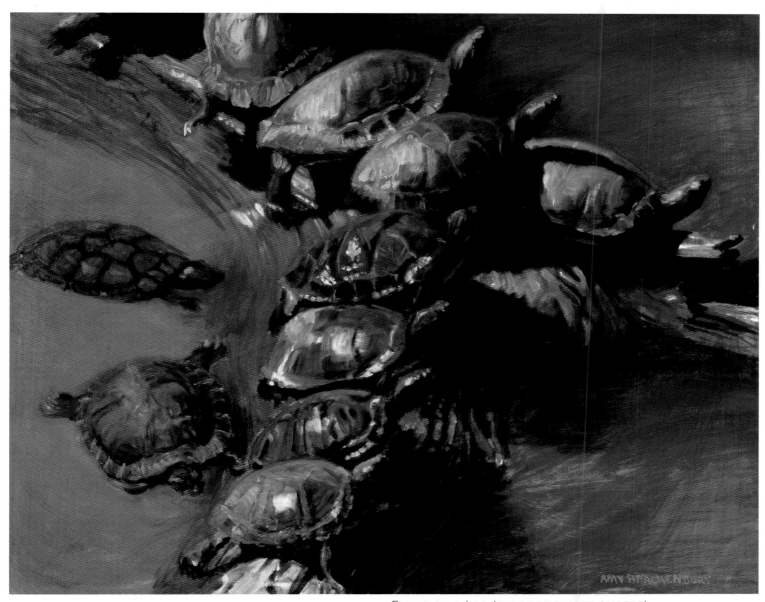

BUMPS ON A LOG (BABY RED-EARRED SLIDERS)
oil, 17½" x 19" (44.5cm x 48cm)

AMY BRACKENBURY

LET YOUR CHILDHOOD MEMORIES INSPIRE YOU

Every piece of art must capture the viewer and hold his attention. Something must be happening in the art. Here some turtles are swimming, some ready to jump in, some stretching their necks and wondering if they should take a dip. The three secondary colors (orange, purple and green) make up the unusual color scheme. Painting green over the orange underpainting gives the water a luminosity, creating the feeling that the water is filled with sunlight. These turtles were a favorite pet when I was little. I could spend hours watching and playing with them, so painting them is like offering a silent prayer of love.

JOHN P. MULLANE

TO KNOW AN ANIMAL, KNOW ITS HABITAT

Before I paint any animal, I like to study it as much as possible, preferably in its natural environment. Part of conveying an animal's character is knowing its habitat. I took care of this raccoon after it had been struck by a car, so I had ample time to study and photograph it. I wanted to portray the playful aspect of raccoons by putting one in a sitting position. I use acrylics, which enable me to paint a lot of detail because of their quick drying time. I block in the whole board loosely and finish one section at a time, starting with the background first. I build up layers from dark to light, and light to dark, refining and glazing until I am satisfied with the background. At the very end I add the animal.

THREE'S A CROWD (RACCOON)
acrylic, 14½" x 12¼" (37cm x 30.8cm)

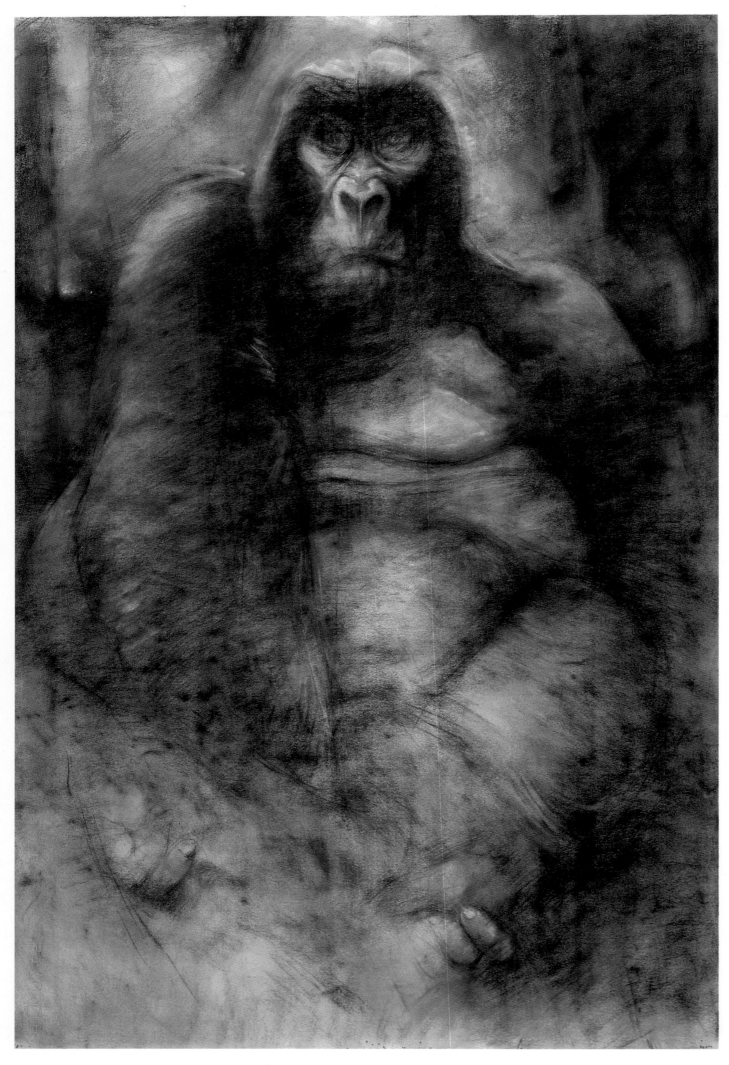

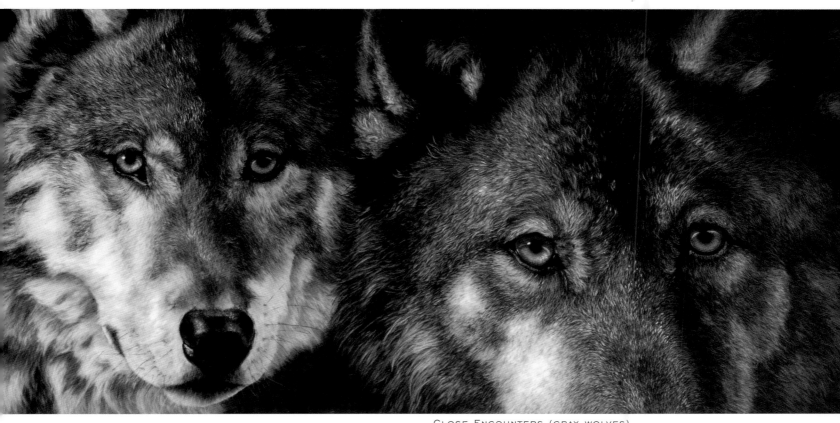

CLOSE ENCOUNTERS (GRAY WOLVES)
soft pastel on suede mat board, 13" x 28" (33cm x 71cm)

JUDI RIDEOUT

CENTER ON THE EYES TO TOUCH THE VIEWER'S SOUL

In *Close Encounters* I wanted the viewer to feel affinity with the wolves. The design is centered on the eyes to bring viewers in as close as possible, but leave them with a desire to see more of the animals. After a very detailed drawing, the design is transferred to the mat board. The painting is blocked in with Gold Ochre, setting the tone for the entire painting. The dark background is completed, then the wolves begin to take shape—I layer the pastel creating the fur one hair on top of the other just as real fur lies. At the stage when I put in the eyes, the painting begins to "talk" to me. The eyes of the wolves are the soul and the spirit of the animal. They have full control of the painting, and when I am satisfied with them, the painting is complete.

BOB ZIERING

USE A BOLD APPROACH TO EXPRESS ENDANGERMENT

This image is one of a large body of work dealing with the endangerment of the mountain gorilla. This species has been decimated by a mankind that has the ability to save or destroy it. The painting is in pastel, which gave me the opportunity to express both in line and in color some of the feelings of regality, strength and beauty, as well as loss, danger, brutality and devastation—all part of this story. This particular "patriarch" suggests the bold leader, full of strength and wisdom—and perhaps an awareness of the dangers ahead.

PATRIARCH (MOUNTAIN GORILLA)
pastel, 22" x 44" (56cm x 112cm)

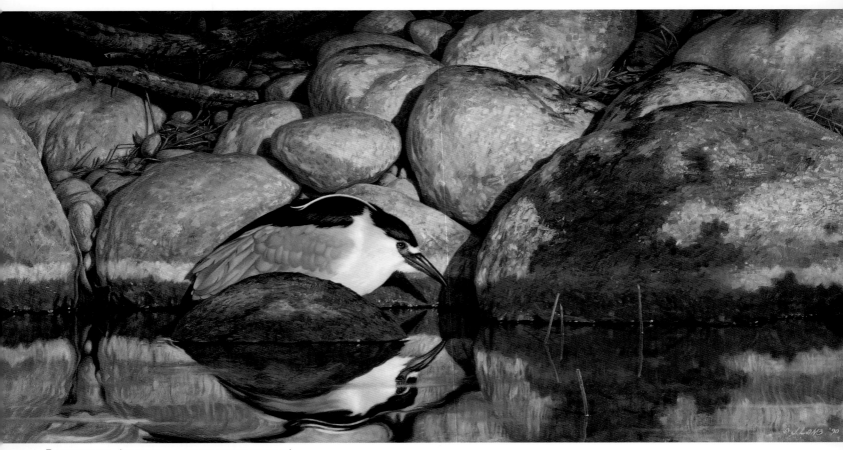

REPETITIONS (BLACK-CROWNED NIGHT HERON)
oil on panel, 15" x 30" (38cm x 76cm)

JIM LAMB

CHOOSE A TELLING POSE TO SHOW CHARACTER

Herons have the ability, while fishing, to become almost stone-like.
They can stand for long periods of time without the slightest move-
ment. Sometimes this ability can make them almost imperceptible in
nature, until they are spooked and decide to fly to a safer location.
Repetitions is named because of the strong design repetitions apparent
in the image. I was struck by the amazing number of rounded shapes
which repeated themselves, and the heron's hunched mimicking of
the rock shapes. The smooth surface and cool color of the heron cre-
ate a very pleasing contrast to the roughness and warm surface of the
rocks. *Repetitions* was painted with oil on a gessoed panel. Thin
washes of dark tones were applied first to establish the overall pattern
and design of the piece. It was my purpose to portray the quiet
predatory nature of the bird within an environment that accentuates
its ability to cleverly blend in with its surroundings. A limited palette,
with only subtle variations in color temperatures, helped to commu-
nicate the character of the bird and establish an overall color harmony.
The textural qualities of the image and the surface of the painting
were accomplished using a combination of acrylic and bristle brush-
es, with an occasional touch of the palette knife when needed.

FOREST BONGO (BONGO ANTELOPE)
acrylic, 13" x 18" (33cm x 46cm)

JOSEPH VANCE, JR.

DEPICT A WARY ANIMAL IN AN ALERT POSTURE

Although I have seen a bongo only once in the wild, the striking colors and markings of this impressive African antelope have kept the thought of painting one in my mind for several years. The bongo is a deep forest dweller and is very rarely sighted, and then usually only as a flash of red and white in the shadows among the trees. However, because I wanted to use reflected light to bring out the deep chestnut color and white stripes of this male, I have depicted him sitting on the bank of a muddy forest stream. The bongo is a very wary animal so I painted him with his head up and his ears out so that he appears alert even though he is resting. Keeping the dark forest close to the animal and giving him a cautious posture enabled me to maintain the bongo's secretive, wary nature and yet have him resting in the light where I wanted him. To get the sheen of reflected light from the chestnut and black coat, I used glazes of ochre, white mixed with Ultramarine Blue, gray and white respectively. Because acrylic paint can be worked quite transparently, I find that glazing is a particularly effective method for indicating light and shadow on the underlying anatomic features of animals with short-hair coats.

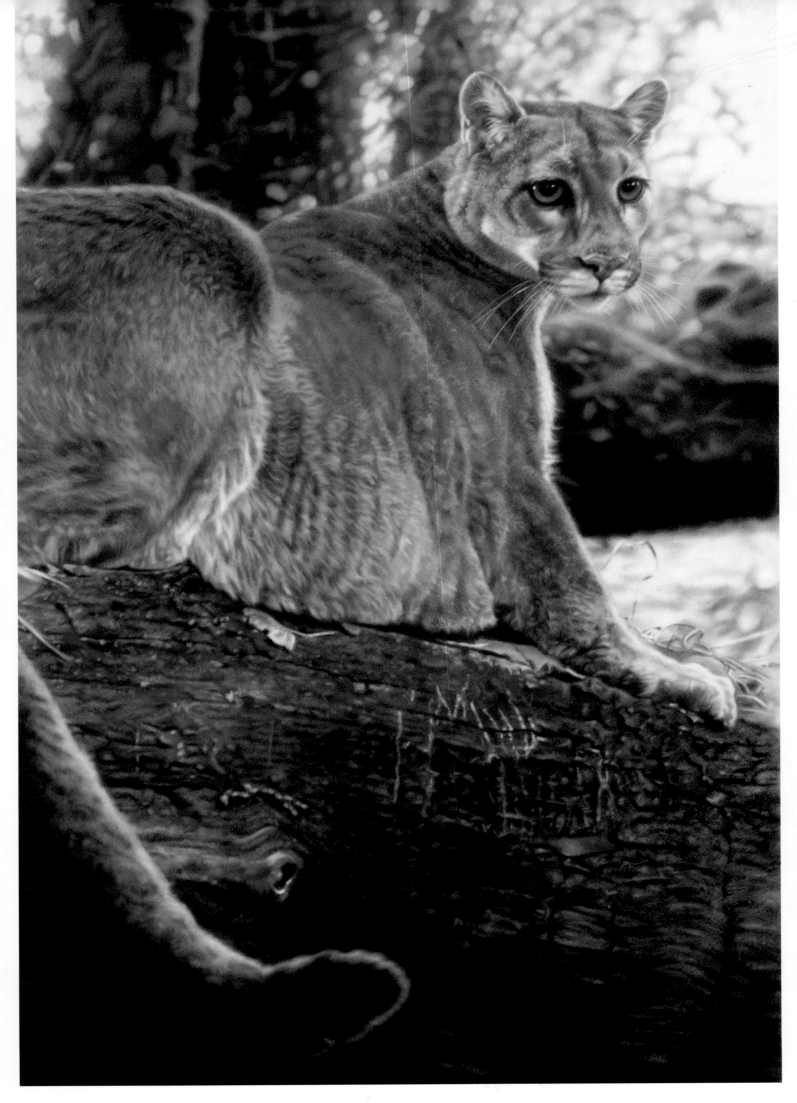

MASTERS OF THE HUNT (LION AND BUFFALO)
oil on canvas, 26½" x 47" (67½cm x 119cm)

CRAIG BONE

PORTRAY EACH SPECIES AS
TRUTHFULLY AS POSSIBLE

It is not common for the larger male lions to hunt prey; rather it is the sleeker, more agile lionesses who do the hunting and the male arrives afterward to join in the feast. Male lions defend their territory from other roaming male lions and keep the area safe for the young cubs and breeding females. A buffalo cow herd can number anywhere from twenty to five hundred. The buffalo bulls tend to roam on their own or in small all-male groups, moving randomly in and out of breeding herds. As an artist, I do everything in my power to make sure that my images reflect the animals and their environment exactly as I see them. It is my privilege to have been born and raised in a country where I have the freedom to explore the wilderness at will.

LESLEY HARRISON

REVEAL THE INDIVIDUAL PERSONALITY
OF YOUR SUBJECT

I am a pastel artist and I work mostly on velour paper. I choose velour because I feel it enhances the softness and reality of fur, feathers, eyes and other textures. I lay down layers of pastel to get the feeling of depth and muscles. Then I use harder, sharpened pastels to put the fine detail of hair or whiskers on the animal, or scars on an old log. Capturing an animal's personality is one of the main reasons I paint. I am so intrigued with the different personalities that I not only pursue visually appealing subjects, but also an animal I feel a connection with. This mountain lion is one I have painted many times. Not only was she gorgeous, but she would purr when I petted her, and we could turn her loose to "model" for me with no rope or leash—she would always come back when I was finished!

WOODLAND ROYALTY (MOUNTAIN LION)
pastel, 25" x 17" (64cm x 43cm)

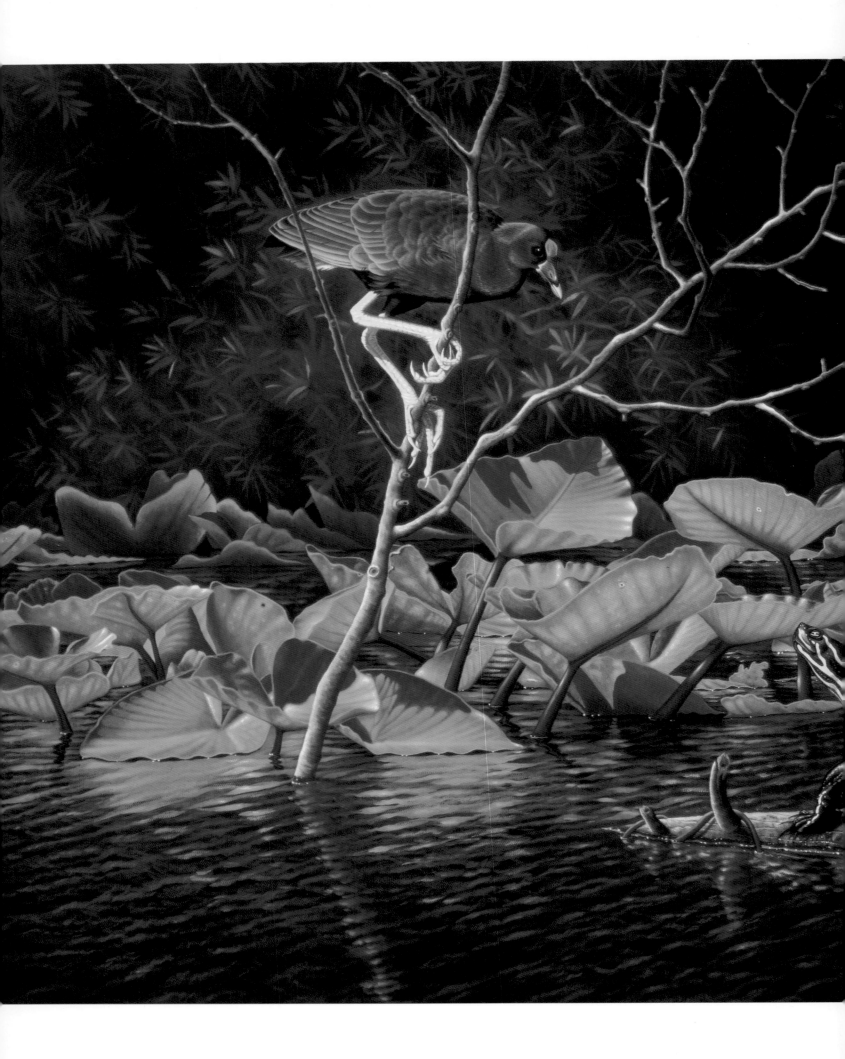

HOLD THE VIEWER WITH

TENSION

DEE SMITH

EYE CONTACT SETS UP A
"MEXICAN STAND-OFF"

Purple gallinules are exquisitely colored wading birds whose plumage looks as if it is made up of iridescent jewels. These birds walk easily on top of the lily pads and with their huge, yellow feet they turn up the edges looking for insects under the leaves. Neither subject in this painting likes to share his domain with other species. Tension is created between the purple gallinule, who most likely has been searching for insects among the lily pads, and the turtle, still wet, who is trying to warm himself on the log. Both are staring at each other as if in a "Mexican stand-off," trying to intimidate the other into vacating the area. I wanted to emphasize the hard, wet and reflective carapace of the turtle, showing how the apex of the shell reflects the blue of the sky while the sunlight glistens off the edges. I also wanted to show how some of the lily pads filter the sun making them yellow-green, while the ones that lay flat reflect some of the sky off their shiny leaves.

CLOSE ENCOUNTER (PURPLE GALLINULE AND TURTLE)
oil on canvas, 24" x 36" (61cm x 91cm)

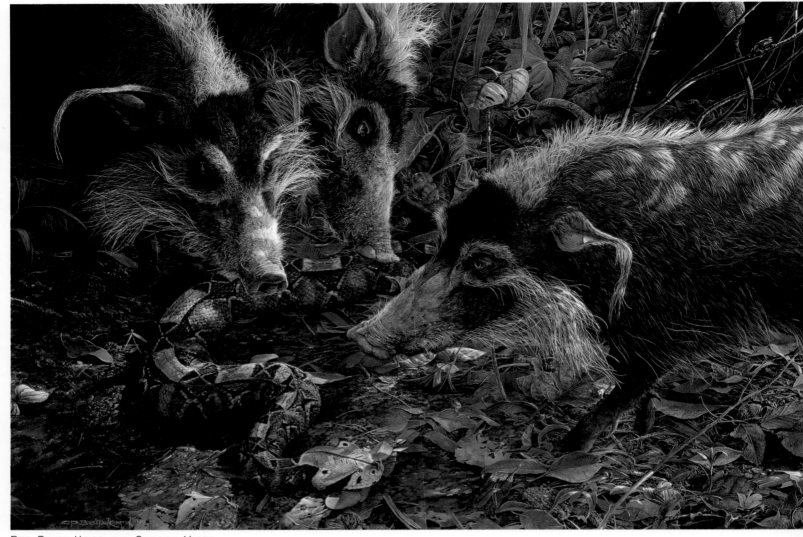

RED RIVER HOGS AND GABOON VIPER
acrylic on illustration board, 20" x 30" (51cm x 76cm)

CAREL PIETER
BREST VAN KEMPEN

A POSE CAN CREATE FRANTIC AMBIVALENCE

Three bushpigs confront a large snake on a west African forest floor. Although capable of inflicting a lethal bite, the phlegmatic, mild mannered gaboon viper is the likely dark horse in this standoff. Of the three pigs, direct sunlight illuminates the bright red coat of but one, begging the viewer's attention. This individual is drawn with its weight on an extended forefoot, making him appear to move forward and backward simultaneously. The angles created by the vines and roots behind him as well as the sloping snouts of his cohorts heighten this effect, giving him a look of frantic ambivalence—at one moment ready to lunge ahead, the next poised to retreat. I enjoy peppering my paintings with superfluous animal subjects that might occur in the particular habitat portrayed. In this painting I went a little crazy—around thirty creatures inhabit the piece.

CAREL PIETER
BREST VAN KEMPEN

SUGGEST MOTIVATION WHILE BUILDING TENSION

My object with this piece was to build a literal tension between the protagonists while imparting motivation to them. The monitor's struggle against the tugging monkey cancels his own simultaneous effort to swing around and face his tormentor, creating a static tension emphasized by the lizard's fingers scraping through the sand. The baboon's air is much more placid: curious but apprehensive. Her cocked head and pigeon-toed stance confirm this. The line describing the tension runs from the curved lizard, through the straight line of tail and arm, ending up in the monkey's kinked tail, which in turn is echoed in the shapes of the acacia suckers behind her.

GRIPPING TAIL (YELLOW BABOON AND WHITE-THROATED MONITOR)
acrylic on illustration board, 30" x 20" (76cm x 51cm)

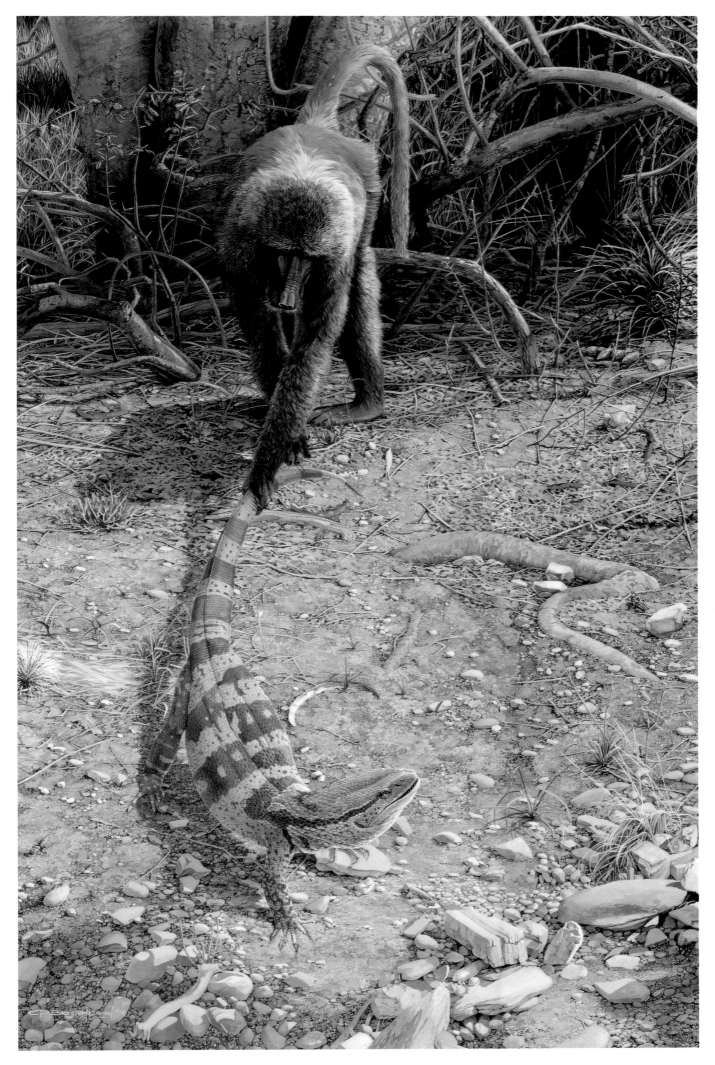

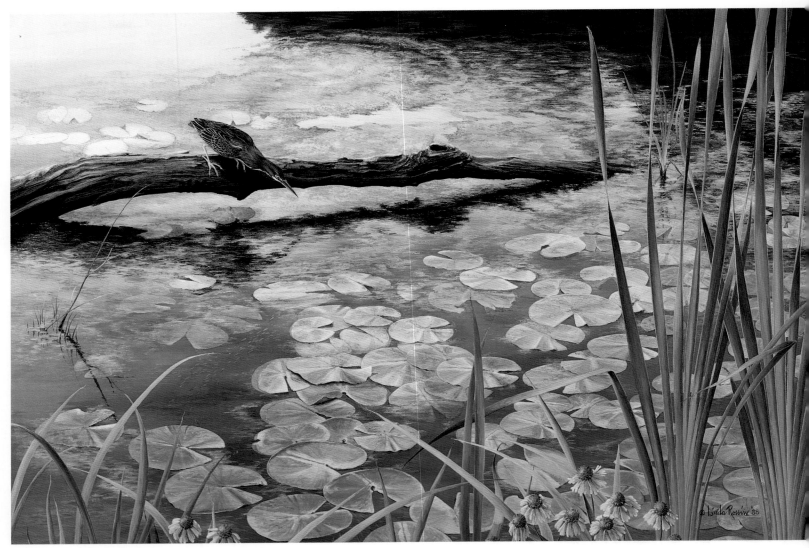

SUMMER'S LAST DAYS (GREEN-BACKED HERON)
acrylic on composition board, 21" x 32" (53cm x 81cm)

LINDA ROSSIN

DEPICT INTENSE CONCENTRATION
WITH CAREFUL COMPOSITION

Not far from my studio is a place locals call the "Duck Pond." This pond is actually two different habitats divided by a walking bridge. In the front section, Canada geese and mallards gather in open water. Eutrophication has taken over the rear pond creating an abundant food source for less gregarious species such as this little green-backed heron. These subtly colored birds are often overlooked since they remain motionless for long periods, intensely concentrating on what is below the water's surface. In order to magnify this tension I placed the bird on a decaying log ready to strike out at the small fish soon to pass underneath his perch. I work with acrylics in layers of scumbles and glazes. This maintains a softness to these otherwise hard-edge paints. To retain richness and purity of color I used liquid frisket on the log, lily pads and cattails while painting the water. After removing the frisket and painting the landscape elements, I added the bird and its reflection and finally the subtle little fish, soon to become dinner!

ULCO GLIMMERVEEN

CREATE UNEASY SPECULATION IN THE VIEWER

Although it is quite unscientific to explain animal behavior in anthropomorphic values—such as happiness or jealousy—these emotions may very well be present in animals. Whether true or not, using human emotions in wildlife paintings usually appeals to us, because we look for recognition. The artist has many design elements available to ignite this spark of recognition, or to create the tension of a story, such as postures, locations of animals, atmosphere, a puzzling scene, etc. *European Tree Frogs* is such a story. The upper frog is comfortable, shaded by a leaf. The lower frog is frozen in action, looking up—perhaps also keen to escape the heat. An interaction seems due, although, with all the thorns around it, its opponent has itself well protected. We never know what will happen, which in itself creates an unease that holds the viewer.

EUROPEAN TREE FROGS
oil on illustration board, 24" x 18½" (61cm x 47cm)

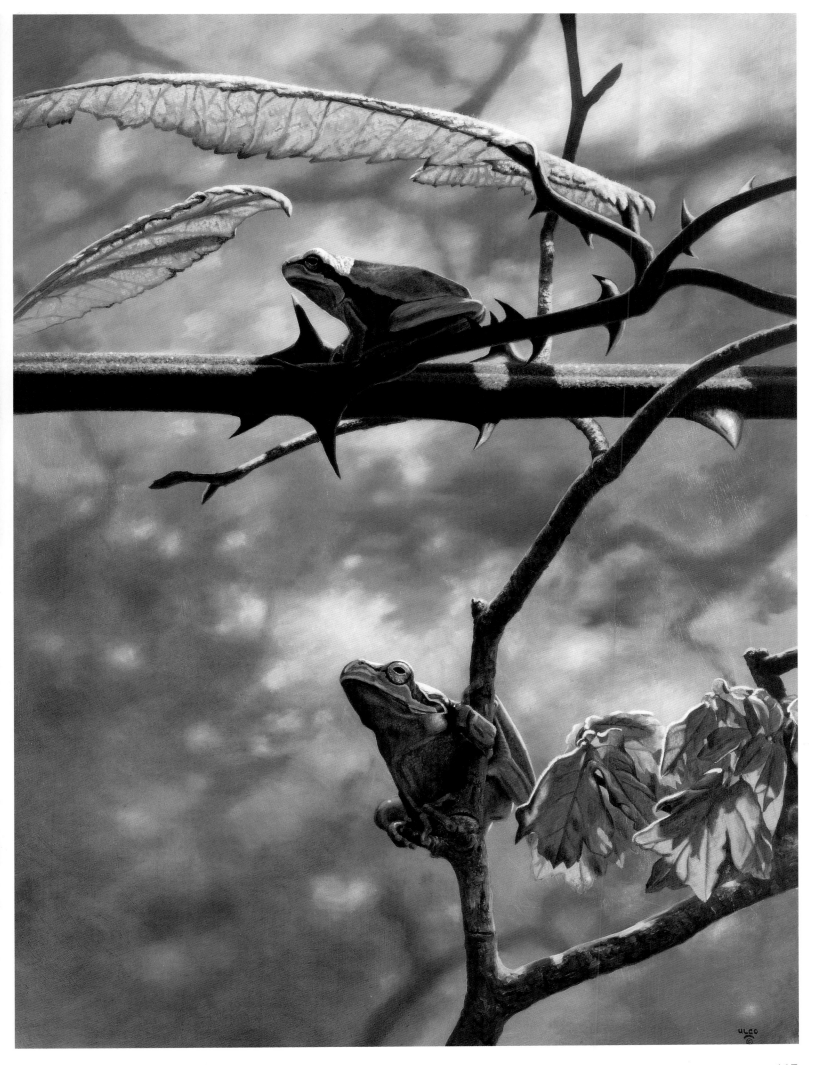

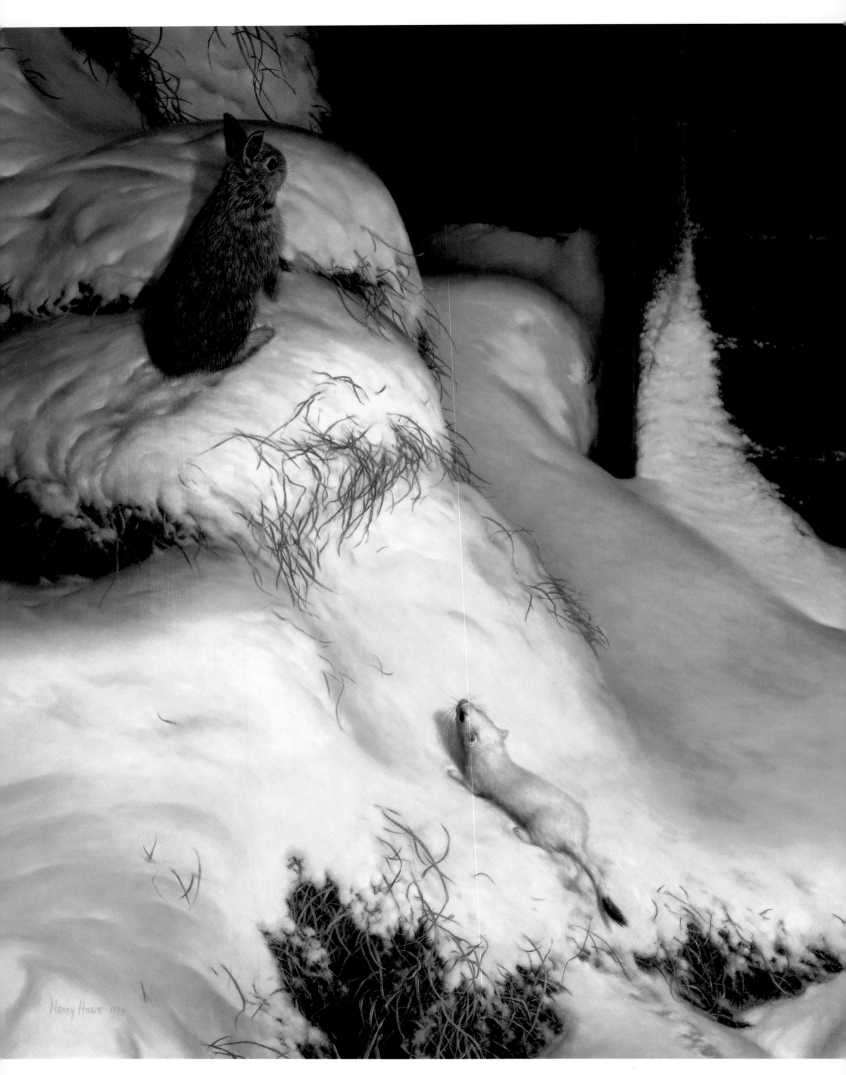

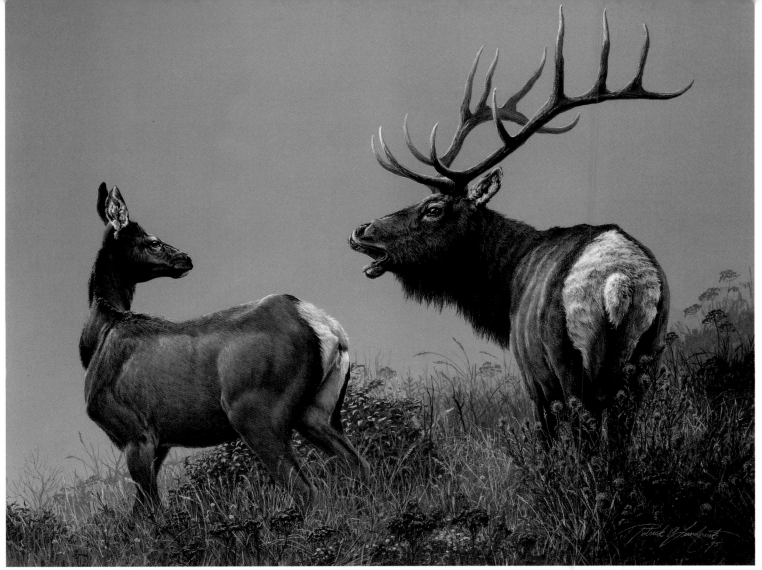

PROPOSITION — ELK AT POINT REYES (TULE ELK)
acrylic, 22" x 28" (56cm x 71cm)

PATRICK A. LUNDQUIST

GIVE YOUR PAINTING AN EDGE WITH EYE CONTACT AND TAUT MUSCLES

Point Reyes is windswept, cold and gray. Elk drift in and out of the fog-like apparitions, their distant bugles haunting. Crawling over a rise, I peer into the fog. Slowly the shape of a huge, dominant bull emerges. His harem surrounds him, skittish; the tension caused by the mating season is so tight you could play a tune on it. I use several devices to portray this feeling: The bull has just bugled and has the cow's attention. Stopped in mid-stride, she's swung her head and locked eyes with him. This eye contact as well as her taut muscles create the tension. Gray fog instead of a background prevents any distraction. The diagonal hillside, spiny thistles, highlighted bulls, sharply pointed horns and exposed teeth give the painting an edge.

As I was studying the bull for this painting, it turned, looked directly at me and suddenly charged! Grabbing my spotting scope, I spun and sprinted for dear life! Oddly, a couple of hikers standing nearby just stared at me curiously. Hearing nothing behind me, after a few more steps I grabbed a quick glance over my shoulder. The charging bull was on the far side of the meadow, herding an errant cow back to his harem. The spotting scope threw me. Red faced, I grinned sheepishly at the couple and returned to my original position. The elk weren't the only skittish ones at this scene.

NANCY HOWE

AUGMENT PREDATOR-PREY TENSION WITH DESIGN ELEMENTS

Tension is created in this painting in two ways. The first is supplied by presenting an obvious predator-prey scenario, suggesting an impending drama. Secondly, the elements of composition and design augment this tension by directing the viewer's eye along strong diagonal and vertical paths. These focus attention on the rabbit in alert posture. The concept for this piece developed from discovering a freshly snow-draped corner of our hay barn that appealed to me because of its simple beauty and strong design. All winter I had seen cottontail tracks up in the hay bales. Once, I came across weasel-like tracks and these images combined to become the basis for an early morning scene that might have been.

BARN THEATRE (EASTERN COTTONTAIL AND LONG-TAILED WEASEL)
oil, 28" x 24" (71cm x 61cm)

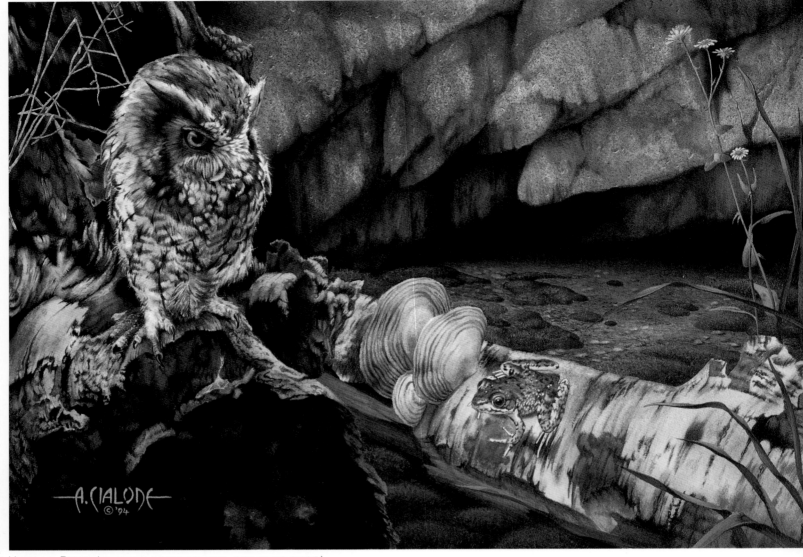

Vantage Point (eastern screech owl and tree frog)
watercolor and acrylic, 12" x 18" (30cm x 46cm)

ANDY CIALONE

DEPICT A SCENE JUST PRIOR TO ACTION

Vantage Point depicts a scene just prior to action, inviting viewers to invent their own versions of the ensuing events. Both opponents are stiffly postured, acutely aware of each other's presence. The painting's composition draws immediate attention to the owl, then follows her line of sight to the frog. As various angles pull the eye into orbit around the sphere of action, visual tension is psychologically enhanced with recognition of this antagonistic situation. A hint of the struggle to survive lies beneath the peaceful veneer. Although watercolors often have a diaphanous quality, I prefer a more substantial look. After sketching on a stretched piece of 140-lb., cold-pressed paper, I apply wet-on-wet washes to render the basic form of each element. From there, I tend to work small areas to near completion, the final step being a dry brush technique that adds density (note the plush appearance of the owl's head feathers). Since the watercolors are fairly opaque at this point, new objects rendered in acrylics can be integrated seamlessly to finish the image.

BEATRICE BORK

PLACING SUBJECTS CLOSE TOGETHER CAN ADD TENSION

Summer Activity expresses a moment in time. The goldfinches were placed close together to add tension both compositionally, as well as logistically. They begin to infringe on their spatial "comfort zone," resulting in a sense of fractional reaction time. The viewer's eyes move around the painting, continually returning back and forth between the two goldfinches. The use of mediums also adds to the drama. Watercolor and gouache create the loose versus detailed look. I enjoy the process of blending loose strokes with detail, and believe the result enables the viewer to experience the painting in a more involved way.

SUMMER ACTIVITY (AMERICAN GOLDFINCHES)
watercolor and gouache, 18½" x 16" (47cm x 41cm)

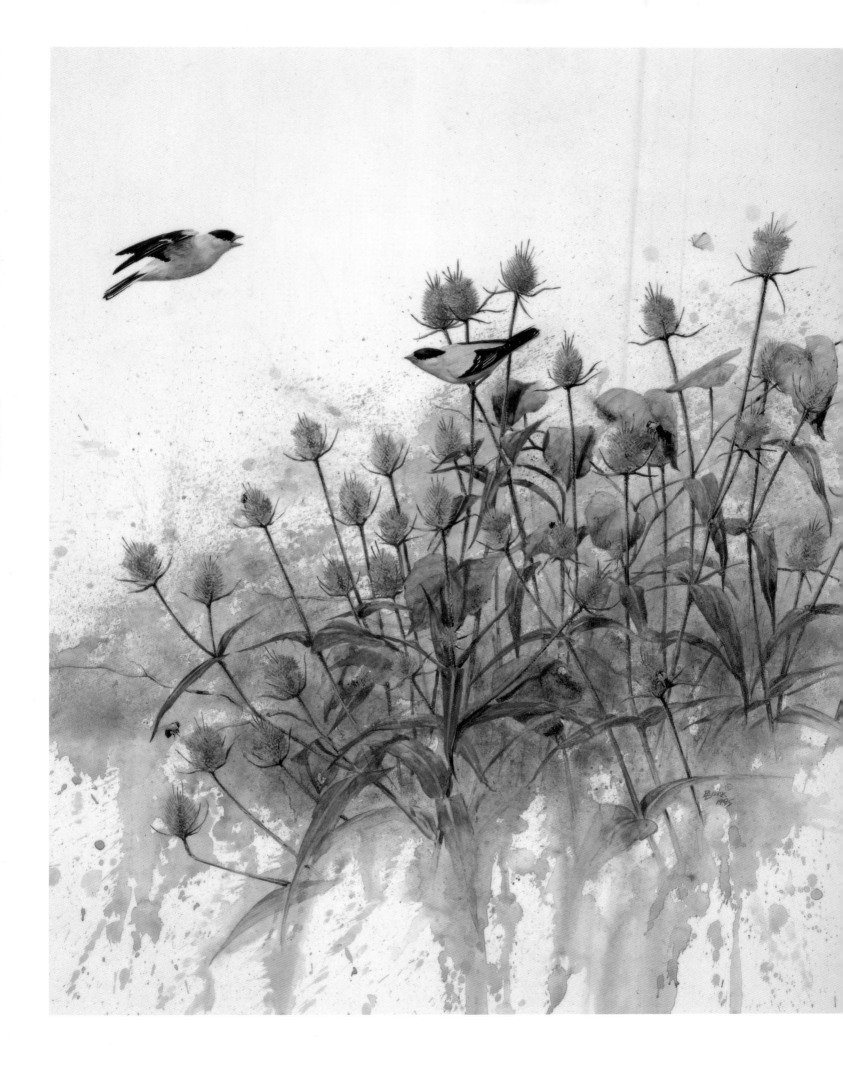

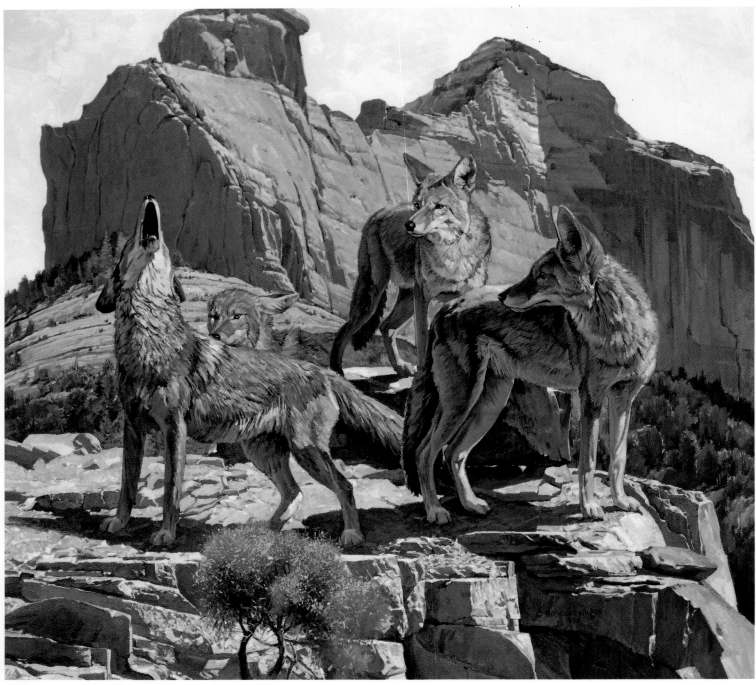

Spirits of Redland (coyote)
oil on linen, 36" x 40" (91cm x 102cm)

NICHOLAS WILSON

FOCUS A GROUP'S ATTENTION ON ONE MEMBER

The deserts of the Southwest offer many unusual shapes and colors for an artist's imagination. I chose to feature the desert coyote, not only because it's indigenous to this place but also due to its unique place in the very soul of the land—whether in Indian lore or a cowboy song. The coyote has been symbolized as a shameless opportunist and wily adversary, but despite any tarnishing allusions, the coyote is a symbol of survival. For that reason I've selected a group of these animals to convey the spirit of this dramatic land. To set the mood, I assigned a particular attitude to each animal toward the one howling coyote. Is there a tension building among the group? Can you sense the sounds as well as the desert heat? It is my hope that the viewer feels somehow a part of this interaction.

WILD TURKEYS AT RED ROCK RANCH
oil, 20" x 30" (51cm x 76cm)

ROBERT K. ABBETT

PAINT THE LULL BEFORE THE STORM

In painting wildlife, I often prefer to depict a point of arrested action—the lull before the storm, that moment of tension when an animal or bird could launch into vigorous movement at any second. Typically, when I watch a flock of these magnificent birds grazing, most are moving at all times. If alarmed, they may all stop at once while the threat is analyzed. The apprehension can be palpable. That is the moment for this painting. To convey the suspense, the birds' heads are all pointing in the same direction, even though their bodies suggest their random browsing. An extra bit of tension is introduced by the zigzag track delineated by the old log, the fallen branches and the largest tree trunk, and the placement of all three heads along the approximate line of the horizon. This was a commissioned painting for which my client and host, Ed Joullian, had constructed a very comfortable blind for me at the edge of the turkeys' favorite feeding ground. From here I could observe and photograph these great birds in relative comfort. Later, I was treated to the sight of twenty or so turkeys flying into the same woods, having been alarmed and flushed as we might expect to happen in the next few seconds of the scene shown in my painting.

ENTERTAIN THE EYE WITH NATURE'S

CAMOUFLAGE

TERRY ISAAC

GLAZES OF WHITE UNIFY AN ARCTIC SETTING

I am intrigued with the mystery of the Arctic. I wanted to paint a polar bear that incorporated this sense of mystery. The background is minimal, symbolic of the actual habitat of the polar bear; its domain is simply miles and miles of ice floe and arctic coast. By using glazes of transparent and opaque white, I tried to create a feeling of arctic mist (tiny crystals of ice floating in the air). This unifies the bear with the setting, creating a camouflage effect where the bear nearly blends into his environment.

FACE OFF — POLAR BEAR
acrylic, 26⅝" x 40" (67⅞cm x 102cm)

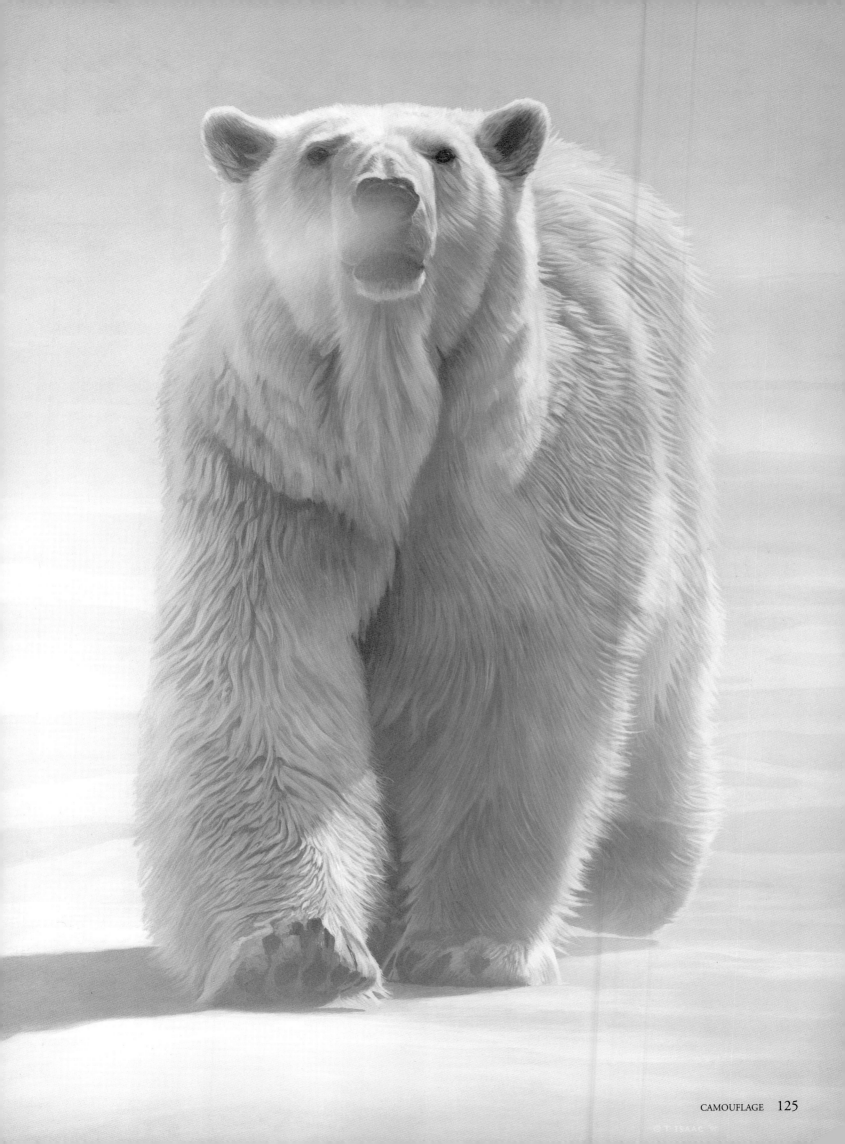

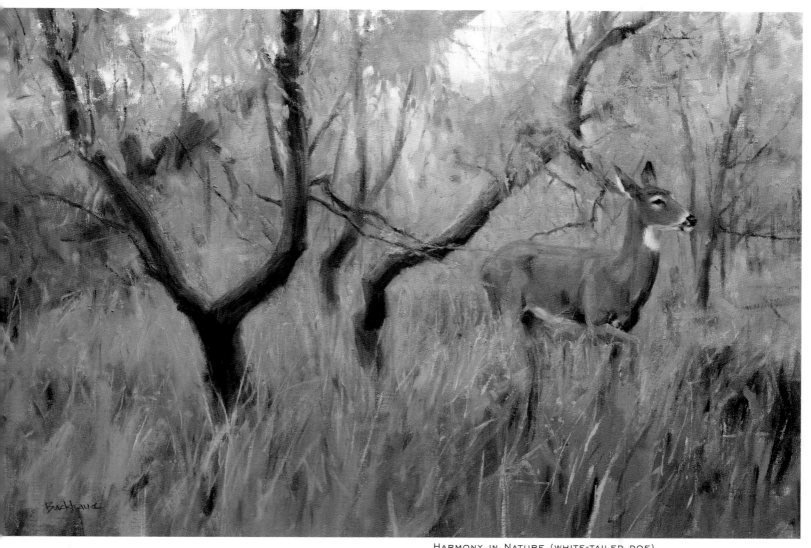

HARMONY IN NATURE (WHITE-TAILED DOE)
oil on linen, 24" x 36" (61cm x 91cm)

KENN BACKHAUS

VISIBLE BRUSHSTROKES UNITE
SUBJECT AND LANDSCAPE

I usually begin a piece from an on-location field study. The pure love for the outdoors with its ever-changing moods of color, light, movement and sound is my inspiration. Some of these landscape studies stand on their own, others are used as visual settings to which I add the animal subjects best matched to the values and conditions found in that study. In this painting the elegance and subtlety of a white-tailed doe related best to the mood of the field study from which this painting was generated. I want the viewer to see the brushstroke, to feel what I might have felt in doing it. If I wanted to merely render, I would use a camera. The paintbrush allows me to record the ever-changing moods that make up the harmonies in nature.

ADELE EARNSHAW

DECENTRALIZE YOUR SUBJECT
TO DELAY DETECTION

In *Sanctuary* I arranged the natural habitat of the bird in a pleasing composition using the vertical lines of the reeds and reflections. By placing the moorhen high in the picture space, it didn't interfere with these lines. In most of my work, as in *Sanctuary*, the bird is not immediately apparent. This is the way it is in nature. I work on dry paper (Arches 555-lb., stretched) and glaze a lot using transparent colors. I use only round brushes, no. 8, no. 14 and no. 26.

SANCTUARY (COMMON MOORHEN)
watercolor, 27" x 14½" , (69cm x 37cm)

PURPLE GALLINULES IN THE RAIN
mixed media, 11" x 40" (28cm x 102cm)

SUEELLEN ROSS

ECHO THE BRIGHT COLORS OF YOUR SUBJECT
IN ITS SURROUNDINGS

I developed my mixed-media technique to take advantage of my strengths—drawing and design—while indulging in my love of dramatic contrast and color. First, I draw a detailed and complete composition in graphite pencil. Then I use India ink for my darkest value. I fill in all remaining areas with watercolor, then use colored pencils to highlight, soften, brighten and enhance whichever areas need it. In *Purple Gallinules in the Rain*, Slate Blue pencil represents the surface of the water. I drew rain patterns on the deep water with Slate Blue over India ink. Then, using the same pencil, I drew over some of the vegetation and land, thus submerging it, and leaving the rest above the water level. When a bird is royal blue, purple, aqua, red, powder blue, yellow and white, and iridescent to boot, it isn't easily hidden. Yet on this rainy day in the Everglades these jewel-like birds would have been impossible to spot if they had not been so busy foraging in the spatterdock. Their colors were echoed all around them—in the reflections on the water and in the tropical greens, blues and yellows of the vegetation.

PAUL K. DONAHUE

A BIRD EMERGES FROM UNDERGROWTH SHADOWS

I have spent much of the last twenty years working with birds in the Amazon Basin, where the white-plumed antbird is reasonably common. Most birds of the rain forest undergrowth are extremely difficult to see due to their retiring habits and the low light levels. White-plumed antbirds, however, are among the species that habitually follow the raiding swarms of army ants moving across the forest floor. Because of this, they are relatively easy to locate. Even so, they can be surprisingly difficult to observe as they flit and hop about in the undergrowth shadows. When they are finally seen, they are frequently clinging to the vertical stems of undergrowth plants, as pictured in my painting. Before attempting the painting, I sketched birds in the field and mist-netted others for in-hand photographs and measurements. I also sketched and photographed the undergrowth vegetation in areas where I had observed the birds. I move freely back and forth among the three media listed, however, in general, acrylics predominate and I build these up slowly with many transparent layers.

WHITE-PLUMED ANTBIRD
acrylic, watercolor and gouache on watercolor board, 13" x 18" (33cm x 46cm)

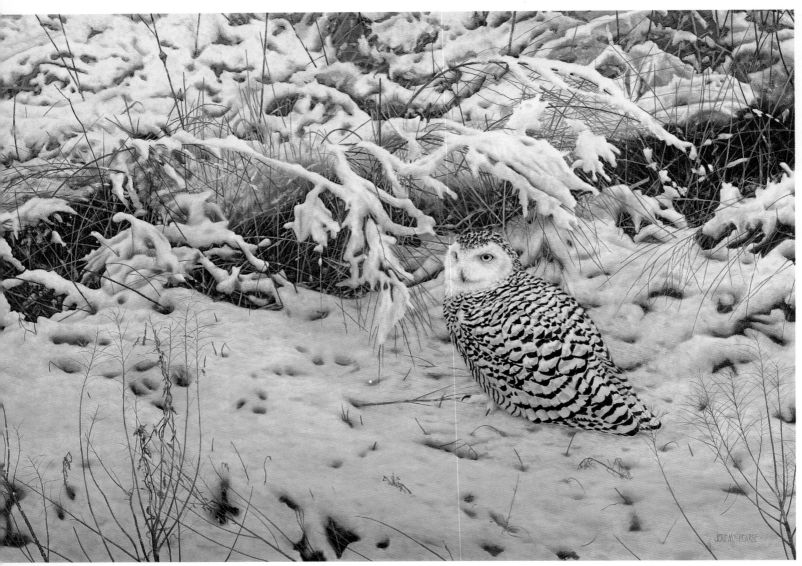

THE MIDDLE OF WINTER (SNOWY OWL)
oil on canvas, 29" x 43" (74cm x 109cm)

JEREMY PEARSE

WORK LIGHT TO DARK FOR A SNOWY SCENE

I am often amazed at the variety of colors and patterns that nature has to offer. Soft tones and counter-shading cause some animals to blend in with their surroundings, others rely on cryptic markings or bold splotches. Such is the case with snowy owls. My idea was to paint a young heavily-marked female snowy owl in its environment, so I set out to capture the scene in oils. My reference included sketches, photos, stuffed birds at the museum, live birds at the zoo and my memory of watching snowy owls in the wild. The hardest part was getting the bird to be part of its environment—it had to look as if it belonged there. I started the painting with the background then carefully put in the owl as I worked my way forward. I first put down a light underpainting, then lay darker colors over it. This worked well as there was a lot of snow in the scene and almost everything that I put down was darker than my base color.

Split Rail Hare (snowshoe hare)
oil on linen, 16" x 28" (41cm x 71cm)

DWAYNE HARTY

CAREFULLY OBSERVE SUBTLE SHIFTS IN COLOR TEMPERATURE

My many treks on out-property afford me frequent glimpses of the snowshoe hare. How marvelously they blend with the winter's snow. Often the only indication of their presence is a blink of a dark eye or a twitch of a black-tipped ear. It was this wonderful sense of discovery that I sought to interpret with *Split Rail Hare*. Close observation of the hare in the wild has been very rewarding. When observed from life, there is no difference in value between the snow's crystalline surface and the soft, furry surface of the hare. What distinguishes the hare from the snow is the subtle difference in color temperature. At all times the hare's white coat appears warmer than the snow because although the tip of each hair is white, the base is a tawny, ochre color. When illuminated by the sun this undercolor lends a warmth to the snowshoe's white. In this light effect most hard edges are lost and the painting became an exercise in close value relationships with subtle shifts in color temperature. I never tire of pursuing the snowshoe hare on my own set of snowshoes. Their tracks supply me with an authentic account of their daily routine. As in *Split Rail Hare* they will often venture from the safety of the willow swales, the split rail fences acting as corridors from one marsh to the next and providing a foil against predators.

BOULDERFIELD (WHITE-TAILED PTARMIGANS)
acrylic on Masonite, 24" x 32" (61cm x 81cm)

ROBERT MCNAMARA

HIDE YOUR SUBJECTS IN A JUMBLE OF SCUMBLED AND SPATTERED TEXTURES

Hiking the boulder fields and alpine meadows of the British Columbia Rockies, one is struck by the severe beauty and harshness of the climate. As I rested while climbing a boulder field in Kokanee Glacier Park, wondering how any life form could survive in such a harsh climate, a ptarmigan materialized out of the rocks not ten feet from me. Upon closer scrutiny of my surroundings, I saw several other birds standing stone still, relying on camouflage to escape detection in a habitat where there is no place to hide. In the painting *Boulderfield* I sought to share my experience with the viewer as well as celebrate the rugged textures, colors and forms of an alpine jumble of rocks. The rocks, while appearing to be an exercise in tedium, were really quite loose and enjoyable to paint. First they were under-painted with quick slashes of darks and lights to build form; then washes were used to develop surface undulations; much scumbling and spattering created texture; more washes enhanced color mottling and finally highlights were painted on to emphasize depth.

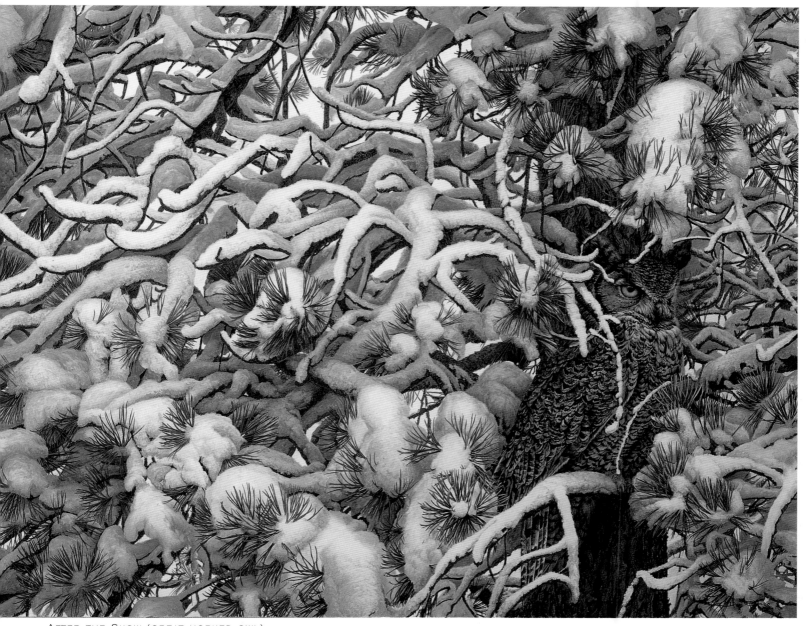

AFTER THE SNOW (GREAT HORNED OWL)
acrylic, 31" x 41" (79cm x 104cm)

DAN D'AMICO

CONCEAL YOUR SUBJECTS WITH A TAPESTRY OF LIGHT AND DARK LINES

After the Snow was inspired by an encounter with a great horned owl on our neighbor's property. While hiking through a dense pine grove on the north facing slope, I discovered the daytime resting place of the owl. As I passed a large pine, I was startled by the owl as he took flight just a few feet from me. A very heavy snow later that winter gave me the idea that the owl would be sheltering under the branches of that large ponderosa. I painted the owl hidden and sheltered after a heavy snow. The natural colors and markings on the bird blend perfectly with the trunk, and the snowy branches befuddle the eye so you can't quite make out if anything is there. In order to create the illusion of depth, it is necessary to overlap elements in your design. My goal was to lead the viewer to believe that certain boughs of the tree were behind others, while still maintaining the effect of a tapestry of light and dark lines that concealed the owl from immediate discovery. This was accomplished by carefully balancing the shapes and delicately modulating the values, with less contrast and cooler colors being applied as the branches receded into the distance.

HIDING PLACE (RACCOONS)
watercolor and gouache on illustration board, 15" x 29" (38cm x 74cm)

F. W. THOMAS

PROVIDE A REWARD FOR YOUR VIEWERS

I did not want this to be a raccoon painting, but I did want it to be
about raccoons. I wanted the viewer to be attracted to the painting
for the flowers but to discover a subtle surprise. This is the reward
camouflage art should provide. The setting for *Hiding Place* is my
own backyard. Although it is not a photo replication, it is a picture
story about the raccoons that often spend time encamped under my
tool shed. I have found that when a story can be incorporated into a
painting it takes on more meaning for the viewer as well as for the
artist. Traditional watercolor techniques were used, however there
was a lot of scrubbing and working back into the paint to allow the
white of the board to glow through. Due to the scrubbing, I used
cold-press illustration board rather than watercolor paper. Gouache
was used to create the soft faces of the raccoons.

QUIET PUDDLE — COMMON SNIPE
oil, 19" x 25" (48cm x 64cm)

BART RULON

POSE YOUR SUBJECT LOOKING
AWAY FROM THE VIEWER

This painting is about mood and camouflage. I witnessed the scene late one evening while bird watching at Point Reyes National Seashore. Instantly I knew it would be ideal for a snipe painting. I came home with a watercolor field painting and several photographs of the scene for reference. The mood of the low-light scene was to be the dominant idea, so I chose to work with oils in a loose manner. Oils are great for portraying the luscious effects at sunset. I chose a spontaneous painting style to keep viewers looking at the painting as a whole rather than just the details. The snipe would be the only thing painted in detail. Normally, I plan where to put the subject in my paintings before even starting to paint, but this one was an exception—I finished the landscape first. The camouflage of the bird would help assure its presence would not overpower the mood of the scene. Choosing an unusual pose for the bird, looking away from the viewer, also helped keep it from being dominant in the composition while adding to the originality of the idea. Camouflaged subjects are often seen upon second glance, and they encourage the viewer to take another in-depth look at the rest of your painting.

BASKING CARP (COMMON CARP)
acrylic on composition board, 30" x 48" (76cm x 122cm)

RICHARD J. SMITH

USE THE SAME COLORS IN SUBJECT AND BACKGROUND

The next best thing to catching fish is painting them. I don't seem to catch many these days, as I spend more time watching them. Fish-watching presents its own challenges: First, you need access to clean, clear water. Then you need to locate the fish—some fish may be enticed to suitable areas with food or you may find their spawning grounds. Finally, special equipment may be needed to see through the surface glare—I've had a pair of prescription polarizing glasses made. I have a favorite lake, a large gravel pit of about thirty acres with several bays and islands. The water is crystal clear, lush green weed beds provide shelter, and firm gravel bars allow one to wade safely. During May or early June many species of fish, including carp, can be seen spawning. They totally ignore a pair of green rubber waders, sometimes even swimming around one's legs allowing study at close quarters. If the weather is hot, carp can sometimes be seen basking in the sun, often with their backs breaking the surface. This painting evolved, as do many, from abstract sponging using my limited palette of mostly earth colors. If the same colors are used in the fish as in the background a unity and natural camouflage can be obtained.

RICHARD SALVUCCI

INCORPORATE AN ELEMENT OF SURPRISE

Camouflage is a natural phenomenon in nature. It makes two yellow and gray-green birds almost disappear in the sun-dappled canopy of a forest, providing protection from predators. In the field it can often be difficult to see a bird and it's always a surprise to see an animal where you thought there was none. This element of surprise is what I was trying to achieve in this painting.

THE RAIN FOREST (YELLOW-BREASTED CHAT AND HOODED WARBLER)
oil, 20¾" x 13¼" (52.5cm x 33.75cm)

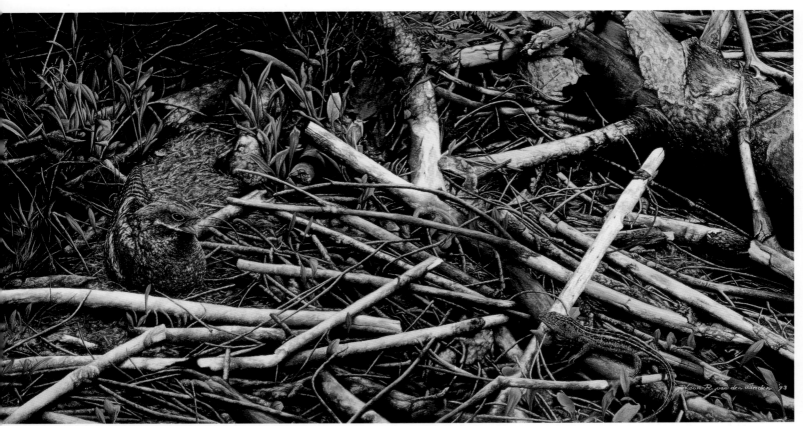

GHOST OF THE FOREST (COMMON NIGHTHAWK)
gouache and watercolor on drawing board, 14⅞" x 29⅛" (37.6cm x 74.2cm)

LÉON R. VAN DER LINDEN

DEVELOP AN ELABORATE PATTERN IN WHICH TO SITUATE YOUR SUBJECT

This is the most detailed painting I have ever made. The reason for this is the nighthawk's spectacular plumage. This bird is known for his skill in camouflaging himself, and I have tried to show every branch and small bit of dead wood in his habitat. Starting with an underpainting of watercolor, I let the composition grow. With so many patterns on the forest floor, it was difficult to find the main lines for the composition, but with a few thicker branches and some dark spots I found the balance. I then finished every part with gouache to maintain the structure of the branches and small plants. I met this bird for the first time in southern France while I was roaming a very dry shrub land on an extremely warm day. After a two-hour walk I almost stepped on the bird, which was sitting on a nest with two chicks. It was movement on the ground and a lot of noise that frightened me, because in this area there were a lot of vipers. Because this is a nocturnal bird it sits during the day, trusting in its camouflage. Animals like the green lizard shown in the lower right corner of the painting can approach too close. Instead of flying, the nighthawk tries to intimidate the intruder with snake-like sounds. This behavior often fools predators, and even humans like myself.

CONTRIBUTOR INFORMATION AND PERMISSIONS

Contact the following artists for information on prints, galleries and showings.

ROBERT K. ABBETT

Oakdale Studio, Inc., P.O. Box 126, Bridgewater, CT 06752-0126

p. 123 *Wild Turkeys at Red Rock Ranch* © Robert K. Abbett, collection of Red Rock Ranch, Bressie, OK

THOMAS ANDERSON

p. 13 *White Pelicans* © Thomas Anderson

KENN BACKHAUS

p. 127 *Harmony in Nature* © Kenn Backhaus

CHRIS BACON

National Wildlife Editions (publisher)
310 Tyson Road
Winchester, Virginia 22601
Phone (800) 699-9693
Fax (540) 722-5333

McNaught Gallery (agent)
191 James St. South, Hamilton, Ontario
L8P 3A8
Canada
Phone (905) 522-7773
Fax (905) 522-5898

p. 52 *White-Breasted Nuthatch* © Chris Bacon
p. 68-69 *Light-Waves* © Chris Bacon

JOHN BANOVICH

Banovich Studio, 362 Lathum Way
Camano Island, WA 98292

p. 62 *Wild Dogs of the Okavango* © John Banovich, collection of Irvin and Wendy Barnhart

p. 67 *104th Congress* © John Banovich, collection of Irvin and Wendy Barnhart

ALAN BARNARD

6 Aquasanta Cres., Hamilton, Ontario
L9B 2K8
Canada

p. 89 *Arctic Calm* © Alan Barnard, collection of Mr. and Mrs. William L. Wallace

BAS

Horizons, Rest Bay Close, Porthcawl
South Wales
CF36 3UN
Great Britian
Phone/Fax 01656 783884

p. 10-11 *The Rainforest Regent* © BAS
p. 23 *River Horse Dawn* © BAS

JENNIFER BELLINGER

p. 21 *Burchell's Zebras* © Jennifer Bellinger, private collection

HENRY BISMUTH

p. 59 Untitled (two magpies) © Henry Bismuth, collection of Newcastle United Football Co. Ltd., Newcastle Upon Tyne, United Kingdom

TERANCE JAMES BOND

p. 29 *European Eagle Owl* © Terance James Bond

p. 37 *Waiting for Rain* © Terance James Bond

CRAIG BONE

Environmental Art Awareness Group, Inc. (publisher), 805 E. Las Olas Blvd.
Fort Lauderdale, FL 33301
Phone (954) 832-0010

Call of Africa's Native Visions Gallery
807 E. Las Olas Blvd.
Fort Lauderdale, FL 33301
Phone (954) 767-8738

Call of Africa's Native Visions Gallery
821 Duval St., Key West, FL 33040
Phone (305) 295-9364

p. 28 *Matusadonna Rhino Refuge* © Craig Bone
p. 111 *Masters of the Hunt* © Craig Bone

BEATRICE BORK

P.O. Box 572, Whitehouse Station, NJ 08889
p. 121 *Summer Activity* © Beatrice Bork

MARK BOYLE

p. 56 *Shimmering Steelhead* © Mark Boyle

AMY BRACKENBURY

15755 Cherokee Park Rd.
Livermore, CO 80536
Phone (970) 221-1123

Mill Pond Press (publisher)
310 Center Ct., Venice, FL 01956-0336
Phone (800) 237-2233

p. 105 *Bumps on a Log* © Amy Brackenbury

CARL BRENDERS

Mill Pond Press (publisher)
310 Center Ct., Venice, FL 01956-0336
Phone (800) 237-2233

p. 24-25 *The Garden Visitor* © Carl Brenders, private collection

CAREL PIETER BREST VAN KEMPEN

Advanced Vivarium Systems (publisher)
10728 Prospect Ave., Suite G
Santee, CA 92071-4558
Phone (619) 258-2629
Fax (619) 258-7262

p. 42 *Two Stories* (painting and sketch) © Carel P. Brest van Kempen

p. 43 *Gainer* © Carel P. Brest van Kempen

p. 114 *Red River Hogs and Gaboon Viper* © Carel P. Brest van Kempen, stolen February 1995—current whereabouts unknown

p. 115 *Gripping Tail* © Carel P. Brest van Kempen

PETER BRUCE

p. 102 *Cooling Off* © Peter Bruce

MICHAEL BUDDEN

p. 73 *Sanctuary, Canada Geese* © Michael Budden

LEE CABLE

p. 6 *Pensive Puma* © Lee Cable
p. 27 *Desert Beauty* © Lee Cable

ANDY CIALONE

Imaginature, Inc., 429 Evergreen Blvd., Scotch Plains, NJ 07076

p. 120 *Vantage Point* © Andy Cialone

GUY COHELEACH

p. 58 *More Lawyers* © Guy Coheleach

SARAIS B. CRAWSHAW

Appletrees, Main Street, Willey, Nr. Rugby, Warwickshire, CV23 OSH
United Kingdom

p. 31 *Peacock Sunning on Stones* © Sarais B. Crawshaw

DAN D'AMICO

Apsen Leaf Studio and Gallery
P.O. Box 254 , Allens Park, CO 80510
Phone (303) 747-2063

p. 133 *After the Snow* © Dan D'Amico

CLAUDIO D'ANGELO

p. 88 *A Fine Spring Day—Moose* © Claudio D'Angelo, collection of Mr. Brian Arnott

LINDA DANIELS

Windcastles Studio, P.O. Box 939
Locust Grove, OK 74352

p. 95 *Dandelion* © Linda Daniels

TRENNA DANIELLS

Spinnaker Studios — Steve Wangler (publisher)
P.O. Box 91717, Albuquerque, NM 87100
Phone (505) 843-7853
Fax (505) 843-7854
E-mail SWANG38926@AOL

p. 14 *Hyacinth High* © Trenna Daniells

PAUL K. DONAHUE

P.O. Box 554, Machias, ME 04654

p. 128 *White-plumed Antbird* © Paul K. Donahue, collection of Will and Gill Carter

KATHLEEN E. DUNN

19232 SE 268th St., Kent, WA 98042

p. 97 *October 31st* © Kathleen E. Dunn, collection of the Leigh Yawkey Woodson Art Museum, Wausau, WI

RANDAL M. DUTRA

p. 90 *In His Domain—Black Bear* © Randal M. Dutra

ADELE EARNSHAW

P.O. Box 1666, Sedona, AZ 86339
Phone (520) 282-7581

p. 126 *Sanctuary* © Adele Earnshaw, collection of Jim And JoAnne Hanson

BETH ERLUND

p. 103 *Hanging On* © Beth Erlund, private collection

INDEX

More Books for Creating Great Art!

Painting Wildlife Textures Step by Step—Paint realistic fur, feathers, antlers and other wildlife textures with accomplished artist Rod Lawrence. He guides you step by step through dozens of easy-to-follow demonstrations using today's popular mediums—from acrylic to watercolor to oil. *#30866/$29.99/144 pages/140 color illus.*

Creative Oil Painting: The Step-by-Step Guide and Showcase—Get an over-the-shoulder look at the diverse techniques of 15 master painters. You'll watch and learn as they use innovative methods and step-by-step projects to create gorgeous landscapes, still lifes and portraits. *#30943/$29.99/144 pages/250 color illus.*

How to Draw Portraits in Colored Pencil From Photographs—Create colored pencil portraits that only *look* as though they were difficult to draw! Professional portraitist Lee Hammond takes you from start to finish with simple instructions, color recipes, layering techniques and inspiring demonstrations. *#30878/$27.99/128 pages/261 color illus.*

North Light Pocket Guides—Capture the beauty of landscapes—in different times of day, seasons and weather conditions. These at-a-glance guides include mini demonstrations, color tips and techniques for every medium.

 Painting Trees—*#30873/$16.99/64 pages/150+ color illus.*

 Painting Skies—*#30874/$16.99/64 pages/150+ color illus.*

Step-By-Step Guide to Painting Realistic Watercolors—Now even the beginning artist can create beautiful paintings to be proud of! Full-color illustrations lead you step by step through 10 projects featuring popular subjects—roses, fruit, autumn leaves and more. *#30901/$27.99/128 pages/230 color illus.*

First Steps Series: Drawing and Painting Animals—Discover how easy it is to draw and paint favorite pets, barnyard critters and wild animals. You'll learn how to simplify the process into easy-to-do steps—from creating basic shapes, to adding the necessary details that will bring your creation to life! *#30849/$18.99/128 pages/96 color illus./paperback*

Painting Vibrant Children's Portraits—Discover the secrets to painting the openness and charm of children in any medium. Whether painting for friends, or working on commission, you'll learn the fundamentals of capturing expressions and deciding on a pose, clothing, size and background. *#30880/$22.99/144 pages/200+ color illus./paperback*

Fill Your Oil Paintings With Light & Color—Create vibrant, impressionistic paintings as you learn to capture light, color and mood in oils! Simple demonstrations help you learn the methods you need to create rich, powerful paintings. Plus, you'll find

a showcase of finished works that's sure to inspire. *#30867/$28.99/144 pages/166 color illus.*

Creative Watermedia Painting Techniques—Explore the exciting possibilities of watermedia! Step-by-step demonstrations take the trial and error out of using wax resist, ink, acrylics, gouache and water-soluble pencils—alone or combined with other mediums. *#30876/$21.99/128 pages/350 color illus./paperback*

The Best of Flower Painting—Get a big, blooming collection of colorful interpretations from 133 of today's finest flower painters! Jan Kunz, Joyce Pike and Elizabeth Mowry are just a few of the artists featured in this tribute to a variety of mediums and styles—from precise botanical studies to spontaneous explosions of color. *#30868/$29.99/144 pages/152 color illus.*

The North Light Illustrated Book of Watercolor Techniques—Master the medium of watercolor with this fun-to-use, comprehensive guide to over 35 painting techniques—from basic washes to masking and stippling. *#30875/$29.99/144 pages/500 color illus.*

Basic Colored Pencil Techniques—Follow along with clear and easy demonstrations as you explore the foundational techniques of this expressive medium. From layering to burnishing, you'll learn a variety of versatile techniques and how to apply them to create trees, flowers, animals, people and other popular subjects. *#30870/$17.99/128 pages/173 color illus./paperback*

First Steps Series: Drawing in Pen and Ink—Now you can draw sketches that actually look like your subjects! Popular instructor Claudia Nice guides you through step-by-step projects and simple techniques for creating realistic-looking trees, flowers, people and more. *#30872/$18.99/128 pages/200 illus./paperback*

Wildlife Painting Step By Step—Capture the excitement and beauty of wild animals as you study demonstrations by distinguished wildlife artists. You'll cover every step of the painting process, from developing the idea to adding final details. Also included

are specifics, such as capturing animal behavior, habitats, field sketching and more! *#30708/$28.99/144 pages/195 color, 30 b&w illus.*

The Art of Painting Animals on Rocks—Discover how a dash of paint can turn humble stones into charming "pet rocks." This hands-on easy-to-follow book offers a menagerie of fun—and potentially profitable—stone animal projects. Eleven examples, complete with materials lists, photos of the finished piece and patterns will help you create a forest of fawns, rabbits, foxes and other adorable critters. *#30606/$21.99/144 pages/250 color illus./paperback*

Painting Birds Step by Step—Now you can depict birds and their habitats realistically, in a variety of mediums. You'll find expert advice and step-by-step instruction from 12 of America's finest bird painters, including a treasury of tips on such topics as fieldwork, painting feather textures, lighting and more! *#30754/$28.99/144 pages/215 color illus.*

Zoltan Szabo's 70 Favorite Watercolor Techniques—Paint dramatic clouds, jagged rocks, rolling surf, the setting sun, rough tree bark and other popular nature subjects using Szabo's step-by-step techniques. *#30727/$28.99/144 pages/230 color, 6 b&w illus.*

Painting Baby Animals With Peggy Harris—Now you can paint adorable baby animals with the help of professional oil painter Peggy Harris! You'll learn her fun, exciting and virtually foolproof method of painting using 11 color, step-by step projects that show you how to paint a variety of realistic little critters—from puppies and kittens to ducklings and fawns. *#30824/$21.99/128 pages/319 color illus.*

Creating Textures in Pen & Ink With Watercolor—Learn how to use pen and ink and watercolors to suggest a wide range of textures from moss to metal to animal hair. You'll discover ways to use such diverse materials as technical pens, paintbrushes, colored inks and liquid acrylics, and ways to alter and combine ink and watercolor for exciting texturing effects. *#30712/$27.99/144 pages*

Other fine North Light Books are available from your local bookstore, art supply store, or direct from the publisher. Write to the address below for a FREE catalog of all North Light Books. To order books directly from the publisher, include $3.50 postage and handling for one book, $1.00 for each additional book. Ohio residents add 6% sales tax. Allow 30 days for delivery.

North Light Books
1507 Dana Avenue
Cincinnati, Ohio 45207

VISA/MasterCard orders call TOLL-FREE
1-800-289-0963

Prices subject to change without notice. Stock may be limited on some books.

Write to this address for information on *The Artist's Magazine*, North Light Books, North Light Book Club, Graphic Design Book Club, North Light Art School, and Betterway Books. To receive information on art or design competitions, send a SASE to Dept. BOI, Attn: Competition Coordinator, at the above address.

8548